SHARON SIMS STUDIO

MAXFIELD PARRISH ❧ *The* MASTERWORKS

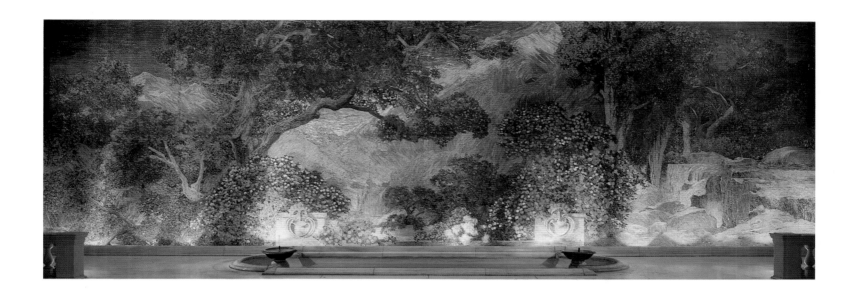

MAXFIELD PARRISH
The MASTERWORKS

BY ALMA GILBERT

To Marianne
With sincere appreciation
for all your help. I
look forward sending you
a copy of "Treasury" which shows
your beautiful photograph of
the Parrishes owned by the
Detroit Institute of Arts —
Thank you!
[signature]
Nov. 2, 1994



10 Ten Speed Press

TEN SPEED PRESS
P.O. Box 7123
Berkeley, California 94707

Library of Congress Cataloging-in-Publication Data
Gilbert, Alma.
 Maxfield Parrish : the masterworks / by Alma Gilbert.
 p. cm.
 ISBN 0-89815-480-4 : $75.00. — ISBN 0-89815-483-9
 (limited ed.) : $250.00
 1. Parrish, Maxfield, 1870-1966—Themes, motives.
 I. Parrish, Maxfield, 1870-1966. II. Title.
 N6537.P264A4 1992
 760'.092—dc20 92-11656
 CIP

Design/Production by David Charlsen & Others
 David Charlsen and Michael Pearce
Typesetting by Recorder Typesetting Network

First Printing, 1992

Printed in Japan
1 2 3 4 5 — 96 95 94 93 92

To my husband, Peter,
who encouraged, cajoled, praised,
and spent hours typing this manuscript,
I love you.

ACKNOWLEDGMENTS

To all the friends and clients who contributed photographs or artworks to be photographed for *The Masterworks* but most specially:

> The Fine Arts Museums of San Francisco
> Dr. Ronald Lawson
> John W. Merriam
> Robert Mason Mills II
> Howard Perdue
> Louis Sanchez
> Jim Seletz
> Sheraton Palace Hotel, San Francisco
> David Stoner
> John E. Walkowiak, Jr.

Unless identified as lithographs, all illustrations of art used in this text are from the original paintings. The bulk of the photography for this collection has been done for me over a period of twenty years by Fred English of English Photographs, Inc. A special thanks goes to him for making it possible to record all the wonderful Parrishes that have passed through my hands year after year.

In reproducing the *Florentine Fête* and details, I am indebted to two individuals: John W. Merriam of Philadelphia, who owns the murals and provided the transparencies, and Jim Seletz of Arizona, who shared with me his photographic collection of details.

The black and white photographs of Sue Lewin as well as family portraits and early black and white photographs of The Oaks were taken by Maxfield Parrish.

COLLECTIONS

Boston Public Library, Boston, Massachusetts
Brandywine River Museum, Chadds Ford, Pennsylvania
Carnegie-Mellon Museum of Art, Pittsburgh, Pennsylvania
Charles Hosmer Morse Museum of American Art, Winter Park, Florida
Cincinnati Art Museum, Cincinnati, Ohio
Cleveland Museum of Art, Cleveland, Ohio
Cooper Union for the Advancement of Science and Arts, New York, New York
Cornell University Library, New York, New York
Dartmouth College, Hood Museum, Hanover, New Hampshire
Delaware Art Museum, Wilmington, Delaware
Detroit Institute of Art, Detroit, Michigan
Everson Museum of Art, Syracuse, New York
The Fine Arts Museums of San Francisco, San Francisco, California
Fogg Art Museum, Harvard University, Cambridge, Massachusetts
Free Library of Philadelphia, Philadelphia, Pennsylvania
Haverford College, Haverford, Pennsylvania
Lyman Allyn Museum, New London, Connecticut
Mask and Wig Club, University of Pennsylvania, Philadelphia, Pennsylvania
Metropolitan Museum of Art, New York, New York
Minneapolis Institute of Art, Minneapolis, Minnesota
Museum of Fine Arts, Boston, Massachusetts
National Academy of Art, New York, New York
New Britain Museum of American Art, New Britain, Connecticut
Pennsylvania Academy of Fine Arts, Philadelphia, Pennsylvania
Philadelphia Museum of Art, Philadelphia, Pennsylvania
Phillips Academy, Andover, Massachusetts
Pioneer Museum and Haggin Galleries, Stockton, California
Precision Museum, Windsor, Vermont
Rhode Island School of Design, Providence, Rhode Island
Saint-Gaudens National Historic Site, Cornish, New Hampshire
Stauffer Foundation, Menlo Park, California
Syracuse University, Syracuse, New York
Union Oil Company of California
United States Department of the Interior, National Park Service,
 Phoenix, Arizona
University of California, Davis, California
University of Pennsylvania, Philadelphia, Pennsylvania
University of Rochester, Rochester, New York
Virginia Museum of Fine Art, Richmond, Virginia

TO MAXFIELD PARRISH
by
Richard Butler Glaenzer

Though like some alchemist of ancient days
You change all baser substance into gold,
Yours only are the secrets that unfold
A sky which rivals liquid chrysoprase;

Yours only is the veil of magic haze
Through which allures a garden, wood or would—
Enchanted vistas that invite the old
To tread anew dear unforgotten ways.

But sweeter still, to those in cities penned,
The silent pool, whose cypress sentinel
Has caught the last red kisses of the West,

To vesper music from yon steeple's bell.
O master-understanding, thus to blend
with solemn beauty all the balm of rest!

Century, February 1907

TABLE OF CONTENTS

MAXFIELD PARRISH ❦ *The* MASTERWORKS

Fig. 1.1

14

INTRODUCTION

In the arts, the term masterwork is used to describe the greatest work or body of work of an artist. Masterworks signify ascendancy or victory in the struggle of creation in the best works of an artist's lifetime. In Maxfield Parrish's art, it could be a single work, such as *Daybreak,* his *magnum opus,* as he called it. It could be a body of work such as the Edison Mazda calendars, or the *Florentine Fête* murals.

A work of art may be deemed a masterwork when the artist recognizes and acknowledges its superiority compared to other works he or she has created. Critics, museum curators, or art dealers may single out a work as being significantly superior to other works of art by the same artist. And popular appeal, the verdict of an overwhelming number of admirers and collectors who flock to view the work of the artist, establishes that work as a major piece.

Parrish's roots in illustration—his books, art prints, calendars, and magazines—insured almost from the start a tremendous wellspring of recognition and support from a loving and loyal public. His emergence in the early twentieth century, at the time when lithography was coming of age, presented him with a stupendous me-

dium to bring his art to a vast populace that relished his work, and could collect it rather inexpensively.

In selecting the pieces to include in this book of Maxfield Parrish's masterworks, I chose paintings that were significant to Parrish, that brought him public acclaim, and that, upon being viewed, were clearly head and shoulders above others that he created. I have collected, sold, and written about the Parrish paintings for almost twenty years, and have had the opportunity to hold close and view a large body of his work. In 1978, I opened the Maxfield Parrish Museum in the artist's home, "The Oaks," in Plainfield, near Cornish, New Hampshire. For the nearly eight years of the museum's existence, I saw firsthand the love and admiration with which the viewing public regarded the paintings of Maxfield Parrish. Most visitors had seen his prints; generation after generation had lovingly collected and preserved them. Few had enjoyed the chance to see or to own the original Parrish paintings because of their high prices, and because museums did not begin to collect Parrish works seriously until well after his death in 1966.

As a collector and dealer of Parrish's works, I have an idiosyncratic way of detecting and selecting a masterwork. Some may call it a sixth sense, some may call it hog-

wash. I use it because it works for me. When viewing and carefully examining a work of art, I have found that sometimes my skin prickles and my heartbeat accelerates in excitement. Whatever faint "magnetic" energy the artist left in the work (Einstein said that all matter has a certain energy that is left behind after contact; perhaps intense creative energy remains locked within the artwork), I seem to have a special antenna that reacts to that vital force and picks it up.

My credentials, then, for selecting the masterworks are based on being someone who has seen most of the original Parrish works pass through her hands in one way or another, and who has been privileged to stand before them, hold, own, and share them with others.

Maxfield Parrish was born in Philadelphia on July 25, 1870, the son of Stephen Parrish, an etcher of substantial note, and Elizabeth Bancroft Parrish, a well-to-do Philadelphia beauty. The Parrishes came from a long line of respected Quaker physicians whose family had been heroically active during the influenza epidemic that decimated the city of Philadelphia in the earlier part of the eighteenth century.

His given name was Frederick Parrish; Maxfield was his paternal grandmother's maiden name, which he adopted as a middle name before dropping "Frederick" altogether from his professional name around 1892. Parrish was very close to his father, who had been the first of his family to leave the medical field to become an artist.

Stephen Parrish encouraged his son's talent from a very early age. Father and son would travel in the summers through the capitals and major museums of Europe, painting and sketching, developing the close, warm relationship that lasted throughout their lives. In 1892 the younger Parrish enrolled in the Pennsylvania Academy under

Robert W. Vonnoh and Thomas P. Anschutz. He also attended the Drexel Institute, where he much admired the work of Howard Pyle, though he never actually studied with him. He eventually presented Pyle with a portfolio of his works; after examining them, Pyle encouraged him to begin professional work immediately and gave him a letter of introduction to *Harper's* magazine, who in 1895 commissioned Parrish's first magazine cover.

Buoyed by his success, Parrish asked the beautiful and talented Lydia Austin, one of his instructors at the Drexel Institute, to marry him. They were wed June 1, 1895. On June 3, the young artist left his new bride and traveled to Brussels, Paris, and London on a painting expedition he had planned prior to receiving the *Harper's* commission. While away, he wrote chatty and witty letters to Lydia, enclosing quick sketches and regaling her with his adventures.

Following his return, major commissions included the *Old King Cole* mural painted for the Pennsylvania Academy's Mask and Wig Club. The publication of the *Harper's Bazaar* cover, titled *Easter Number,* and the sale of the painting *Sandman,* which won him honorable mention at the Paris Exposition of 1900, allowed him to move in 1898 to Cornish, New Hampshire—an artist's colony started by the sculptor Augustus Saint-Gaudens—to be near his father's house, "Northcote." With some financial help from his father Parrish bought some acreage on a hill with a twenty-mile view of the Connecticut Valley. Starting with a one-bedroom log cabin, Parrish created The Oaks, the house he was to occupy until his death in 1966. With the help of a carpenter named George Ruggles, Parrish's lifelong friend, companion, and sometime model for humorous paintings and advertisements, Parrish designed what little by little became a twenty-room house with a fifteen-room studio nearby.

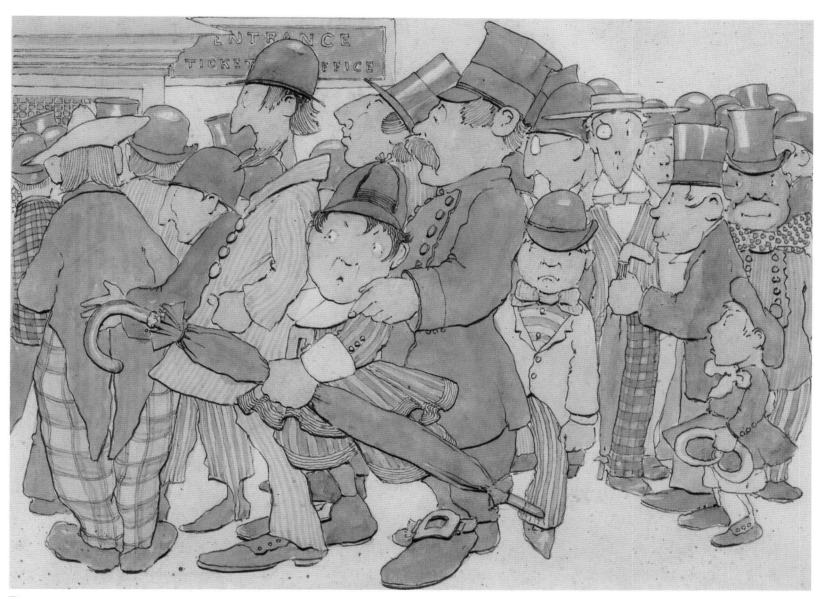

Fig. 1.2

The Oaks housed Lydia and their four children: Dillwyn, Max, Jr., Stephen, and Jean. Across the lawn was the studio where Parrish lived for years with Susan Lewin. Susan, who had initially come to the house to help Lydia with the children, eventually served as Parrish's model, housekeeper, and companion for almost fifty-five years. At first, Susan had lived in the main house, her quarters connecting with the master bedroom through a secret passageway. In the early 1920s, she moved into the studio with Parrish. Susan was the Muse that inspired a number of the masterworks; it was in the studio that great paintings such as *Daybreak, Garden of Allah,* the *Florentine Fête* murals, and the Mazda calendars were created, and Susan modeled for all of them.

Parrish eventually used this studio as his year-round home. Lydia and the children would close the main house during winters

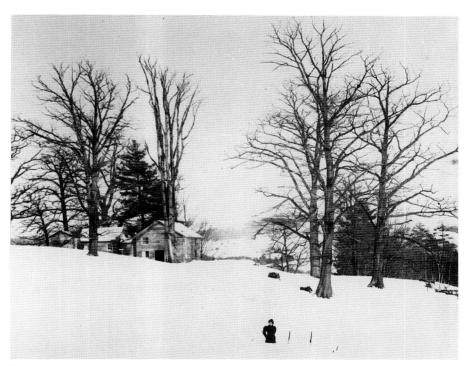

Fig. 1.3

and either travel abroad or winter on Saint Simons Island, off the coast of Georgia. Parrish almost always remained behind at The Oaks, painting, tending to the property, and being attended by Susan Lewin.

Between 1901 and 1925 Parrish created the major portion of his life's work; many of the masterworks were painted in these years. His greatest book illustrations, for *Poems of Childhood* (1904), *Italian Villas and Their Gardens* (1904), *Arabian Nights* (1909), *Tanglewood Tales* (1910), and *The Knave of Hearts* (1925), established his reputation as one of the best illustrators of the

early twentieth century, along with N. C. Wyeth and Howard Pyle.

Parrish's *Great Southwest* series for *Century Magazine* (1902), his advertisements for Edison Mazda (1918–1934), and the phenomenal *Florentine Fête* murals for the Curtis Publishing Company (1911–1916) brought him fame and great monetary success. His cover designs for magazines such as *Collier's, Ladies' Home Journal, Hearst, Cosmopolitan, Life, Scribner's,* and *Century* kept him in the eyes of the public in his own country and abroad. It was, however, his work for the House of Art (also known as Reinthal

Newman) and for Dodge Publishing Company that established him as the most-reproduced painter in the history of art.

His success had come from painting fanciful and idyllic scenes peopled with idealized or whimsical figures, but in the 1930s (when Parrish was already in his sixties), he made the famous pronouncement: "I'm done with girls on rocks!" The last painting with a human figure that Parrish did was for the famous *Collier's* cover, *Jack Frost* (1936), suggested by his daughter Jean. From then on, Parrish's work consisted of the beautiful landscapes that he painted to please himself and for calendars and greeting cards for Brown and Bigelow.

Maxfield and Lydia Parrish never publicly admitted to anything being amiss within their marriage. During the latter years of her life, Lydia traveled to Egypt and the Middle East with a companion and continued to winter at Saint Simons Island. She died alone of cancer on Saint Simons on March 29, 1953. Susan Lewin remained with Parrish until she reached her seventies. Because of his absolute, phobic fear of scandal, and not wishing to hurt his children or diminish their inheritance, Parrish

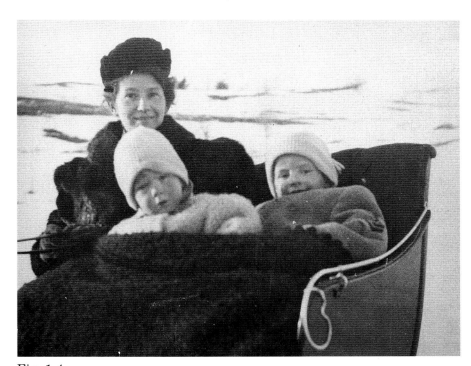

Fig. 1.4

did not marry Sue, even after Lydia's death. In 1960, Susan finally left Parrish to marry Earle Colby, her childhood sweetheart. She was seventy-one years old; Maxfield Parrish was ninety. Susan and Parrish corresponded frequently with each other until his death. Their letters speak volumes about their devotion to one another.

Parrish's popularity waned during the 1950s and 1960s but he lived to see a resurgence of his fame. In June 1964, when he was ninety-four, Parrish attended the first of many museum exhibitions of his work at the Gallery of Modern Art in New York.

On March 30, 1966, at the age of ninety-five, Parrish died peacefully at his beloved Oaks. He had not wanted to leave it, and in his will he asked that his ashes be scattered around the large oak tree he had so often painted. "This tree has sustained me for all these years, I want to fertilize it," he told his heirs. For some reason, the family chose not to honor his last request. Perhaps it was because Maxfield Parrish, Jr., the executor of his father's estate, felt he needed to sell The Oaks and did not want to leave his father's remains to strangers. The estate and all the paintings it contained were sold. Inheritance taxes (which Parrish had neglected to provide for) were paid and the proceeds of the sale of paintings distributed among the remaining heirs.

It was not until 1986, after the death of Max, Jr., that his father's and grandfather's ashes were found in urns in the Lexington, Massachusetts basement of Max, Jr.'s house. They finally rest in the Plainfield, New Hampshire cemetery, near other family members.

In my years as curator of the Maxfield Parrish Museum, I became intimately aware of Parrish the man, as well as Parrish the artist. Through his letters and the letters of his sons Dillwyn and Max, a very clear, warm picture of the elusive and reclusive Parrish appeared. Warm, witty, handsome, stubborn, and self-deprecating, he jealously guarded his privacy from the local community and the world at large. He was able to accomplish his large volume of work through a very productive lifetime because of a rigorous painting discipline and "tunnel vision" that allowed him to focus on doing what he loved most, painting pictures.

From the large body of work of nearly one thousand paintings, I have selected the roughly one hundred works I consider to be Parrish's masterworks. View them through my eyes, if you will, and once more enjoy the greatness of the man whose work has influenced and touched so many others in this century. Mr. Parrish: With this book, I who have delighted in viewing, owning, and caring for your masterworks, salute you!

List of Figures for Chapter 1

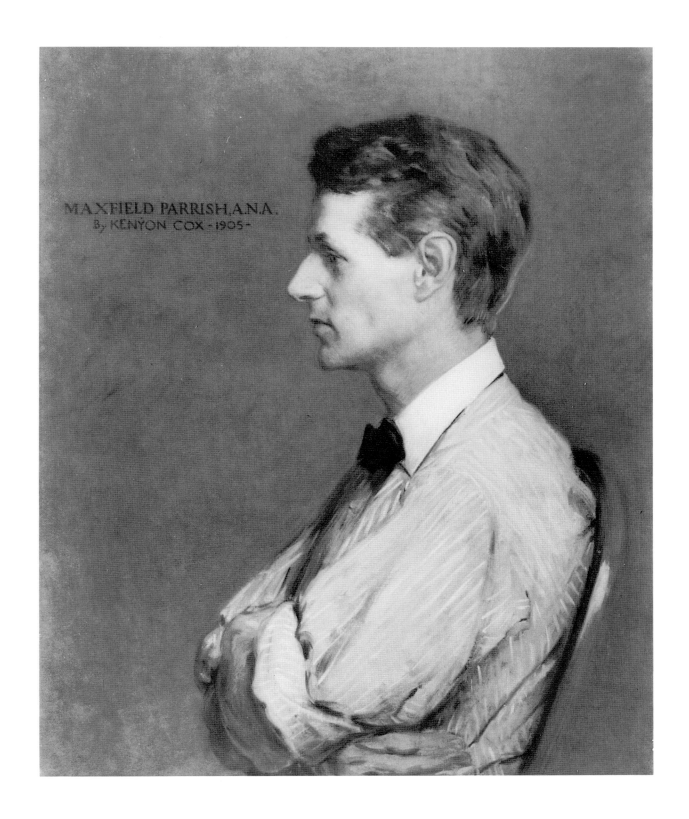

MAXFIELD PARRISH, A.N.A.
By KENYON COX · 1905 ·

Fig. 1.5

Fig. 2.1

T H E B O O K I L L U S T R A T I O N S

(1 8 9 7 - 1 9 2 5)

My personal introduction to Maxfield Parrish's art was through the wonderful books he illustrated. As a child I was a voracious reader; books were my friends. Whenever I was ill and had to stay in bed I could always look forward to receiving a special book as a gift from my mother, grandfather, or a loving aunt. My favorites as a very young child were the wondrously illustrated fairy tales from all the corners of the world. I graduated to pirate tales and other adventure stories. The books that I treasured most were the beautifully illustrated ones. I was a collector even then.

Strangely enough, I was not introduced to the wonderful world of the Parrish book illustrations until after childhood. I grew up in Mexico City, so the first books I collected were in Spanish; to my knowledge, none of the Parrish illustrated books had yet been translated. As an adult, browsing in an antiquarian bookstore looking for children's books to give to my own children, I came across my first Parrish illustrated book: *The Arabian Nights,* compiled by Douglas Wiggin and Nora A. Smith, which Scribner's had published in 1909. The first illustration I came upon was that of *Cassim in the Cave of the Forty Thieves* (fig. 2.16). I stood riveted by the play of light, by the art-

ist's use of chiaroscuro . . . and I was hooked! The cerulean blues and greens of the water in *Prince Codadad* (fig. 2.17), the magnificent golden tones of *Prince Agib* (fig. 2.18), made me want to buy and read everything this man had illustrated.

Modern book reproductions would not do! I began searching for first or very early printings. Other books that followed my initial discovery were *Poems of Childhood* by Eugene Field (Scribner's, 1904); *Tanglewood Tales* by Nathaniel Hawthorne (Duffield and Co., 1910), and then, the greatest of all the books illustrated by Parrish, *The Knave of Hearts* by Louise Saunders (Scribner's, 1925).

In the spring of 1973, when a client walked into my gallery and asked if I could find an original Parrish painting for him, memories of my beloved books with their wondrous illustrations crowded into my mind in joyous, tumultuous abandon. Could I find an original Parrish? What if I found one for him? Could I bear to part with one if I found it? Would I buy it for myself? But most importantly, would it be as good as the illustrations that had so captivated me? Of course, I had to try!

It took me nearly a year before I finally located not one, but *twenty-three* Parrish paintings. I was tipped off by a friend at Sotheby's in New York that Mr.

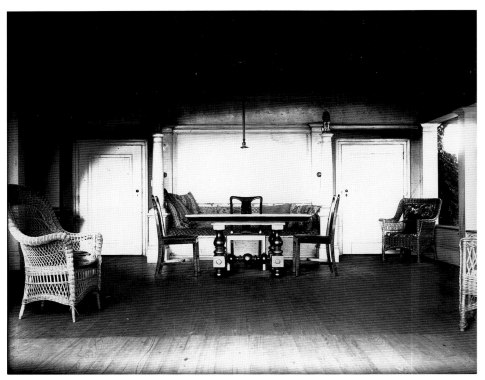

Fig. 2.2

Parrish's estate would be coming up for sale at the prestigious Vose Galleries of Boston. I called and was told in the courtly manner of Mr. Robert Vose that indeed, yes, they had a number of "nifty" paintings by Maxfield Parrish. Would I care to see a few photographs?

I flew East to view them, and out of the twenty-three available paintings, I bought seventeen. I had to mortgage my house in California . . . No matter! I was a woman with a mission. A number of the magical book illustrations that I so cherished were available in the paintings. I did not hesitate. At that instant, I became a Parrish dealer.

I am not alone in discovering Parrish through his book illustrations. This was the medium that, along with magazine covers, first brought him to public notice. His book illustrations extended from 1897, with a cover design for Emma Rayner's *Free to Serve* (published by Copeland and Day), to the 1925 *Knave of Hearts*.

The earlier books, such as *The Golden Age* (1899) and *Dream Days* (1902) by Kenneth Grahame, *Mother Goose in Prose* by L. Frank Baum (1897), and *Knickerbocker's History of New York* (1900) by Washington Irving, were all illustrated in pen and ink drawings. Although first editions of these books can fetch large sums (such as $750 for a mint condition *Mother Goose*), my special preference remains with what brought Parrish so much adulation: the color illustrations reproduced from his paintings, where his luminous effects, created by glazing between layers of paint, make his works shimmer with brilliant color and dazzling tonalities.

The following book illustrations should be considered among Parrish's masterworks.

The Cardinal Archbishop, painted as an illustration for *The Turquoise Cup* by Arthur Cosslett Smith (Charles Scribner, 1903), is a wonderful example of Parrish's luminism (fig. 2.3). It is one of the few pieces for which the artist used himself as a model,

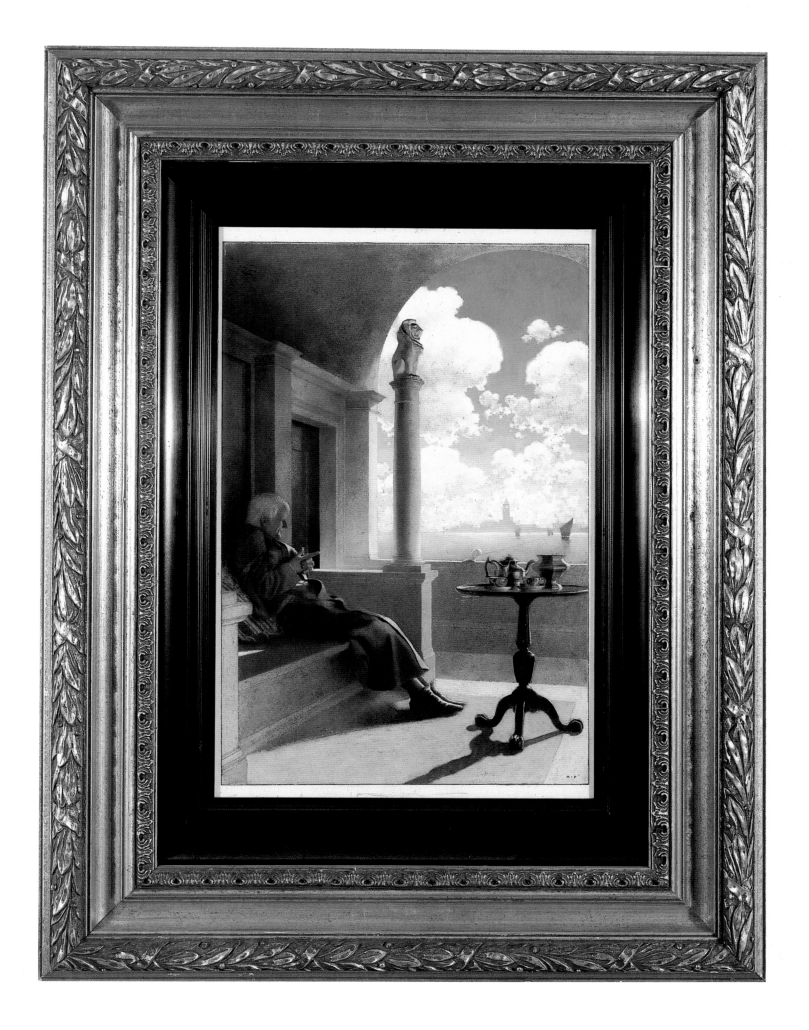

Fig. 2.3

25

Fig. 2.4

Fig. 2.5

in a thoughtful, beautiful portrait of the pensive archbishop. Parrish used his own back porch as the setting. The Duncan Phyfe table holds his pewter service; the lion on the pedestal was crafted by Parrish in the Saint-Gaudens studio. The lion was still sitting on the column when I purchased The Oaks. Parrish's view of Venice in the painting is a perfect example of how he would transport a different locale to blend it effortlessly with his own surroundings. The painting was shown in 1984–1985 at San Francisco's M. H. Memorial De Young Museum in the exhibition *Venice: The American View 1860–1920.*

Two major books illustrated by Parrish appeared in 1904, *Italian Villas and Their Gardens* by Edith Wharton (Century), and Eugene Field's *Poems of Childhood* (Scribner's). Parrish and Lydia traveled to Italy with his camera and sketchbook in preparation for the book illustrations for *Italian Villas.* Edith Wharton was a known taskmistress whose deadlines were not to be ignored. Parrish confided in a letter to his friend, the American writer Winston Churchill (1871–1947): "Dear old Doc: Working for this lady author can keep one on his toes. I'm painting as fast as I can and dread when I have to face her with a late deadline."[1] Parrish would use his photographs and sketches at home to finish the paintings. Evidently, Wharton's deadline did catch up with him. The illustration of Villa Caprarola was reproduced from a painted photograph rather than a painting (fig. 2.9).

The best images from the *Villas* are *Garden of Isola Bella; Villa Este; Villa Chigi; Villa Scassi;* and *Villa Cicoqna* (figs. 2.4–2.8). The soft hues and delicate precision of these oils on stretched paper are sensitive interpretations by a man who would have been an architect if not a painter.

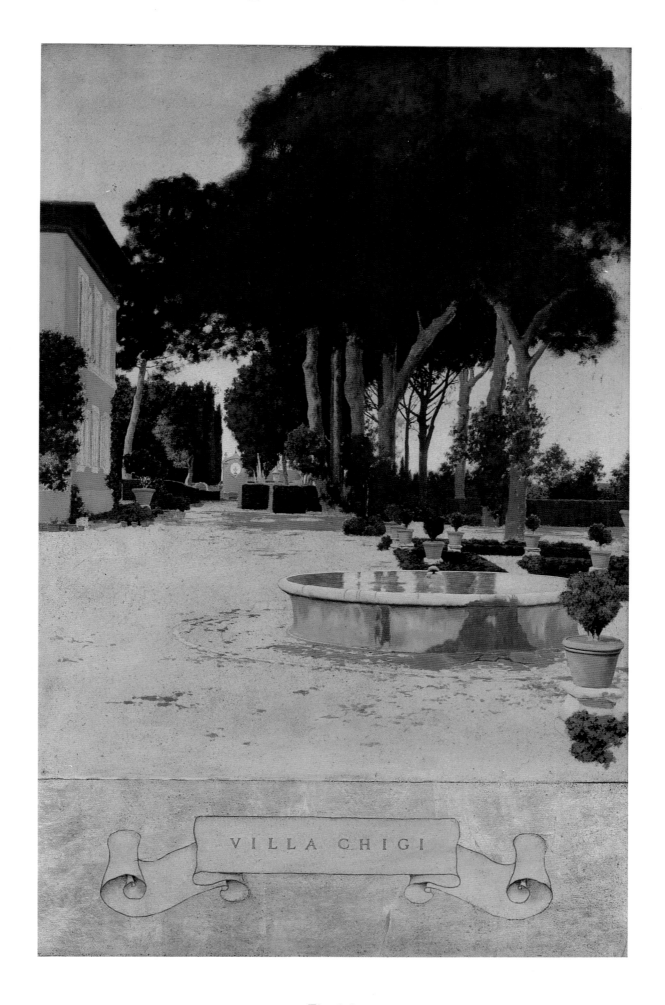

Fig. 2.6

Fig. 2.7

Fig. 2.8

Fig. 2.9

Fig. 2.9

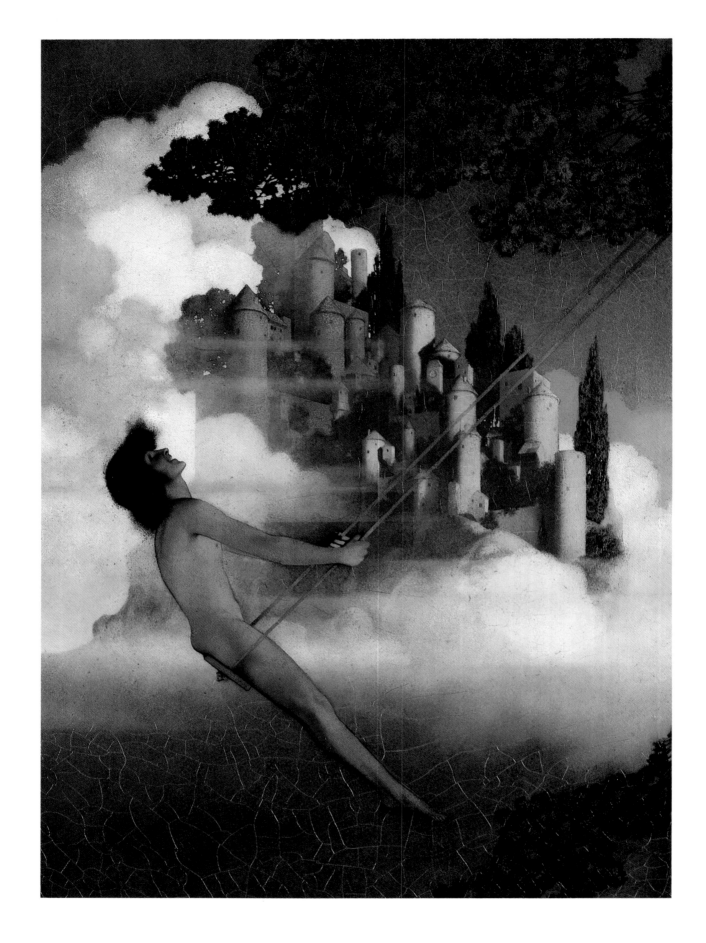

Fig. 2.11

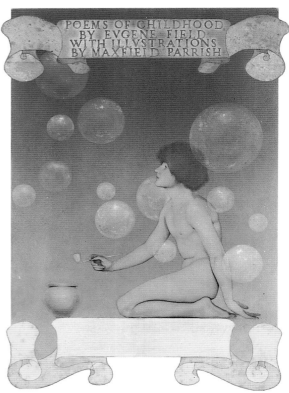

Fig. 2.10

Eugene Field's *Poems of Childhood* appeared on the bookstalls two months before Wharton's *Italian Villas.* No wonder Parrish was pressed! In contrast to the soft pastels of the architectural settings of the *Villas,* the illustrations for *Poems of Childhood* gave Parrish his first chance to have his paintings reproduced in broad color. The whimsical and childlike facets of his nature were given full rein in this marvelous book. So many of us learned those poems in close association with the illustrations of *Dinkey Bird* and *Wynken, Blynken, and Nod.* In *Dinkey Bird,* the spirit of abandoned joy captured on the swing in full flight reminds us of a never-never land that we, too, probably inhabited as children. This painting, which appeared at the Pennsylvania Academy's 100th Anniversary Exhibition in 1905, is one of the images in Parrish's work that many viewers today probably recognize at once, along with *Daybreak* or *Ecstasy. Dinkey Bird* has the kind of instant recognition that Grant Wood's *American Gothic* has in the American art consciousness.

All the paintings for Field's *Poems of Childhood* were executed in oil colors on stretched paper, a medium that permitted Parrish a magical luminosity in their rendering. The finest of them are *Title Page: Poems of Childhood; Wynken, Blynken, and Nod; With Trumpet and Drum; The Fly-Away Horse;* and *Sugar Plum Tree* (figs. 2.10–2.15). All of these paintings had surfaced in the art market by 1991. *Dinkey Bird* remained hidden, its whereabouts unknown until recently.

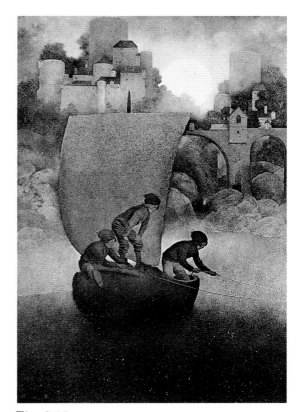

Fig. 2.12

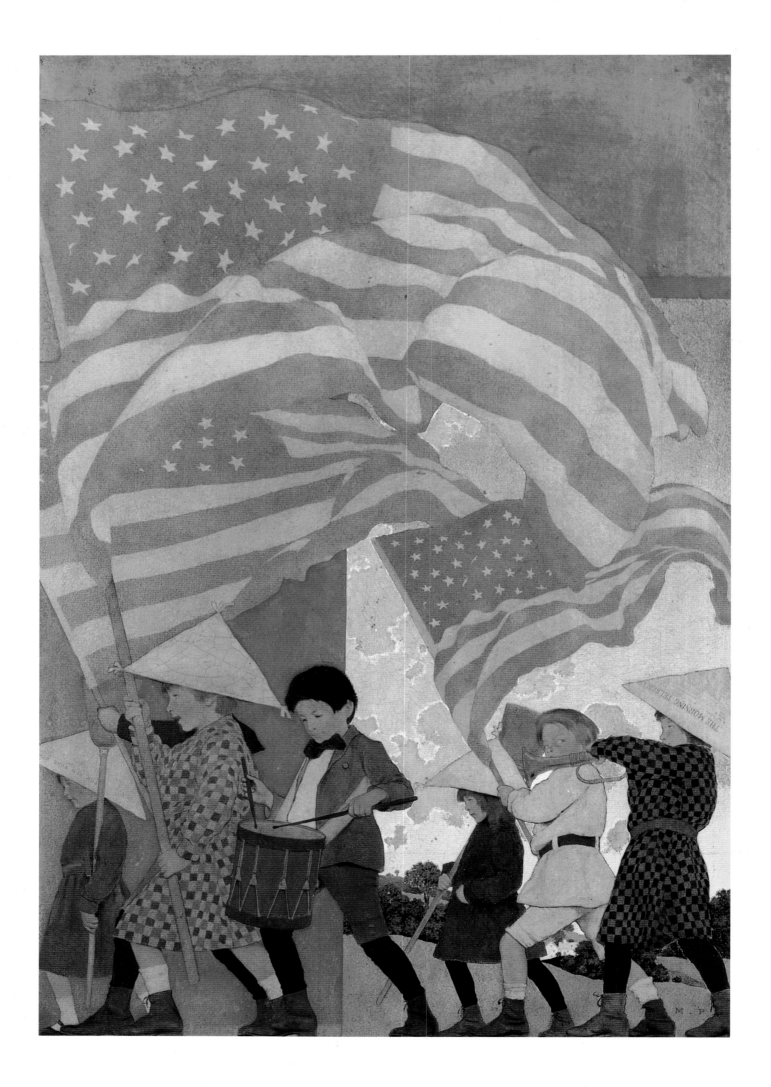

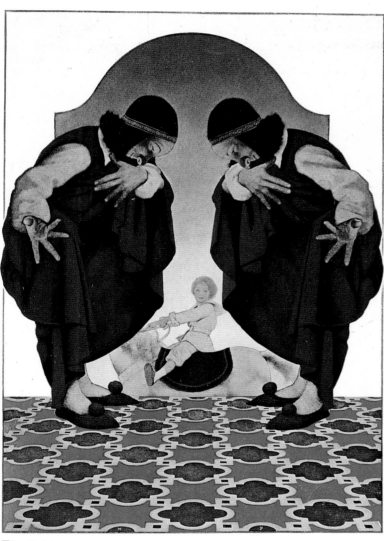

Fig. 2.14

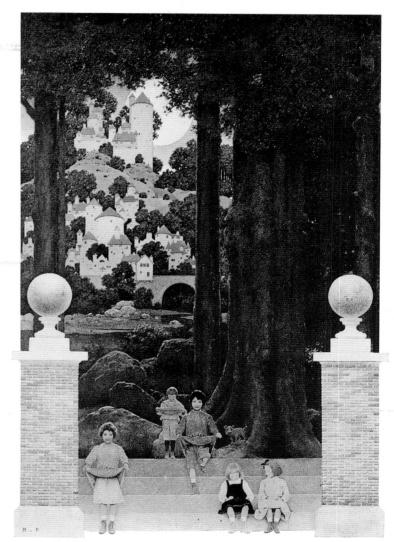

Fig. 2.15

(facing page) Fig. 2.13

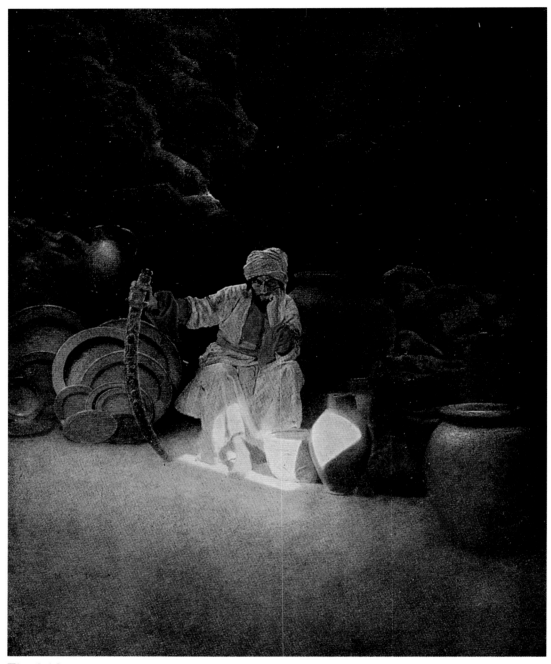

Fig. 2.16

The twelve *Arabian Nights* paintings first appeared as full-page color illustrations for *Collier's,* the magazine to which the artist was under exclusive contract between 1904 and 1910. Charles Scribner, with whom Parrish had discussed the possibility of illustrating *Arabian Nights* as early as 1904, purchased the book rights for the series from *Collier's* and commissioned Kate Douglas Wiggin (author of *Rebecca of Sunnybrook Farm*) to write a subdued translation of the lusty tales in 1909.

In *Cassim and the Cave of the Forty Thieves, Prince Agib, Codadad and His Brothers, Young King of the Black Isles, Sinbad Plots against the Giant,* and *Gulnare of the Sea* (figs. 2.16–2.21), the richness of color and the harmony of the compositions

Fig. 2.16

36

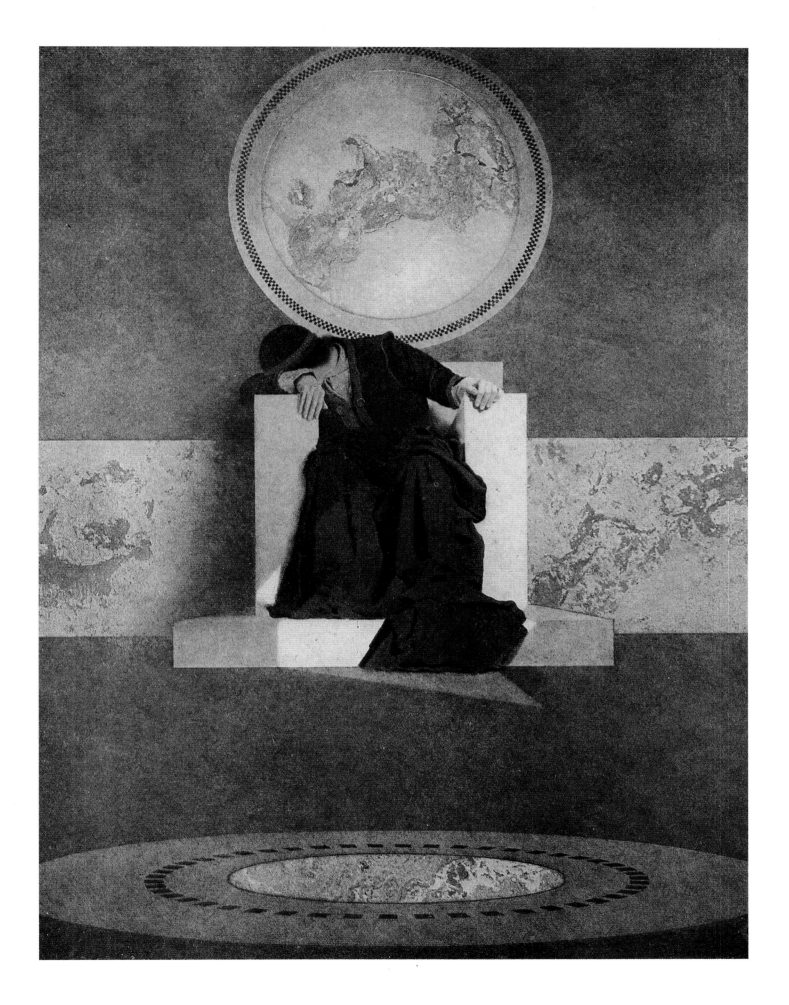

Fig. 2.19

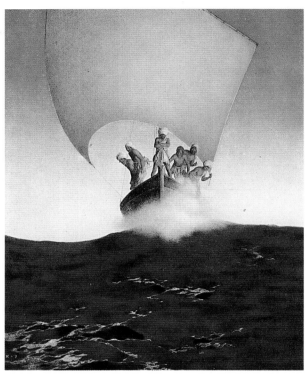

Fig. 2.17

make the illustrations, painted on canvas laid down on board, some of the best work of the period. At about the same time, *Collier's* published a series of works based on Greek mythology. These, too, reproduced large paintings measuring approximately 40″ by 30″ inches, which Parrish executed on canvas laid down on board.

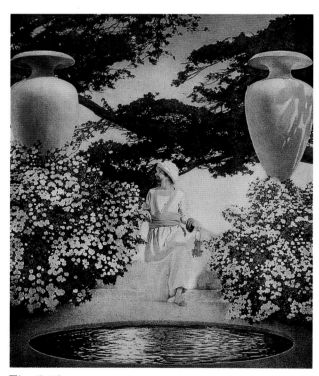

Fig. 2.18

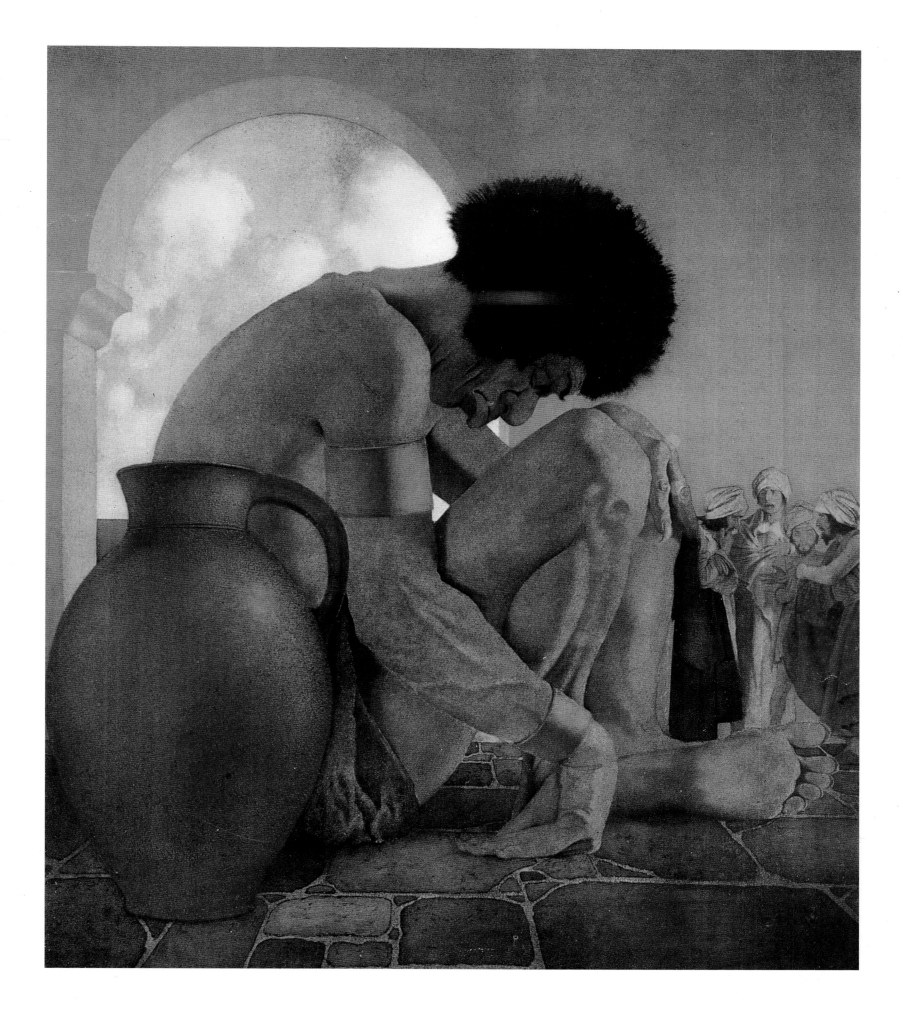

Fig. 2.20

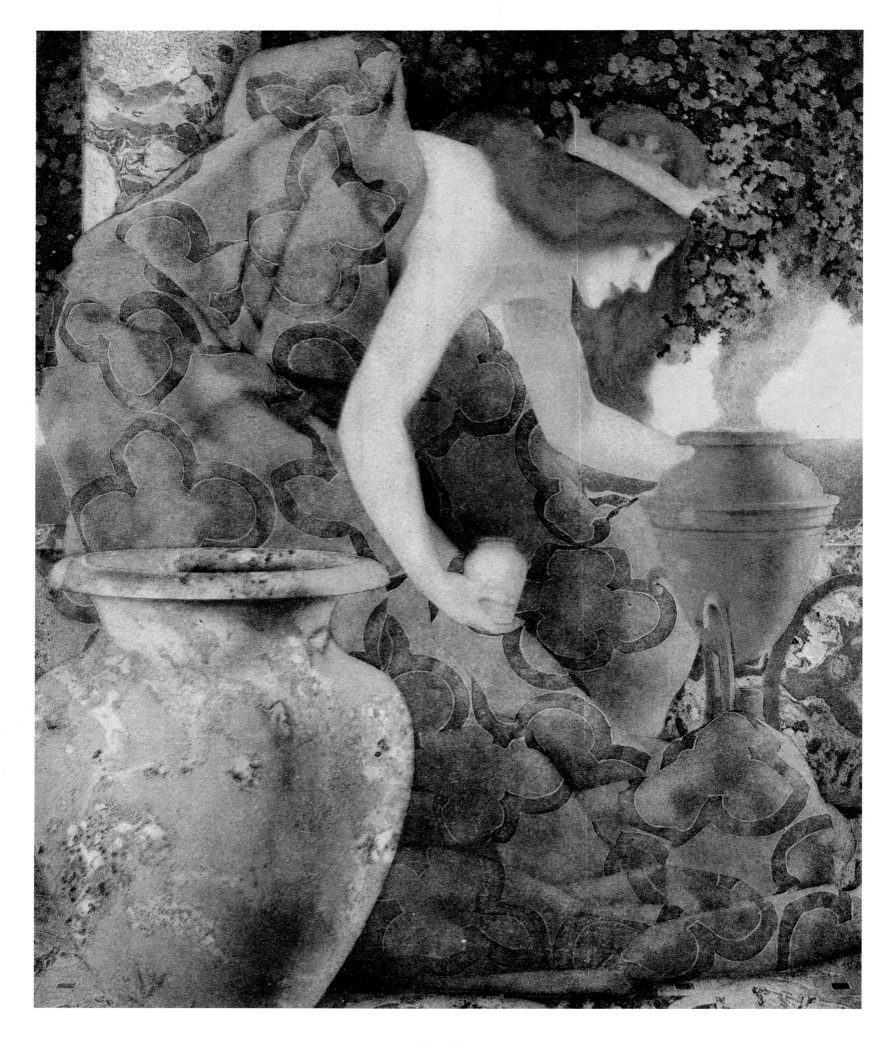

Fig. 2.21

Duffield and Company purchased rights to the series from *Collier's* to illustrate Nathaniel Hawthorne's *A Wonder Book of Tanglewood Tales,* which had first appeared in two volumes in the 1850s. Duffield published the book in 1910, with permission to reproduce two paintings from the Philadelphia collection of Austin Purves: *Jason and His Teacher* and *Jason and the Talking Oak* (figs. 2.22–2.23). These, incidentally, were two of the pieces I first saw when I purchased the Parrish and Purves collections at the Vose Galleries in 1973. The richness of the textiles, the decorative, heroic flow of the robes, have made these pieces particular favorites of mine. Other enchanting paintings for *Tanglewood Tales* include *Cadmus Sowing the Dragon's Teeth* and *Proserpina and the Sea Nymphs* (figs. 2.24–2.25).

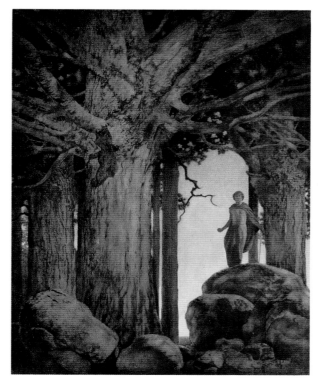

Fig. 2.23

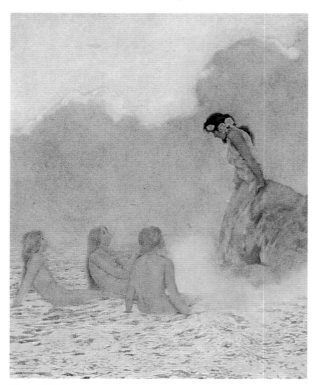

Fig. 2.25

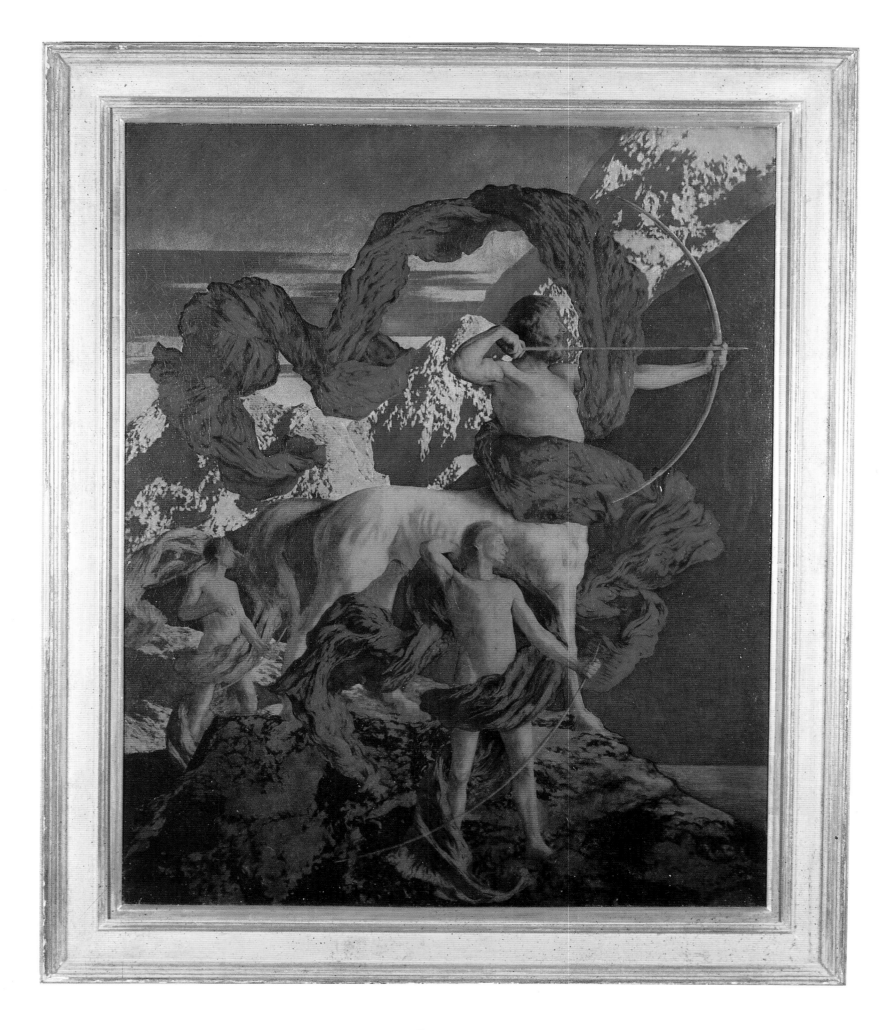

Fig. 2.22

Fig. 2.24

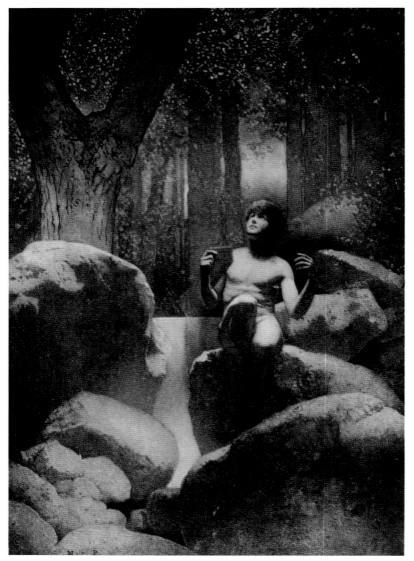

Fig. 2.27

Lantern Bearers, Summer, Pierrot, Spring, and *Easter (Boy with Lilies)* (figs. 2.26–2.30), as reproductions in Francis Turner Palgrave's *Golden Treasury of Songs and Lyrics,* are among the most collected of Parrish illustrations. But the book caused Parrish a great deal of embarrassment when it was published by Duffield and Company in 1911 without his knowledge or consent. Duffield had "borrowed" the illustrations, which Parrish had done as covers for *Collier's* magazine, without seeking the artist's permission. This episode marked the turning point for subsequent contracts. Parrish retained strict control over his paintings and would sell the magazines one-time-only permission to reproduce his work.

The timelessness of the paintings in the *Golden Treasury* remains undiminished, however, eighty years after their publication. Parrish posed Sue Lewin as a model in *Lantern Bearers,* and a young neighbor, Kimball Daniels (who was later killed in an untimely accident on the Parrish property), for *Harvest,* which had served as a *Collier's* cover in 1905 (fig. 4.9).

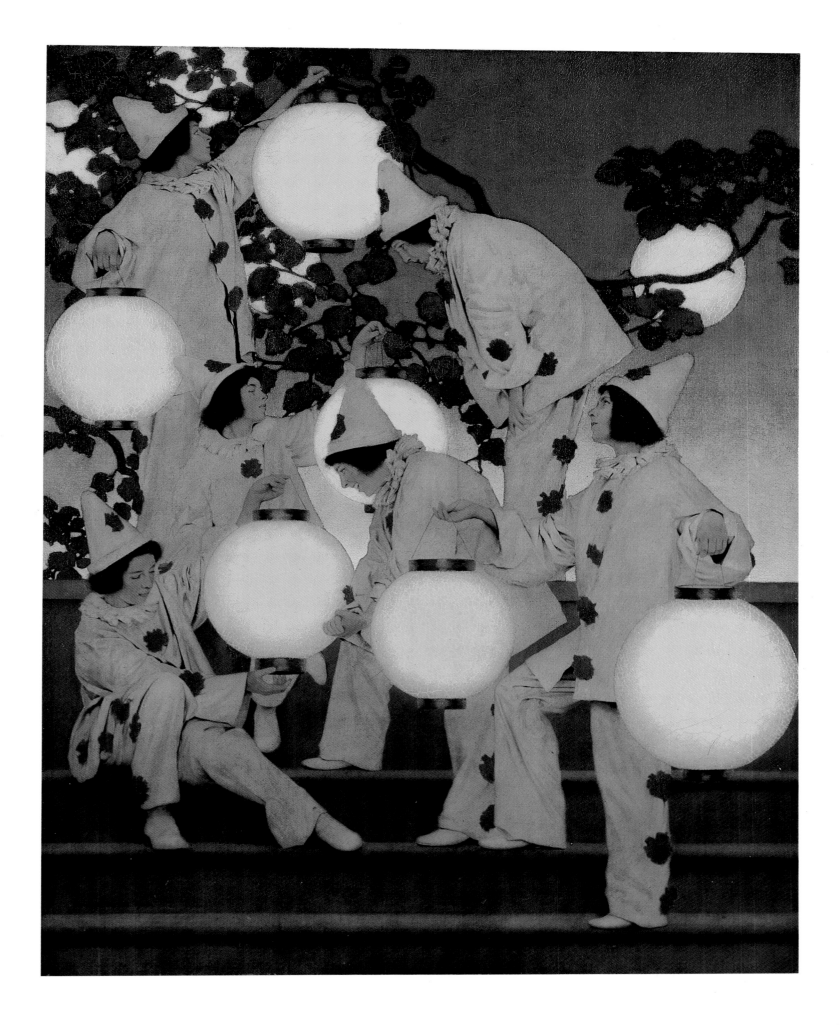

Fig. 2.26

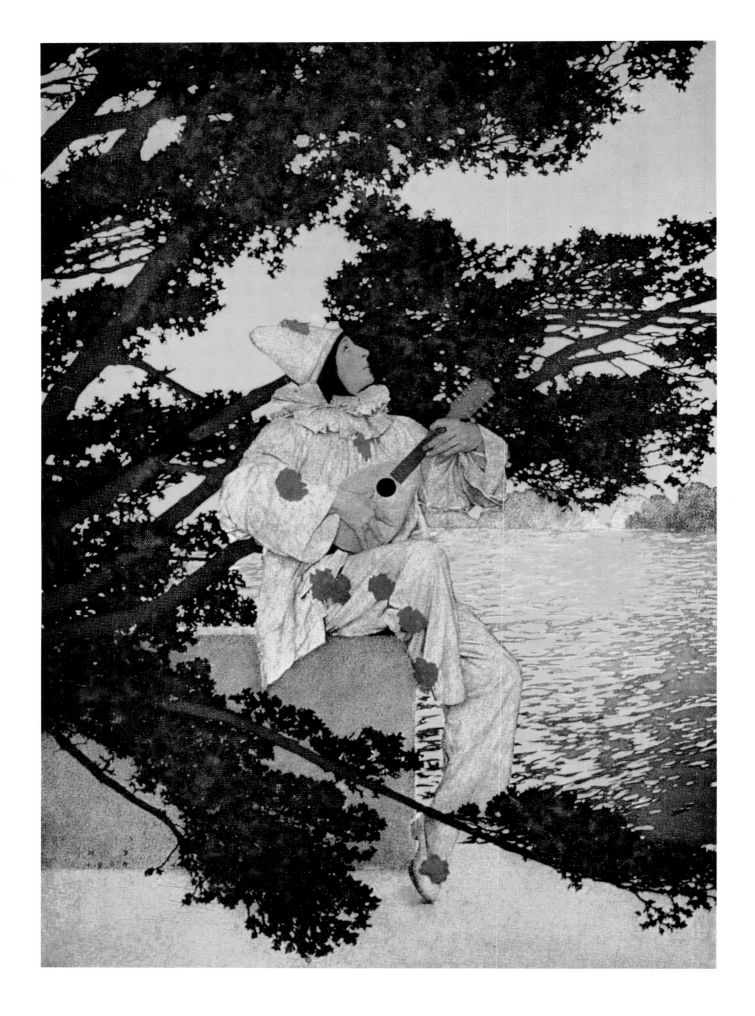

Fig. 2.28

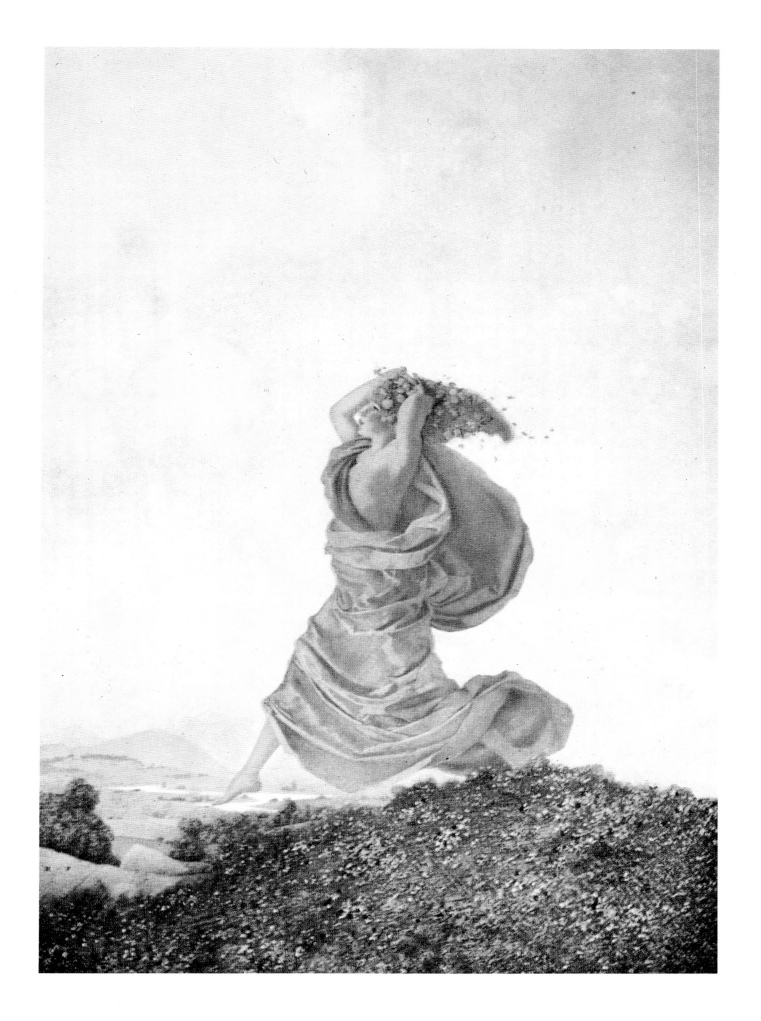

Fig. 2.29

47

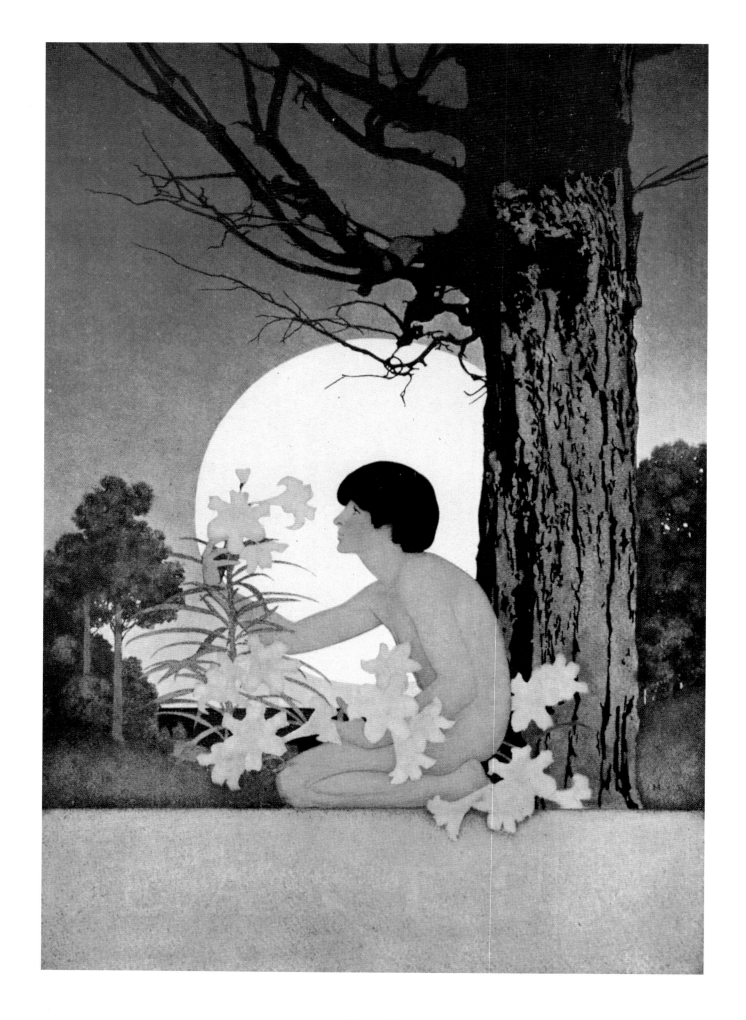

Fig. 2.30

The debacle with Duffield and the *Golden Treasury* soured Parrish for a long time against accepting commissions to illustrate books. Not until 1920 did he agree to illustrate what was to become one of the most valuable children's books ever published, Louise Saunders's *Knave of Hearts.* Saunders was the wife of Maxwell Perkins, the editor of Scribner's. They summered in Cornish, New Hampshire, and were friends of the Parrishes. In a letter to J. H. Chapin of Scribner's, Parrish wrote on October 24, 1920:

> *The reason I wanted to illustrate the* Knave of Hearts *was on account of the bully opportunity it gives for a very good time making the pictures. Imagination could run riot, not bound down by the period, just good fun and all sorts of things.*
> *You must understand all this layout to be in gorgeous color. The landscapes back of the figures in the cover lining—a very beautiful affair illuminated by a golden late afternoon sun: castles, waterfall, rocks and mountains.*[2]

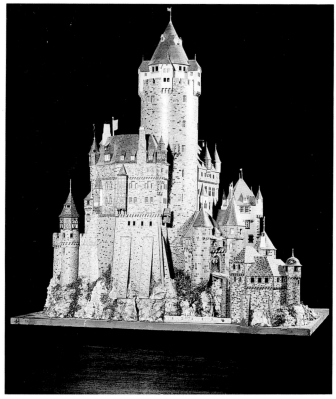

Fig. 2.31

Parrish relished working three years on the twenty-six paintings for *Knave of Hearts.* He built an elaborate castle model in his fully equipped workroom to use in the illustrations for the book (fig. 2.31). Many of the fixtures in the illustrations show handcrafted items from the Parrish household, such as elaborate hinges and a wonderful clocklike affair (actually an ingenious device that Parrish had built to let him know when the main house ran out of well water; since he and Susan lived in the studio, all Parrish had to do was look out the window at the water gauge-clock and he could immediately activate the well pumping system to provide his family across the way with water).

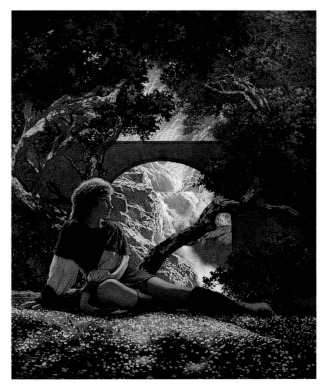

Fig. 2.34

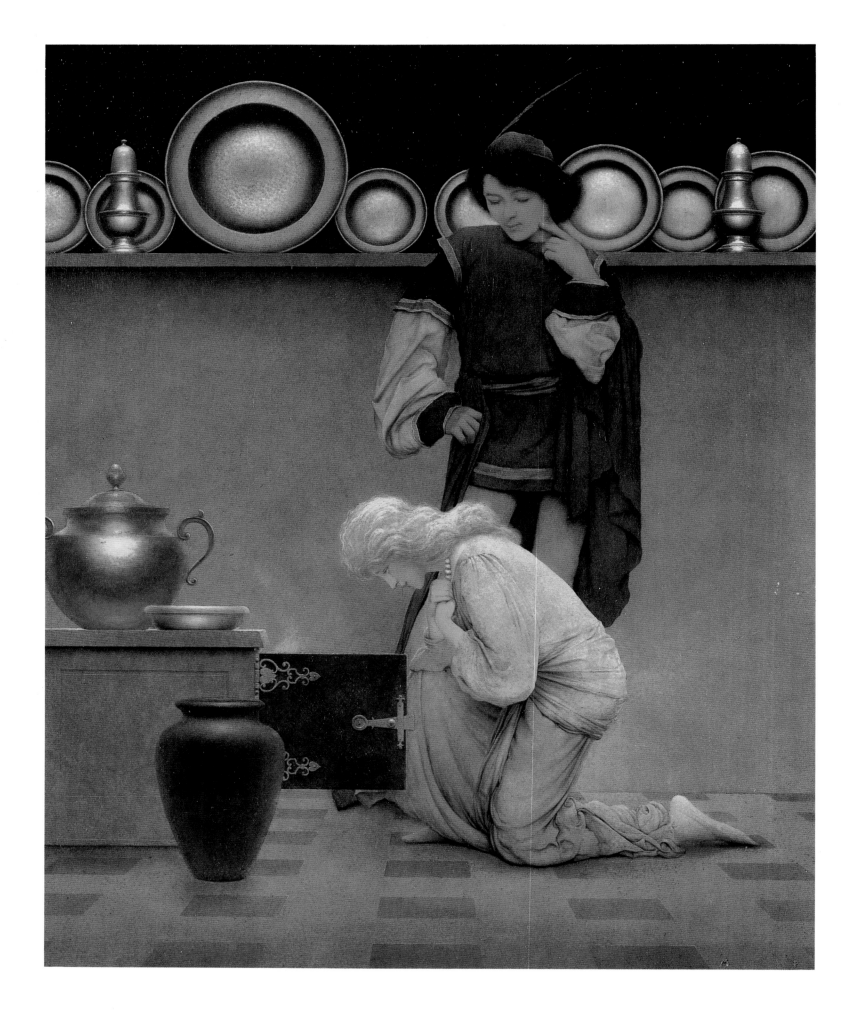

Fig. 2.32

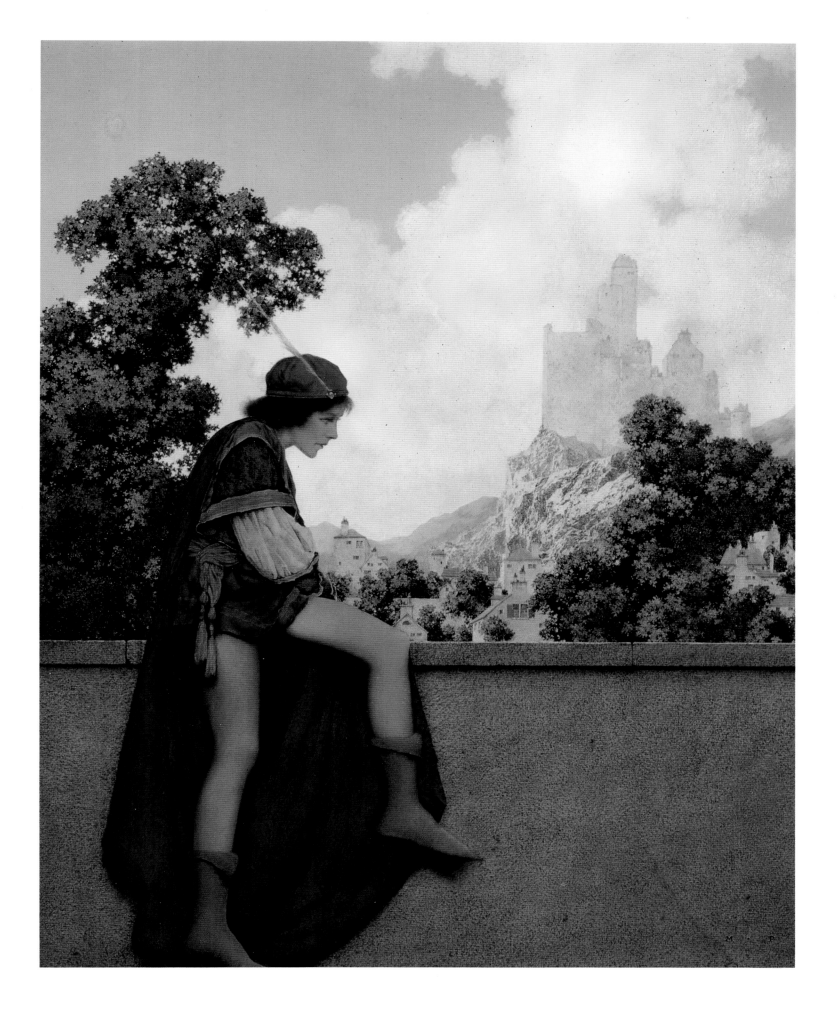

Fig. 2.33

Knave of Hearts, published in October 1925, was printed in rich colors on heavy coated paper. The illustrations were the highest quality reproductions that could be printed. The book originally sold for $10 a copy, a phenomenal amount for a children's book, since the average weekly take-home pay at that time was no more than $25. Prices today in excess of $1,000 for the first edition are standard. The release of the book in 1925, in conjunction with a highly publi-cized exhibition of Parrish's works at Scott and Fowler Galleries in New York, made 1925 and 1926 two of the most remunerative years of the artist's career. *Romance,* one of the paintings for *Knave of Hearts,* sold for $10,000, no mean feat when one could buy a perfectly decent home for $2,000 at the time. Other important paintings for the book were *Lady Violetta and the Knave, Knave Watching Violetta Depart, The Knave,* and *The End* (figs. 2.32–2.35).

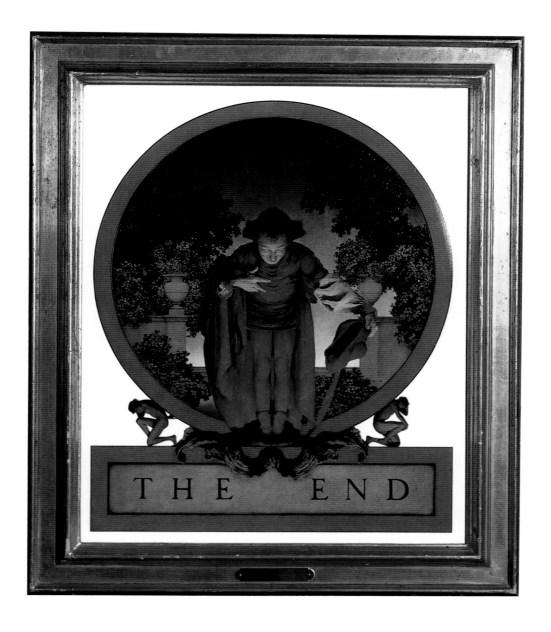

Fig. 2.35

List of Figures for Chapter 2

2.1 *Manager Draws the Curtain.* Frontispiece *Knave of Hearts,* 1925, oil on board, 14″ × 18″. Private collection.

2.2 Parrish's Porch, 1910. Photograph by Maxfield Parrish. Collection of the author.

2.3 *Cardinal Archbishop,* 1901, oil on paper, 18″ × 12″. Private collection.

2.4 *Garden of Isola Bella,* 1904, oil on paper, 11″ × 18″. Private collection.

2.5 *Villa Este,* 1904, oil on paper, 28″ × 18″. Private collection.

2.6 *Villa Chigi,* 1903, oil on paper, 28″ × 18″. Private collection.

2.7 *Villa Scassi,* 1904, oil on paper, 16″ × 11″. Private collection.

2.8 *Villa Cicogna,* 1904, oil on paper, 28″ × 18″. Private collection.

2.9 *Villa Caprarola,* 1904, painted photograph by Maxfield Parrish. 14″ × 10″. Coll. Michael Leavitt, Hayward, California.

2.10 *Title Page, Poems of Childhood,* 1904, oil on paper, 21″ × 15¼″. Private collection.

2.11 *Dinkey Bird,* 1904, oil on paper, 21¼″ × 15½″. Coll. Charles Hosmer Morse Museum of American Art, Winter Park, Florida.

2.12 *Wynken, Blynken and Nod,* 1904, oil on paper, 21¼″ × 15″. Private collection.

2.13 *With Trumpet and Drum,* 1903, oil on paper, 21¼″ × 14¾″. Private collection.

2.14 *The Fly Away Horse,* 1904, oil on paper, 28¼″ × 20½″. Private collection.

2.15 *The Sugar Plum Tree,* 1902, oil on paper, 21¼″ × 14¾″. Private collection.

2.16 *Cassim,* 1910, color lithograph. Coll. David Stoner, Sunnyvale, California.

2.17 *Codadad and His Brothers,* 1910, color lithograph. Coll. David Stoner, Sunnyvale, California.

2.18 *Prince Agib,* 1910, color lithograph. Coll. David Stoner, Sunnyvale, California.

2.19 *Young King of Black Isles,* 1910, color lithograph. Coll. David Stoner, Sunnyvale, California.

2.20 *Sinbad Plots Against the Giant,* 1906, oil on paper, 20″ × 16″. Coll. Pennsylvania Academy of Fine Arts, Philadelphia, Pennsylvania.

2.21 *Gulnare of the Sea,* 1910, color lithograph. Coll. David Stoner, Sunnyvale, California.

2.22 *Jason and His Teacher,* 1909, oil on canvas laid down on board 38″ × 32″. Private collection.

2.23 *Jason and the Talking Oak,* 1908, oil on canvas laid down on board, 40″ × 33″. Private collection.

2.24 *Cadmus Sowing the Dragon's Teeth,* 1908, oil on canvas laid down on board, 40″ × 33″. Private collection.

2.25 *Proserpina,* 1908, oil on canvas laid down on board, 40″ × 33″. Private collection.

2.26 *Lantern Bearers,* 1910, oil on canvas laid down on board, 40″ × 32″. Coll. Klaus Bruns, Hamburg, Germany.

2.27 *Summer,* 1905, color lithograph from *Golden Treasury of Songs and Lyrics.* Coll. Louis Sanchez, San Mateo, California.

2.28 *Pierrot,* 1908, color lithograph from *Golden Treasury of Songs and Lyrics.* Coll. Louis Sanchez, San Mateo, California.

2.29 *Spring,* 1905, color lithograph from *Golden Treasury of Songs and Lyrics.* Coll. Louis Sanchez, San Mateo, California.

2.30 *Easter* (Boy with lilies), 1905, color lithograph from *Golden Treasury of Songs and Lyrics.* Coll. Louis Sanchez, San Mateo, California.

2.31 *The Castle* (model for *The Knave of Hearts*) 1923, photograph by Maxfield Parrish. Collection of the author.

2.32 *Lady Violetta and the Knave,* 1923, oil on board, 19¼″ × 14¾″. Private collection.

2.33 *Knave Watching Violetta Depart,* 1925, oil on board 20″ × 16″. Private collection.

2.34 *The Knave,* 1925, oil on board, 20″ × 16″. Private collection.

2.35 *The End,* 1925, oil on board, 22″ × 18″. Private collection.

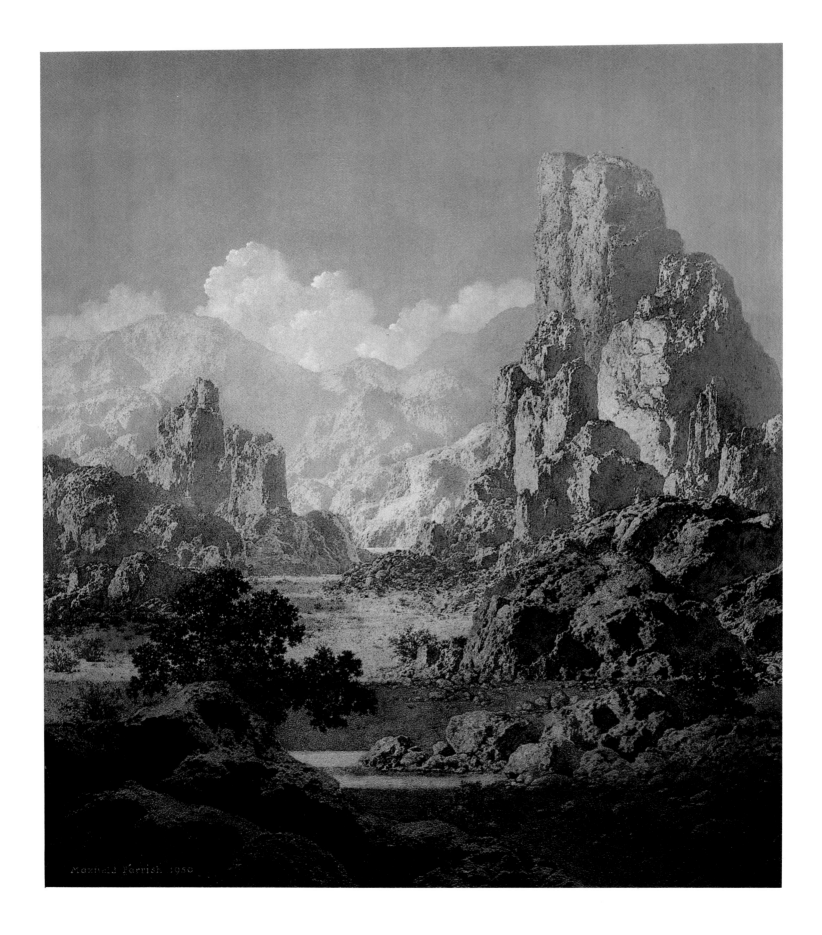

Fig. 3.1

T H E G R E A T S O U T H W E S T
P A I N T I N G S

(1 9 0 2)

Although Parrish's Western paintings were among the works that served as magazine covers and illustrations, their particular dignity and beauty make them stand alone.

In the fall of 1901, Parrish accepted an offer from *Century Magazine* to travel to Arizona to prepare paintings to accompany Ray Stannard Baker's series on "The Great Southwest." Having spent the last winter recuperating from a nervous breakdown and a bout of tuberculosis, Parrish felt that a change of pace was in order. The trip to Castle Creek Hot Springs, Arizona, would enable him to continue his recovery in a climate more suitable for painting than that of the Saranac Lakes in New York's Adirondacks, where he had been convalescing. Parrish and his wife left from New York by train and traveled to the Grand Canyon. Besides picking up the tab for his travel expenses, *Century* paid him $125 for each of the nineteen illustrations.

Parrish wrote from Arizona to his cousin, Henry Bancroft: "You get a sense of freedom and vastness here that I never imagined existed. . . . Lydia is a regular 'Annie Oakley,' rides the desert horses astride, and is a crack shot with a six-shooter. But shooting people is considered bad form here nowadays, so she has to content herself with targets. . . ."[3]

Century was extremely pleased with the series of paintings, and in an article that appeared in the July 12, 1902, issue, editorialized:

> *The pictures of the great Southwest made by Maxfield Parrish are a new and striking pictorial contribution to the knowledge of the West. There is an understanding and perspective of these mountains and plains that lives in the mind of an artist of imagination, and that strikes the imagination of those who look upon them.*
>
> *Parrish is moved by the vivid sense of loneliness. It seems that after drawing figures in a picture he would sometimes paint them out, feeling that they were an impertinence, that the picture with figures failed to convey one of the most characteristic features of the Western scene: space. Parrish in his Western pictures has added a brilliant page to American Western painting.*[4]

On August 12, 1902, after *Century* ran the series, Parrish wrote to the editor in reply to a request to send some notes on the subject of color in the Southwest:

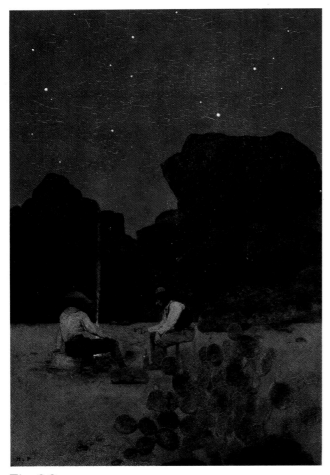

Fig. 3.2

Fig. 3.3

The things themselves, the rocks, the hills, the sands are, for the most part lightly colored. They are red and ochre and black and blue and purple. The desert is grey and white and yellow, a background which intensifies the red shirt of the cowboy and the blanket of the Indian. The landscape of red and ochre also brings out all the blue there is in the sky. Titian did the same thing: how fond he was of placing tan colored figures against his blue skies, a contrast which, no doubt, helped to make his skies the marvel they are. In the Southwest, your face is always lifted up, looking into the air and space and freedom, and day after day, the sky is clear and blue; it is always with you, and you see more of it than you ever saw before: so no wonder you say there is no blue like the sky in Arizona.

. . . When you see a bare red Arizona mountain a long way off, the blue and violet and purple of it seem like the work of magic. . . . A field of alfalfa is the most brilliant of green; the vermillion flycatcher is a comet in the sky—he positively glows like a light, he is so brilliant. One has but to stand on the rim of the Grand Canyon, look across at the other wall, thirteen miles away, and watch it at sunrise or sunset, in order to see the color which can exist nowhere else. At the beginning or at the end of a great day, the great forms of which the walls are made, cast their most wonderful shadows. They are so far off, and there is so much air in between that the light and shade seem unreal, like a mirage which you know will vanish in a little while. The low sunlight falls on the red towers and spires and causes them to glow as though a light

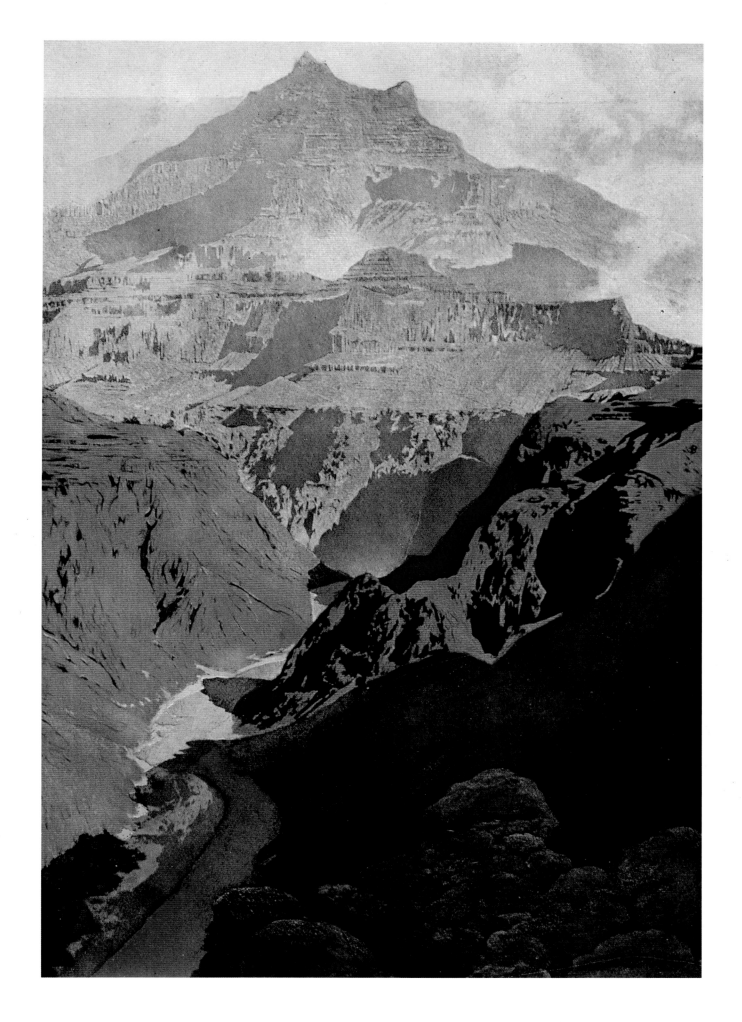

Fig. 3.4

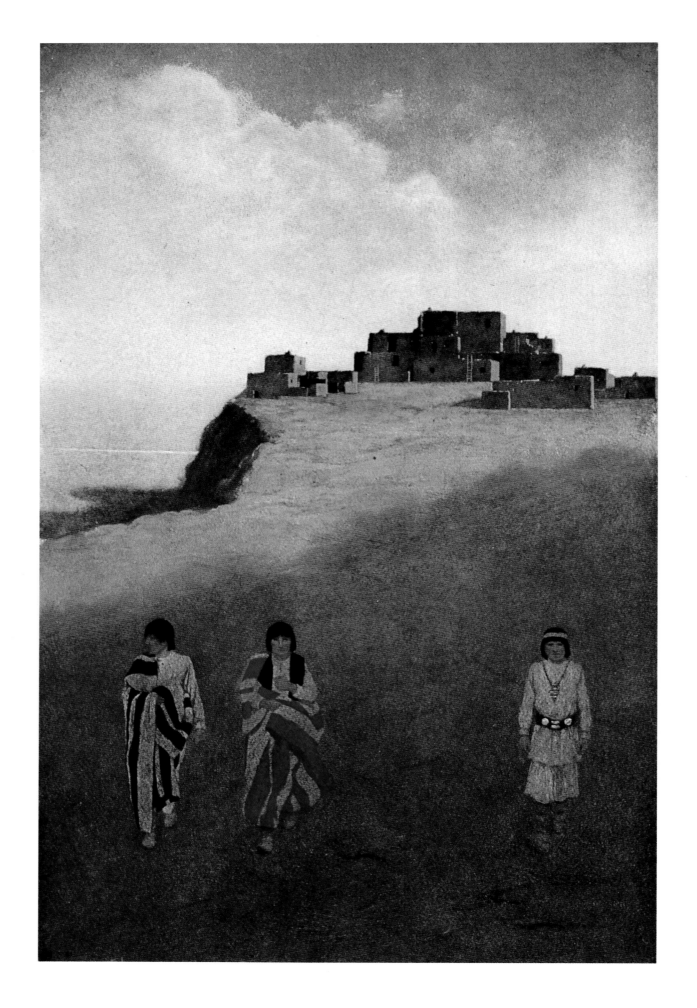

Fig. 3.5

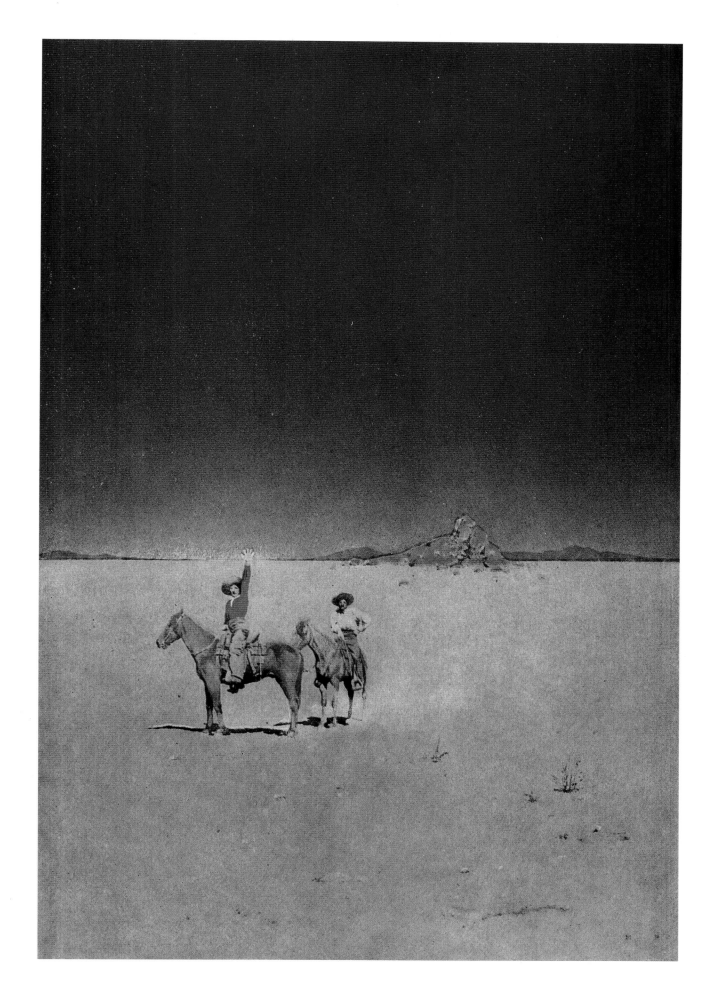

Fig. 3.6

Fig. 3.7

were within them, like a great thunderhead at sunset, and thousands of feet down in the chasm falls the shadow, a blue from dreamland, a blue from which all the skies in the world were made.

The more you look, the more unreal it grows, until you wonder if the lights are blue and the shadows are red, so intense and far off are both colors. The sun sets and the thousands of feet of wall and the great depths of canyon are a sea of still more magic blue, and out of it rise a few of the highest towers of the giant forms, bathed in the last rays, glowing like rubies. Here where the two ends of the earth come together, is color of such strength and beauty as can be nowhere else on earth.[5]

As a result of spending two winters in Arizona preparing the nineteen illustrations, Parrish began using more intense color in his work. He was strongly affected by nature's show of hues. The *Great Southwest* paintings—*Night in the Desert, Desert with Water, The Grand Canyon, Pueblo Dwellings, Desert without Water (Cowboys),* and *Water on a Field of Alfalfa* are perhaps the finest (figs. 3.2–3.7)—influenced forevermore Parrish's approach to landscape painting.

Although the painting *Arizona* (fig. 3.1) was not executed until 1950, almost half a century after the trip to the Southwest and the creation of the *Century* illustrations, in all its beauty and glorious color it shows the lasting effects of his Southwest experience.

List of Figures for Chapter 3

From Maxfield Parrish.
Windsor : Vermont.

Fig. 4.1

62

T H E M A G A Z I N E W O R K
(1 8 9 5 - 1 9 3 6)

The vehicle that catapulted Parrish's art into the limelight was his work as a cover artist for the better magazines of the turn of the century. From every newsstand his work would be instantly recognized, sometimes gracing different publications alongside each other.

Parrish was "discovered" in 1895, at the age of twenty-five. He had done some studies for wall decorations for the Pennsylvania Academy of Fine Arts' Mask and Wig Club, which were being exhibited at the Academy's Architectural Exhibition in New York. One of the visitors to the exhibition was Thomas W. Ball of the publishers Harper and Brothers' art department. Mr. Ball had received a note from Howard Pyle (of Philadelphia's Drexel Institute) urging him to view the work of one Fred Maxfield Parrish. Mr. Ball liked what he saw, arranged to meet Parrish in Philadelphia, and invited him to submit a design for a special cover for the 1895 Easter number of *Harper's Bazaar*. Parrish submitted two designs. The first showed two young, almost Pre-Raphaelite characters wearing intricately designed robes, holding lilies. To Parrish's delight, both covers were accepted, one for the Easter issue (fig. 4.2), the other

for *Harper's Young People*. In the same year he married Lydia Austin.

His work was so well received that between 1895 and 1900 Parrish won commissions for covers from five different Harper and Brothers periodicals: *Harper's Bazaar, Harper's Weekly, Harper's Monthly, Harper's Round Table,* and *Harper's Young People*. He was also responsible for the format design used by *Harper's Monthly* for covers for several issues. On the back of the painting for the design was the following notation by one of the editors: "Pay M. Parrish $50. for the design with an additional $100. (royalty) later."

Parrish's work at *Harper's* alerted another enterprising editor, J. H. Chapin from *Scribner's* (who later was to become one of the artist's close friends in New Hampshire). Chapin commissioned him to create a series of eleven drawings for the August 1897 issue, to illustrate "Its Walls Were as of Jasper," a short story from Kenneth Grahame's book *Dream Days. Century Magazine* editors commissioned Parrish in 1897 to illustrate Edna Procter Clark's poems *Christmas Eve* and *A Hill Prayer* (fig. 4.3). The illustrations' beautiful, haunting, poetic quality reveals a mystical side of Parrish, usually hidden away and not evident in his other posters or commercial endeavors.

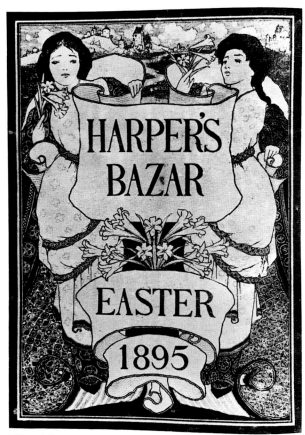

Fig. 4.2

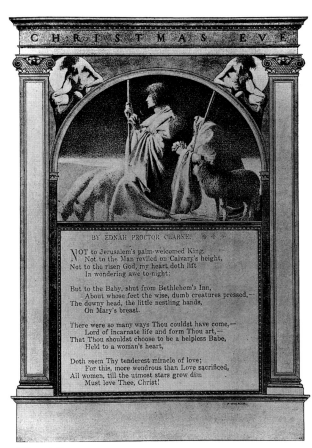

Fig. 4.3

Up to this time the magazine illustrations had been rendered mostly in pen and ink or were monochromatic, given the reproduction capabilities of the day. In 1901 *Century* suggested that Parrish illustrate John Milton's poem *L'Allegro* and that he execute the paintings in only two or three tints so that they would reproduce equally well in color or in black and white.

The color reproductions of the paintings for *L'Allegro* were received with acclaim not only by the public but by established artists of great reputation and scope, including the sculptor Augustus Saint-Gaudens and artist Celia Beaus. Saint-Gaudens in particular became a fan. Later on, when *Century* had published, again in color, a series taken from the book *Italian Villas and Their Gardens,* Saint-Gaudens sent Parrish a letter with a wonderful drawing showing Parrish's head exuding rays of Olympic splendor, with Saint-Gaudens groveling at his feet saying:

> *How many thousands of dollars would it take, Oh, Parrish, to purchase one of your splendid creations?*

To which Parrish replied, with a drawing of a young man with his vest buttons popping:

> *Oh, Great and Magnificent One: Since I received your kind note, my chest has swollen so with pride that I do not fit into any of my vests or breeches. Of course you may have any Villa that you wish, but instead of payment, I covet one of your Robert Louis Stevenson medallions . . . Could we, Oh Great One . . . trade?*[6]

In July 1896 Edward Bok, editor of the *Ladies' Home Journal,* commissioned Parrish for his first cover in color for the magazine. The design featured a maiden standing by a large tree. The success of the cover prompted

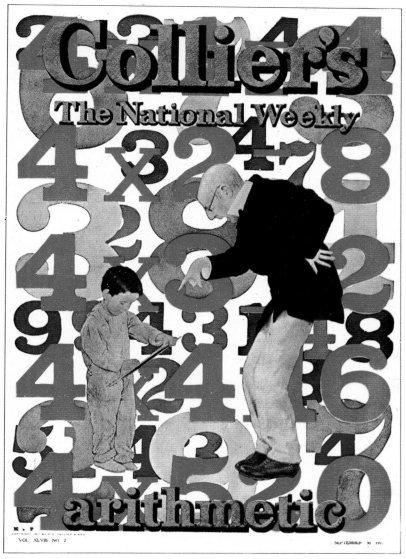

Fig. 4.36

the magazine to commission a series based on the illustrations from Eugene Field's *Poems of Childhood,* beginning in 1902. This was Parrish's first major illustration series, for which he was paid $1,000.

Life magazine joined the bandwagon for successful color covers; Parrish executed his first for them, titled *A Christmas Cover,* in December 1899. The popularity of his magazine reproductions took a decided leap when *Century Magazine* published the *Great*

Southwest illustrations discussed in the previous chapter. It seemed as if Parrish had discovered the glorious qualities in his spectacular color spectrum and was reveling in their emergence.

Century attributed a tremendous surge in readership to the Parrish illustrations. This prompted the magazine to serialize the works done for *Italian Villas and Their Gardens,* in 1903 and 1904. At this time the magazine for which Parrish worked

Fig. 4.5

Fig. 4.6

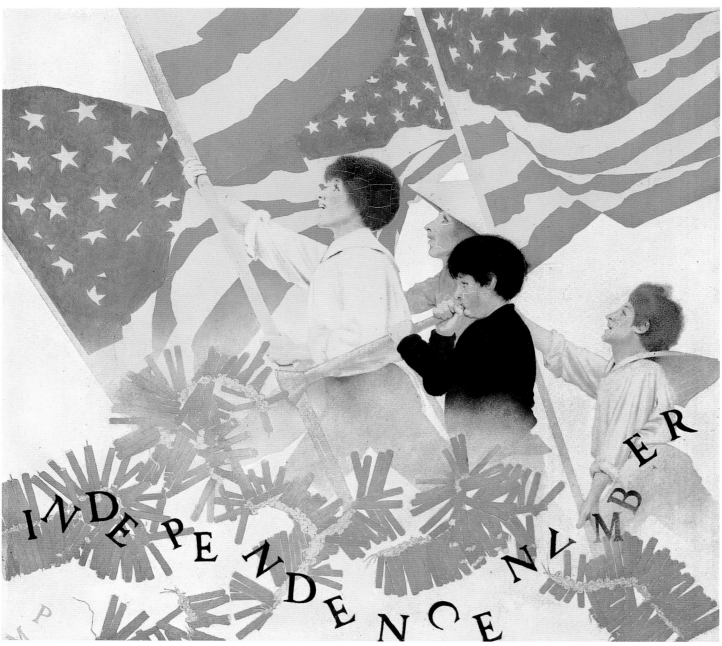

Fig. 4.8

the longest climbed on the bandwagon. *Collier's* published their first Parrish cover in December 1904, titled *Christmas Number*. This was to augur a mutually rewarding association that lasted almost thirty years and from which some of the best of the Parrish magazine covers emerged, such as *Summer*, July 1905 (fig. 2.27), *Alphabet*, September 1904, *The Idiot*, September 1910, *The Prospector*, February 1911, *Winter*, March 1906, *Independence Number*, July 1905 (figs. 4.4– 4.8), *Harvest*, September 1905, and the last magazine cover that Parrish did, titled *Jack Frost*, October 1936 (figs. 4.9–4.10). *Collier's* had also done a series of covers between 1906 and 1910 based on Parrish's

Fig. 4.7

Fig. 4.9

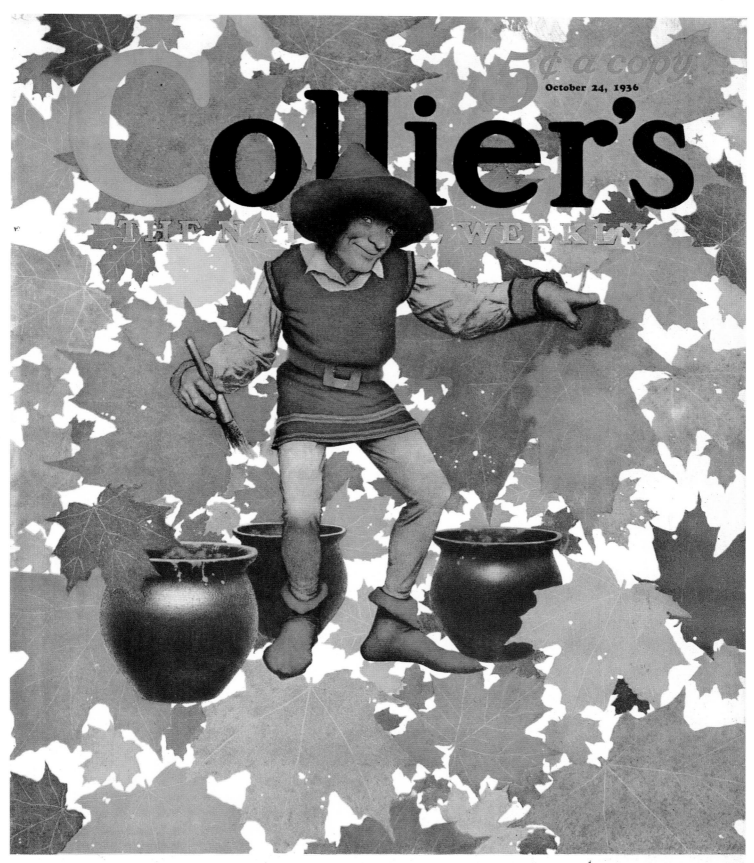

What This Country Needs By John T. Flynn

Fig. 4.10

Fig. 4.13

Fig. 4.14

illustrations for *Arabian Nights* and *Tanglewood Tales*. The artist received $6,000 from the magazine for the reproduction rights for the twelve *Arabian Nights* paintings, and Robert J. Collier purchased the original paintings from the artist for a total of $4,000. In 1929, after the resounding success of *The Knave of Hearts, Collier's* published five more covers based on the illustrations: *Two Sentries with a King, The End, The Knave Watches Violetta Depart, Two Sentries at the Entrance,* and *Two Pastry Cooks: Blue Hose and Yellow Hose.*

The last major magazine to carry important Parrish covers was *Hearst Magazine.* The artist created a series of covers based on fairy tales, much prized by collectors today because of their scarcity. These were: *Jack the Giant Killer,* June 1912, *The Frog Prince,* July 1912, *The Story of Snow Drop* (fig. 4.11; from *Snow White and the Seven Dwarfs*), August 1912, *Hermes* (from the *Greek Mythology* series, but not used by *Collier's*), September 1912, *Sleeping Beauty,* November 1912, and *Puss 'n Boots,* May 1914 (fig. 4.12).

The Story of Snow Drop was especially successful, and in 1916 Parrish was asked to design and build the models for a production of *Snow White* which, however, was canceled because of the United States' entrance into World War I. The models remained in the attic of the artist's studio until the time of his death. Parrish spent an enormous amount of time preparing for a painting; his painstaking work in model making was amazingly accurate and detailed. Three of the models he constructed are reproduced herein: "The Queen's Barge" (Snow White's bed), "The Throne" (also used in the *Arabian Nights' Young King of the Black Isles*), and the castle for *Knave Watching Violetta Depart* for *The Knave of Hearts* (figs. 4.13, 4.14, and 2.31).

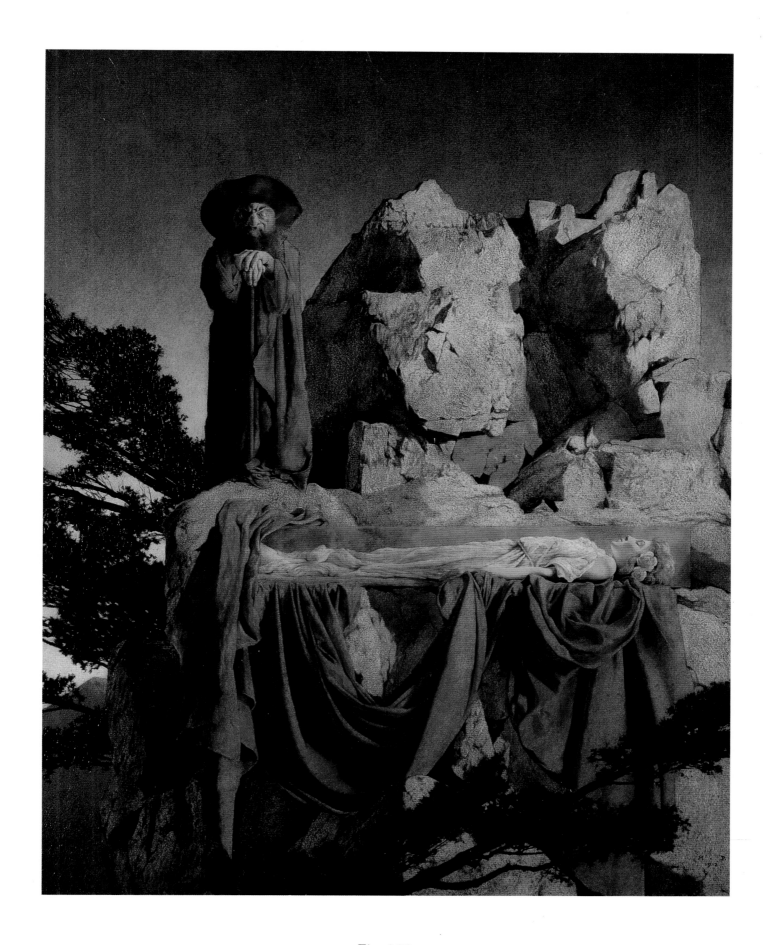

Fig. 4.11

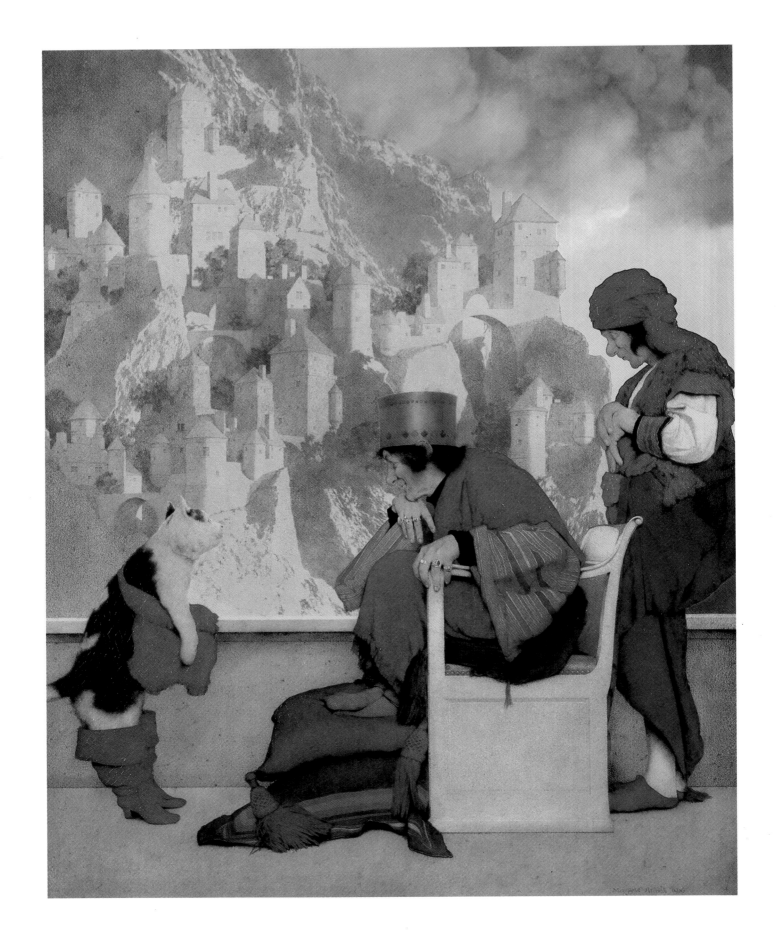

Fig. 4.12

Maxfield Parrish, Jr., authenticated the pieces in a letter to Mr. Robert Korey:

> *Yup, by God that's it! The throne from "Snow White" or "Snow Drop" actually is what they called the story based on Snow White. . . . Now with the photograph I am able to remember, and sure enough there were two steps down in the front. I'd forgotten them entirely. Well, it tickles me that they, the three pieces, the Queen's Barge, the Proscenium Arch Caryatids and The Throne itself are now there owned by one man. . . . The urns and the columns and all the round stuff were turned in his machine shop on the same sort of lathe Coy [Ludwig] shows in his biography of Dad, on page 18, only it was two sizes smaller than the one he was operating on that page. I might also say that the gold on the throne ornamentation was not paint, but real gold leaf . . .* [7]

Designs for magazine covers worthy of inclusion among Parrish's masterworks include (listed with date of publication):

October 1900, Scribner's, October 1900 (fig. 4.15)
St. Patrick's, Life, March 1904 (fig. 4.16)
Air Castles, Ladies' Home Journal, June 1914 (fig. 4.17)
Story of Snow Drop, Hearst, August 1912 (fig. 4.11)
A Call to Joy: A Detail, Ladies' Home Journal, December 1912 (fig. 4.18)
Puss 'n Boots, Hearst, May 1914 (fig. 4.12)
Garden of Opportunity, Ladies' Home Journal, June 1914 (fig. 6.18)
Humpty Dumpty, Life, March 1921 (fig. 4.19)
Sweet Nothings, Ladies' Home Journal, April 1921 (fig. 4.20)
Evening, Life, October 1921 (fig. 4.21)
The Canyon, Life, March 1923 (fig. 4.22)

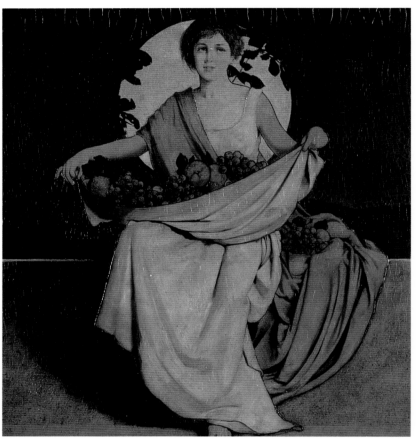

Fig. 4.15

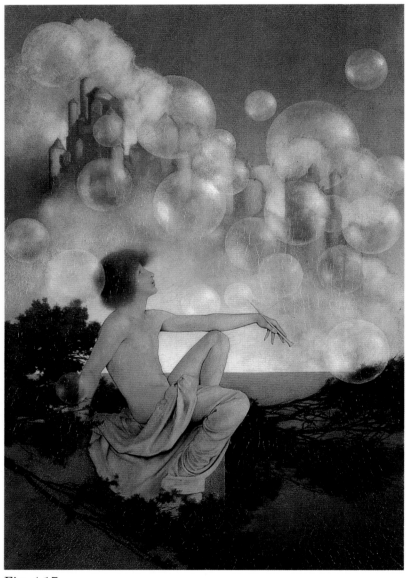

Fig. 4.17

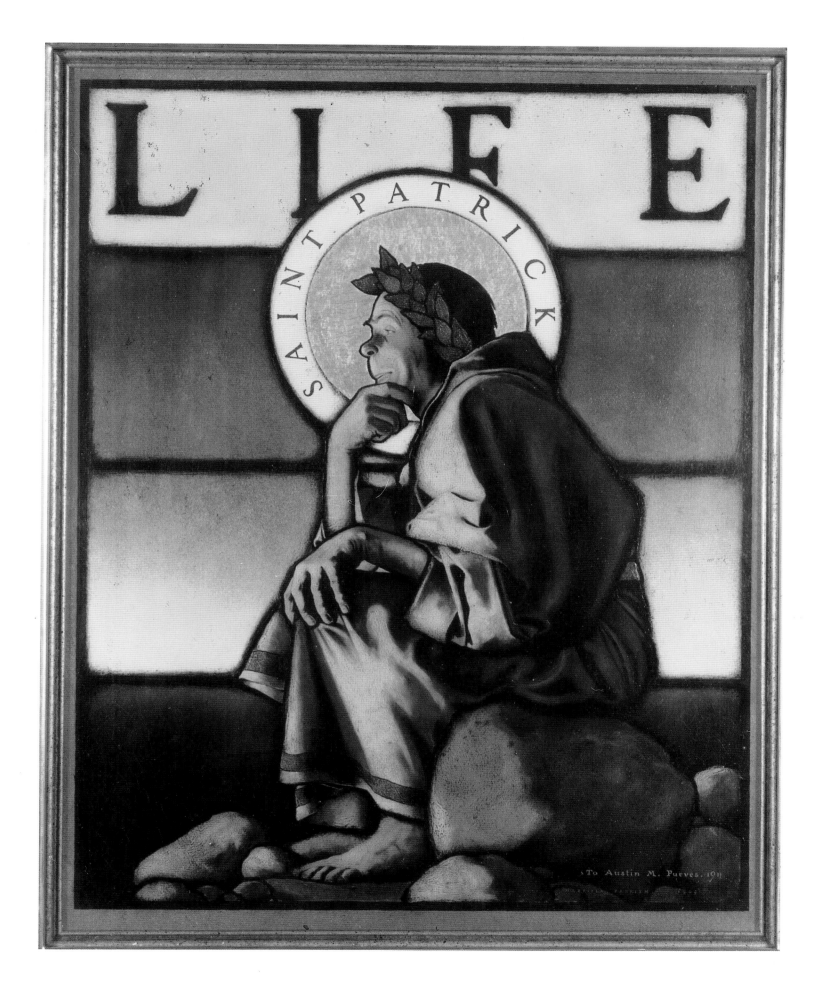

Fig. 4.16

THE LADIES' HOME JOURNAL

CHRISTMAS 1912

FIFTEEN CENTS · THE CURTIS PUBLISHING COMPANY PHILADELPHIA

Fig. 4.18

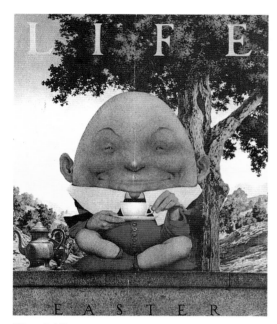

Fig. 4.19

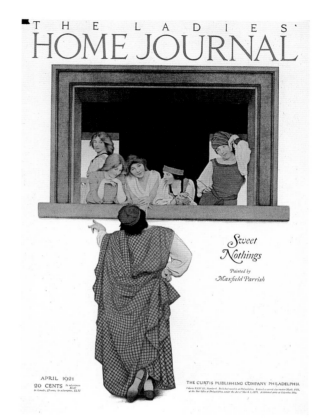

Fig. 4.20

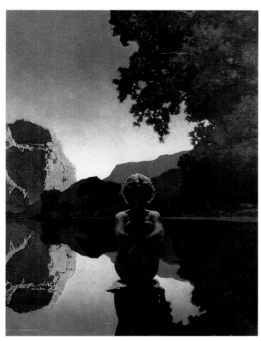

Fig. 4.21

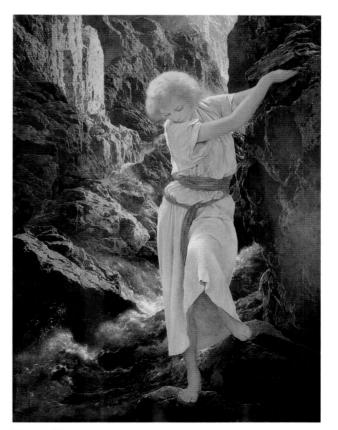

Fig. 4.22

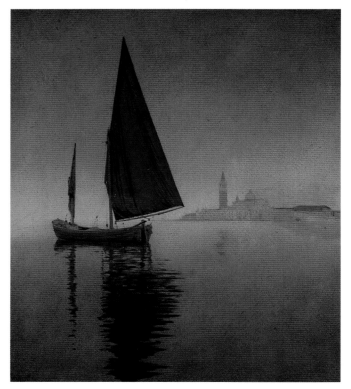

Fig. 4.26

Parrish created illustrations or designed covers for a total of thirty-three magazine publishers. The best of this work was for the following seven publications, listed with the years of the artist's involvement:

Harper's, 1895–1906
Scribner's, 1897–1923
Ladies' Home Journal, 1896–1931
Century, 1898–1917
Life, 1899–1924
Collier's, 1904–1936
Hearst, 1912–1914

In addition to the paintings represented by the cover designs listed above, and the series of magazine illustrations published from designs originally produced for books, there are a number of paintings that rank among the masterworks that were created as illustrations for stories or poems published in the periodicals. These include:

Christmas Eve, Century, December 1898 (fig. 4.3)
Poet's Dream, Century, December 1901 (fig. 4.23)
The Milkmaid, Century, December 1901 (fig. 4.24)
A Venetian Night's Entertainment, Scribner's, December 1903 (fig. 4.25)
Venice: Twilight, Scribner's, April 1906 (fig. 4.26)
Griselda, Century, August 1910 (fig. 4.27)
Errant Pan, Scribner's, August 1910 (fig. 4.28)
Land of Make Believe, Scribner's, August 1912 (fig. 4.29)

Fig. 4.25

A Venetian Night's Entertainment served as the *Scribner's* frontispiece for Edith Wharton's short story of the same title. Mrs. Wharton was so pleased with the work Parrish was producing for her book *Italian Villas and Their Gardens,* being serialized by *Century,* that she asked *Scribner's* to commission the work from Parrish. The painting's frame is quite important. Through his friendship with Saint-Gaudens, Parrish met the great architect of his day, Stanford White. It was White (whose mistress Eleanor Nesbitt was currently posing for Saint-Gaudens's famous *Diana* that was to be placed atop the Madison Square Building that White had designed) who drew the design for the ornate, gilded frame for *A Venetian Night's Entertainment,* and whose

second design was used for the frame for the famous *Garden of Allah* later.

A Venetian Night's Entertainment was the first Parrish oil purchased by a museum. In 1905 the St. Louis Museum of Art purchased it, followed by *St. Patrick's,* another Parrish oil. An additional Venetian theme, *Venice: Twilight,* was used for a frontispiece by *Scribner's* to illustrate Arthur Symons's story, "The Waters of Venice," in the April 1906 issue. No doubt Mrs. Wharton's book of Parrish-illustrated villas was making a substantial impact on readers interested in Europe and particularly Italy. The De Young Museum in San Francisco used the painting *Venice: Twilight* (and *The Cardinal Archbishop,* fig. 2.2), in the 1984–1985 exhibition, *Venice: The American View 1860–1920.*

Fig. 4.23

Fig. 4.24

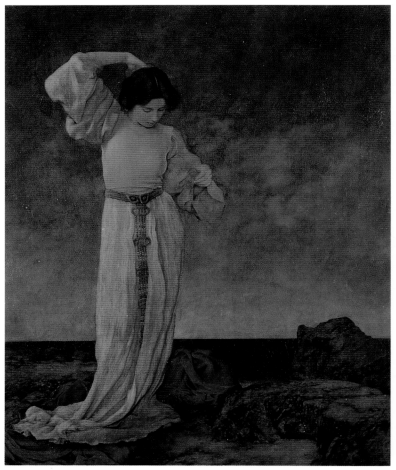

Fig. 4.27

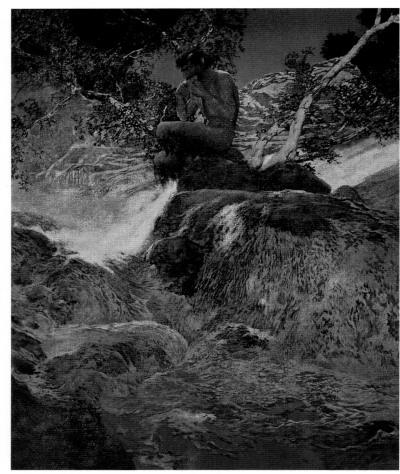

Fig. 4.28

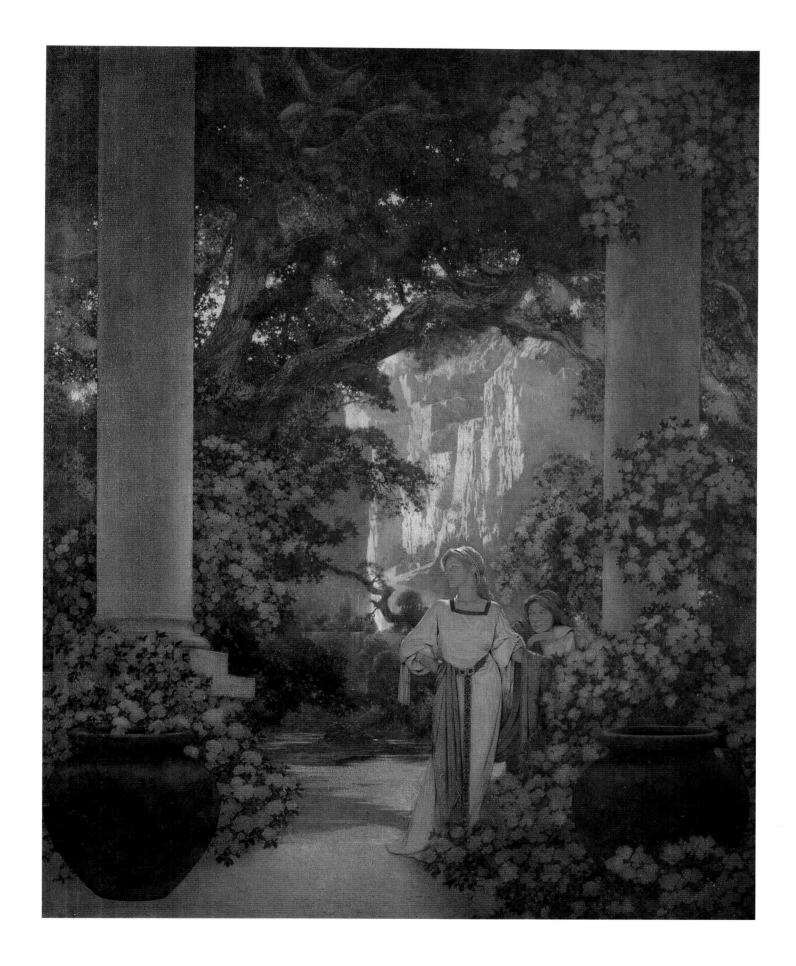

Fig. 4.29

In 1905 Parrish's life was changed forever. A sixteen-year-old girl named Susan Lewin came to The Oaks to help Lydia with the care of Dillwyn, the Parrish's one-year-old son. Parrish, who had an eye and appreciation for all that was beautiful, could not help but notice her. Susan was an unmistakable quiet beauty, a younger version of Lydia Parrish. Slender and willowy, she had cascading masses of thick, chestnut brown hair framing an oval face with large expressive eyes and classic profile. Parrish saw her as the perfect model and asked her to pose that year for *Land of Make Believe,* which was used by *Scribner's* in August 1912 to illustrate Rosamund Mariott Watson's story of the same title.

Lydia, now occupied with child rearing and her own painting and writing, no longer had time to pose or devote much attention to her husband. Parrish turned to Susan more and more for modeling assignments as well as companionship. Susan's days at The Oaks grew increasingly busy. Besides helping with the children, she also was charged with cooking for Parrish, making the costumes used in his paintings, posing, and seeing that he was not disturbed by the numbers of visitors who would trudge up the hill in hopes of catching a glimpse of the famous artist. Susan tended Parrish hand and foot, and her character lent itself precisely to that docile, worshipful role. She was untrained but eager, and she probably was infinitely more compliant to his wishes than Lydia.

In 1909 Susan modeled again for another major painting, one that came to be titled *Griselda.* That characterization became a prototype for the relationship that evolved between Parrish and Lewin. Griselda, the beautiful peasant consort of a powerful king in the last tale of Boccaccio's *Decameron,* remains faithful to her lover despite the many trials he makes her endure before acknowledging her rightful place by his side.[8]

The painting had been used to illustrate Florence Wilkinson's story "Seven Green Pools at Cintra" in *Century's* August 1910 issue. In a reversal of what he often did (painting a figure out and replacing it with pure landscape), Parrish painted out the background surrounding Lewin and retitled the painting *Griselda.* (To my knowledge, in none of the paintings for which Lewin posed was her figure ever replaced or painted out.)

Griselda, Land of Make Believe, Jason, Cadmus, and all of the major pieces executed by Parrish from 1905 to 1910 were large oils painted on canvas affixed to board. Another among these was *Errant Pan,* the 40″ by 30″ oil commissioned by *Scribner's* to illustrate their August 1910 short story by George T. Marsh. After that period, Parrish reverted to painting on either masonite or stretched paper. *Errant Pan,* for which Parrish posed himself as the figure of Pan, was acquired by the Metropolitan Museum of Art and remains in its collection to this day.

Parrish's painting career, launched by that first *Harper's* cover, became one of the most extraordinary in the history of magazine illustration, raising the level from what early detractors dismissed as "simply illustrations" to museum-quality art.

In addition to the commissions for magazine covers and illustrations, Parrish was asked to design advertisements for everything from light bulbs to seeds, from perfumes to tires, from Jell-O to ham and quite a number of other products in between. He was unique in the sense that his art was the vehicle that carried the product. His fame was generally far more established than that of the product he was being asked to promote. Advertisers were riding on his artistic coattails instead of the other way around.

Five of the best paintings that Parrish created for advertisements were the

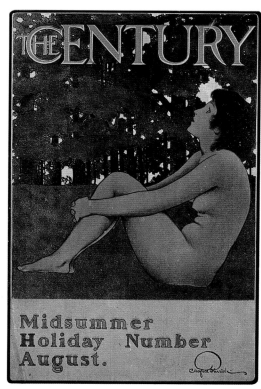

Fig. 4.30

Century Midsummer Holiday Number, Century Magazine (1898), *Djer Kiss,* Djer Kiss Cosmetics (1916), *The Spirit of Transportation,* Clark Transportation Company (1920), *Mary, Mary, Quite Contrary,* Ferry Seeds (1921), and *Jack and the Beanstalk,* Ferry Seeds (1923; see figs. 4.30–4.34).

 The latter four designs appeared not only as advertisements but were also issued as individual posters; their masterly quality lifts them beyond what might be termed "poster art." Two of them, the "Ferry Seeds" ads, are in the permanent collection of the University of California.

 Parrish fulfilled the dream of every advertiser of the day. Here was an artist whose work had such a tremendous popular appeal that his reproductions sold by the millions. What a novel idea! People wanted to *pay* for a copy of an ad for a product because it reproduced a Parrish painting.

 One of the most compelling images of Sue Lewin photographed by Parrish is the thoughtful, romantic study that he took of her in 1916 posing for *Djer Kiss* (fig. 4.35).

Parrish used his daughter Jean as the model for *Mary, Mary, Quite Contrary* and *Jack and the Beanstalk.* The little trucks seen traversing the awesome gorge in *The Spirit of Transportation* were built in his machine shop below his studio as toys for his children, and then were pressed into service as props for the painting.

 One sees the Parrish children, the furniture, dishes, and toys placed artfully throughout Parrish's commercial work. Even a faithful black cat is a frequent prop within the ads. But even though Parrish was paid handsomely for his venture into what he called "the commercial game," one cannot but feel that he did it grudgingly. His heart was just not in it. In the early twenties, Parrish became determined to stop making advertisements with the exception of the Edison Mazda calendars, which he enjoyed doing and which challenged him artistically. (The Mazda calendars were to become the most valued of all the advertisements; as a body of work, they stand alone, and will be examined in the following chapter.)

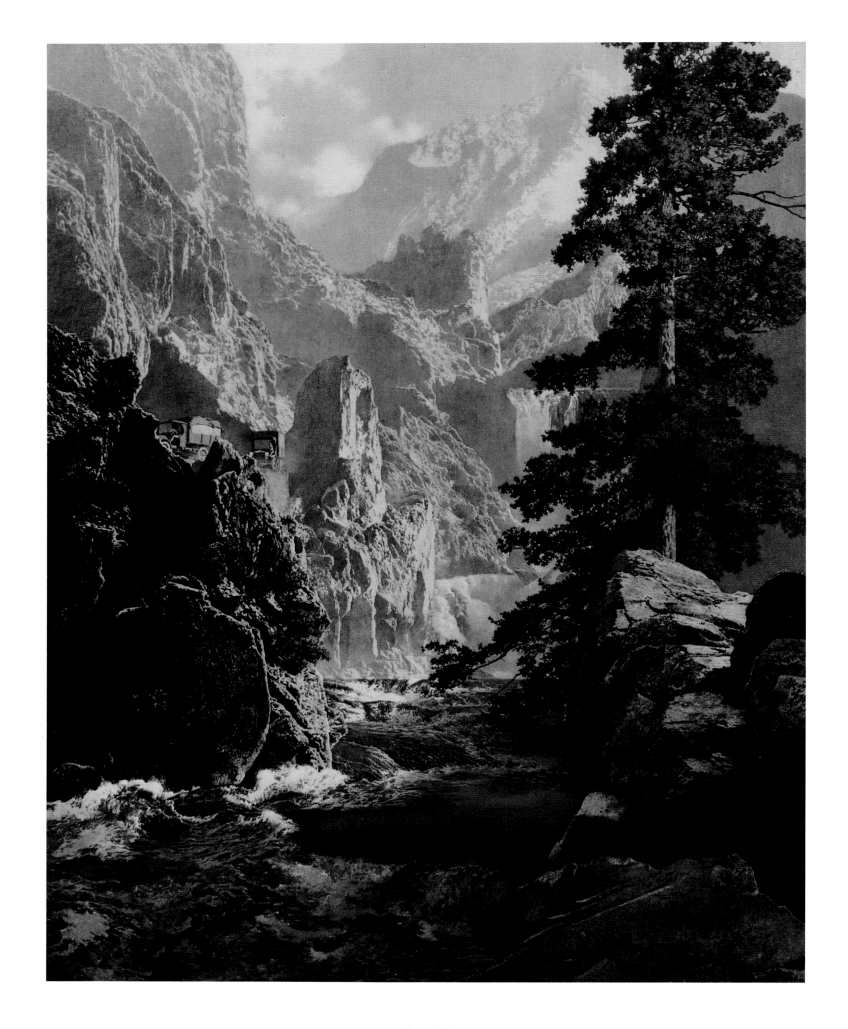

Fig. 4.32

Fig. 4.33

Fig. 4.34

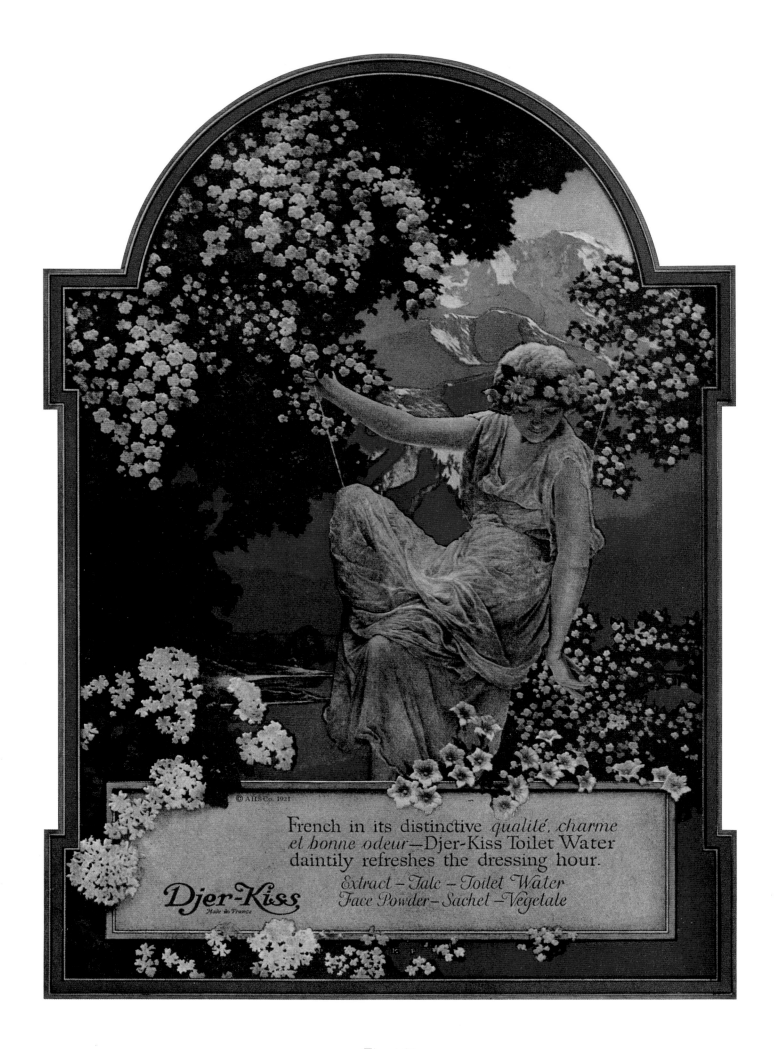

French in its distinctive *qualité, charme et bonne odeur*—Djer-Kiss Toilet Water daintily refreshes the dressing hour.

Extract — Talc — Toilet Water
Face Powder — Sachet — Vegetale

Djer-Kiss *Made in France*

© A H S Co. 1921

Fig. 4.31

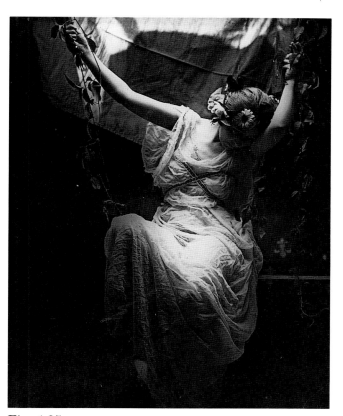

Fig. 4.35

Parrish wrote to Rushing Wood on February 5, 1923:

. . . As I told you, I want to get out of advertising work . . . I am perfectly sincere in this. I am now very happy in the other kind of work I am doing. Even making covers for Life *is mighty good fun. They pay just as well as my work for the ad people for only the reproduction rights! The originals come back to me, of which I have the exclusive print rights, should any be suitable for that purpose, and I can sell the originals. I also want to do some serious painting for publications as prints for it would be a grand satisfaction to have an income three or four times the price of one advertisement for a number of years, and own the original as well. This is plain arithmetic, not to mention common business sense. . . ."*[9]

It was, indeed, Parrish's success with the Mazda calendars and the art print market that allowed him to leave the advertising that so confined him artistically. He could eventually price himself out of the market and choose only the clients with whom he especially enjoyed working.

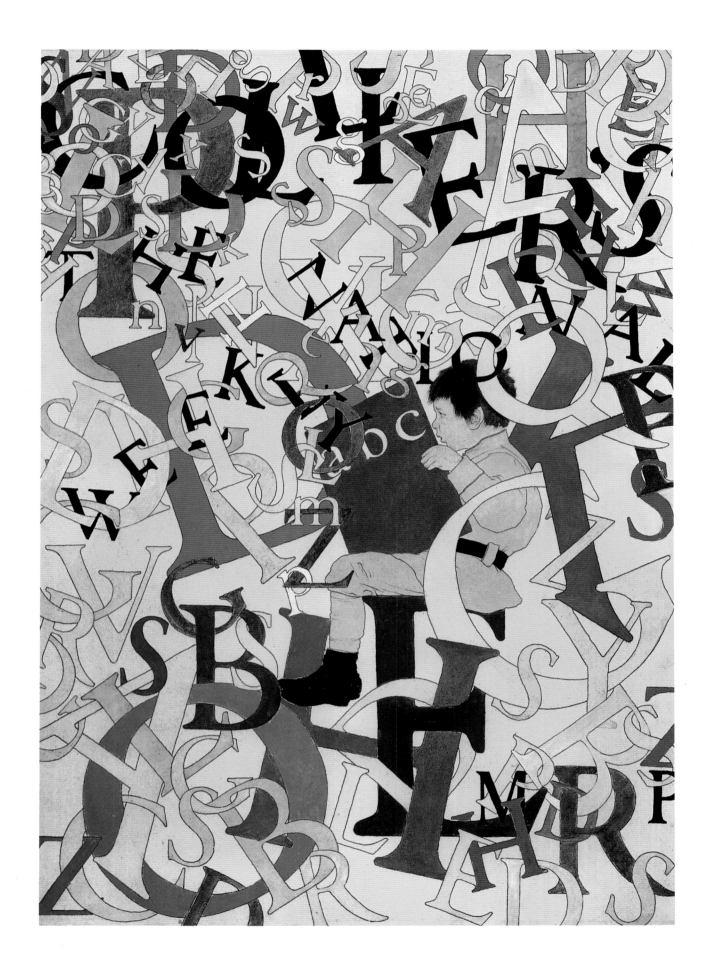

Fig. 4.4

List of Figures for Chapter 4

4.1 *Collier's,* 1908, A Funnigraph, oil on paper, 19″ × 24″. Private collection.
4.2 *Harper's 1895, Easter,* magazine. Coll. Louis Sanchez, San Mateo, California.
4.3 *Christmas Eve,* 1899, lithographic crayon and wash, 17¼″ × 12″. Coll. Creston Tanner, Baltimore, Maryland.
4.4 *Alphabet,* 1909, oil on board, 22″ × 16″. Private collection.
4.5 *The Idiot,* 1910, oil on paper, 22″ × 16″. Coll. The Fine Arts Museums of San Francisco. Photo courtesy the Fine Arts Museums of San Francisco.
4.6 *Prospector,* 1911, oil on board, 15″ × 10″. Private collection.
4.7 *Winter,* 1906, oil on board, 19″ × 19″. Private collection.
4.8 *Independence Number,* 1906, oil on paper, 15″ × 17″. Private collection.
4.9 *Harvest,* 1905, oil on paper, 28″ × 18″. Private collection.
4.10 *Jack Frost,* 1926, oil on board, 25″ × 19″. Coll. Pioneer Museum and Haggin Galleries, Stockton, California.
4.11 *Story of Snow Drop,* 1912, oil on board, 30″ × 24″. Coll. the Fine Arts Museums, San Francisco, California. Photo courtesy the Fine Arts Museums of San Francisco.
4.12 *Puss n Boots,* 1913, oil on board, 30″ × 24″. Coll. Alma Gilbert Galleries, Inc., Burlingame, California.
4.13 *The Queen's Barge,* 1910, oil cutout, 14½″ × 16″. Coll. Gary Sample, Cincinnati, Ohio.
4.14 *The Throne,* 1907, oil cutout. Coll. John Walkowiak, Minneapolis, Minnesota.
4.15 *October 1900,* 1900, oil on board, 16″ × 17″. Coll. Robert Takken, San Luis Obispo, California.
4.16 *St. Patrick's,* 1903, oil on board, 20″ × 16″. Private collection.
4.17 *Air Castles,* 1904, oil on paper, 29″ × 20″. Private collection.
4.18 *Call to Joy (Detail),* 1911, color lithograph. Coll. Howard Perdue and Robert Mason Mills, San Francisco, California.
4.19 *Humpty Dumpty,* 1921, (Life Magazine). Coll. Louis Sanchez, San Mateo, California.
4.20 *Sweet Nothings,* 1913, (Ladies Home Journal Magazine). Collection of the author.
4.21 *Evening,* 1921, color lithograph. Coll. Louis Sanchez, San Mateo, California.
4.22 *The Canyon,* 1923, oil on board, 19½″ × 15″. Private collection.
4.23 *Poet's Dream,* 1901, oil on paper, 25″ × 18″. Coll. Mr. and Mrs. Randall Dardanelle, Moss Beach, California.
4.24 *The Milkmaid,* 1901, oil on paper, 25″ × 18″. Private collection.
4.25 *A Venetian Night's Entertainment,* 1923, oil on paper, 17¾″ × 11¾″. Private collection.
4.26 *Venice: Twilight,* 1904, oil on paper, 16″ × 14″. Private collection.
4.27 *Griselda,* 1910, oil on canvas laid down on board, 40″ × 32″. Private collection.
4.28 *Errant Pan,* 1910, oil on canvas laid down on board, 40″ × 33″. Coll. Metropolitan Museum of Art, New York, New York. Photo courtesy Metropolitan Museum of Art.
4.29 *Land of Make Believe,* 1905, oil on canvas laid down on board, 40″ × 32″. Coll. Dr. Ronald Lawson, Memphis, Tennessee.
4.30 *Midsummer Holiday Number,* 1897, (Century), color lithograph, Coll. Louis Sanchez, San Mateo, California.
4.31 *Djer Kiss,* 1916, color lithograph. Collection of the author.
4.32 *Spirit of Transportation,* 1920, color lithograph. Coll. Howard Perdue and Robert Mason Mills, San Francisco, California.
4.33 *Mary, Mary Quite Contrary,* 1921, color lithograph. Collection of the author.
4.34 *Jack and the Beanstalk,* 1923, color lithograph. Collection of the author.
4.35 Susan Lewin posing for *Djer Kiss,* 1916, photograph by Maxfield Parrish. Collection of the author.
4.36 Arithmetic, 1908, oil on paper, 22″ × 16″. Private collection.

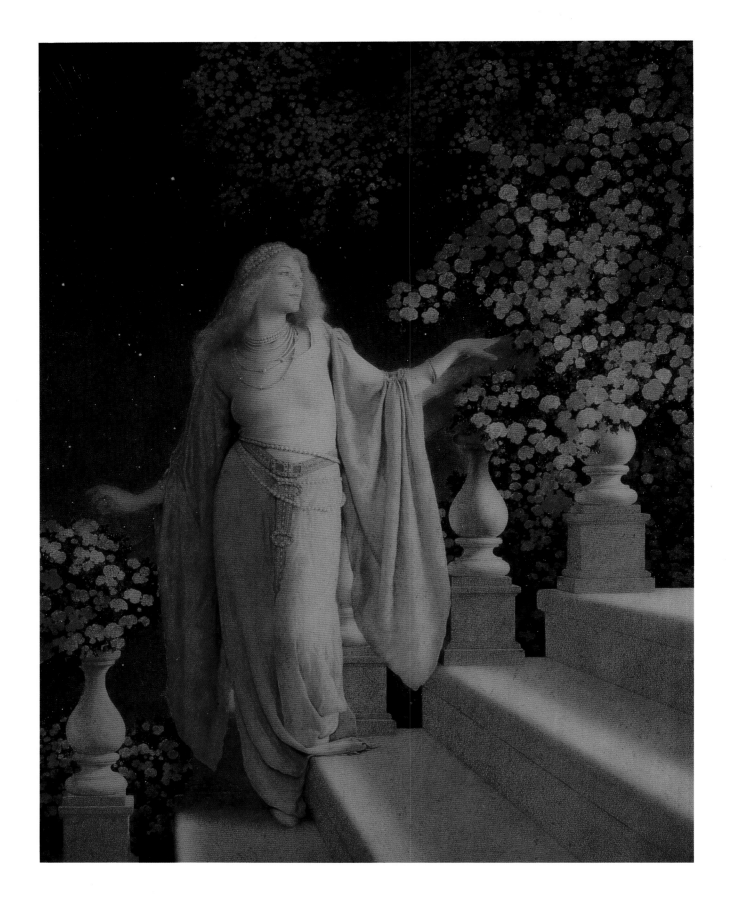

Fig. 5.10

T H E M A Z D A C A L E N D A R S

(1 9 1 7 - 1 9 3 2)

The Mazda calendars were the only advertisements Parrish truly cared about. The quality of many of the oils from which the calendar images were reproduced lifts them from the area of advertising into the realm of fine art.

The work came about through another major commission, which Parrish had done for Djer Kiss Cosmetics. A call came from the Forbes Lithograph Manufacturing Company of Boston inquiring whether the artist might be interested in doing a yearly series of paintings advertising the General Electric–Edison Mazda Lamps.

Parrish accepted the Forbes commission, and the company spared no effort in making the reproductions for the Edison Mazda calendars as faithful to the original paintings as possible. If required, as many as fourteen color separations would be made from the original painting. These were printed on separate lithographic stones to serve as guides for the lithographer in making the actual drawings on the stones. The lithographer always had the original painting in front of him when he was working on these drawings. Because the stones would not endure the number of printings required to make over a million calendars, they were used only as matrices for the more durable aluminum plates from which the actual printing was done.

The paper on which the calendars were to be printed was coated and then kept in the press area, where the atmosphere was carefully controlled to prevent humidity changes that might cause the paper to expand or contract, making the color register inaccurate. This painstaking attention to detail appealed to the perfectionist in Parrish, and he began work in earnest.

The theme was to suggest the progression of the history of light. Parrish was to be paid $2,000 for each design. So great was the appeal of the Mazda calendars that Edison Mazda soon began to be identified with Maxfield Parrish's art. In an article in the *Artist and Advertiser,* J. L. Conger wrote:

> *The series began in 1918 with a piece titled "Dawn." Its success was so imposing that Forbes decided to go all out in the production of the next calendar.*
>
> *"Spirit of the Night," which shows the figure of a girl bathed in light surrounded against a gorgeous Parrish-blue night sky, was lithographed using twelve different colors each of which required a separate press run.*

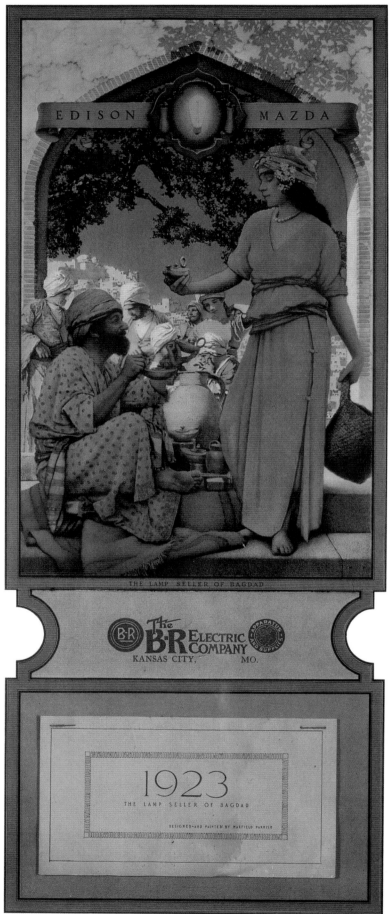

Fig. 5.7

Most of the Parrish calendars were issued in two sizes, a large size (38" × 18") for use by intraorganizational purposes and a small size (19" × 8½") for distribution to the public. There were two variances. The 1919 calendar of "Spirit of the Night" had three sizes, and the last one in 1932, "Moonlight," only one. The editions of the small calendars are almost staggering. They increased steadily from 400,000 copies of "Spirit of the Night" and 750,000 of "Prometheus" (1920) to 1,250,000 copies of "Venetian Lamplighters" (1924), and 1,500,000 of "DreamLight." Between 1917 and 1931 there were over 17,000,000 of the regular calendars and 3,000,000 of small pocket sized ones printed in four colors.

In 1931 General Electric calculated that if each one of the regular calendars was seen by one person each day in the year that it was current, they would have delivered SEVEN BILLION advertising messages for Edison Mazda since 1918. If Maxfield Parrish was not already known to nearly every man, woman and child in the United States through his illustration and other ads, his name certainly became a household word through Edison Mazda.[10]

Because the seventeen paintings done for General Electric's Mazda calendars form one of the most substantial bodies of work by Parrish, the series is reproduced in its entirety in this chapter. So that the reader can get an idea of how complex some of the designs were (Parrish executed elaborate borders for many of them, as in *Egypt,* with its intricate scarabs and cloisonné effects), some of the lithographed calendars are reproduced as well as original paintings.

The Mazda people wanted the emphasis of the calendars to reflect on the many facets of light, the history of light as kindled by mankind, as well as phenomena of nature such as sunrise, sunset, light and shadow, the nuances of light in its reflections on clouds or water, and "dream light."

All these works were painted a year or two before their publication. The first two, *Night Is Fled* (or *Dawn,* published in 1918; fig. 5.2), the first of the "Girl-on-the-Rock" series, and *Spirit of the Night* (published 1919; fig. 5.3), as well as *Solitude* (1932; fig. 5.16), and the last two of the series, *Sunrise* (1933; fig. 5.17), and *Moonlight* (1934; fig. 5.1), depicted effects of light at morning or night.

Beginning with the 1920 calendar of *Prometheus,* followed by *Primitive Man* (published in 1921), *Egypt* (1922), *Lampsellers of Bagdad* (1923), and *Venetian Lamplighters* (1924), the history of light was fancifully chronicled. In Greek mythology, Prometheus (see fig. 5.4) stole fire from the gods and brought it to earth. Zeus was enraged and had Prometheus chained to a mountaintop, where an eagle would repeatedly tear out and devour his liver. This punishment lasted for many years, until his rescue by Hercules. Prometheus became the patron of all earthly artists and thinkers. He brought fire and light to the world, and suffered for enlightening others.

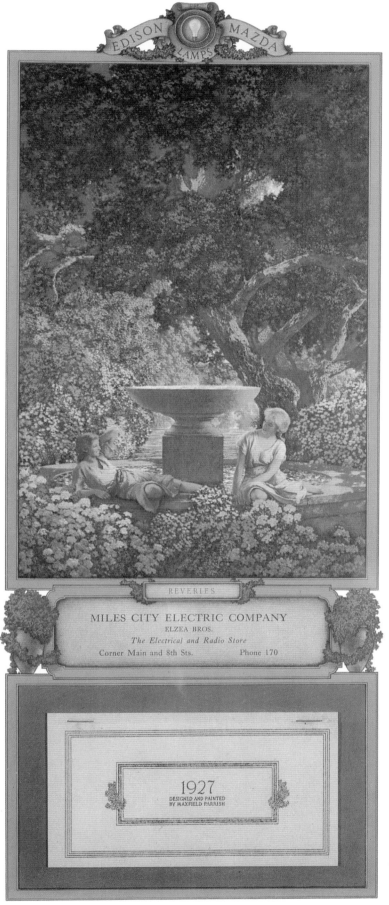

Fig. 5.11

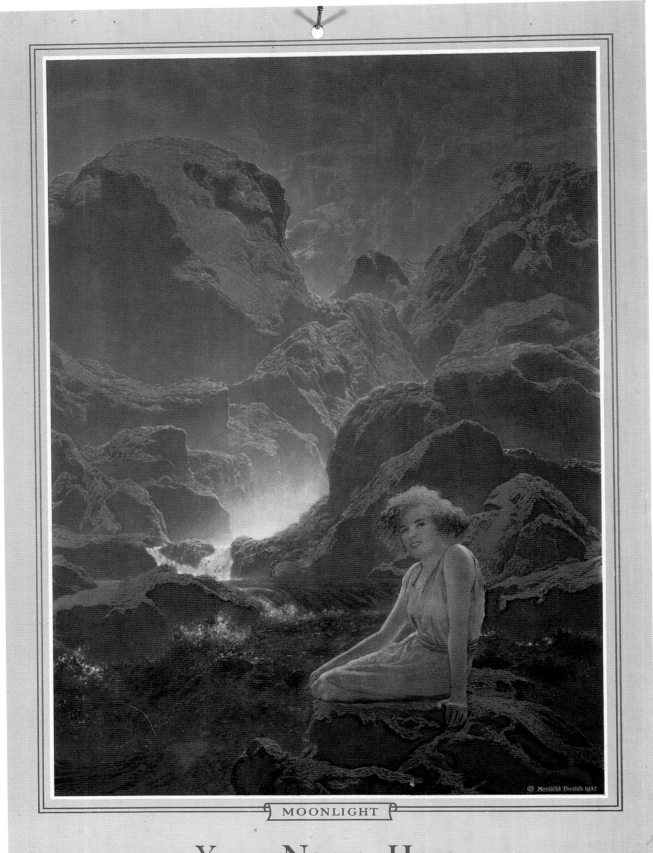

MOONLIGHT

Your Name Here
Address and Telephone Number
Will be Printed Here

Fig. 5.1

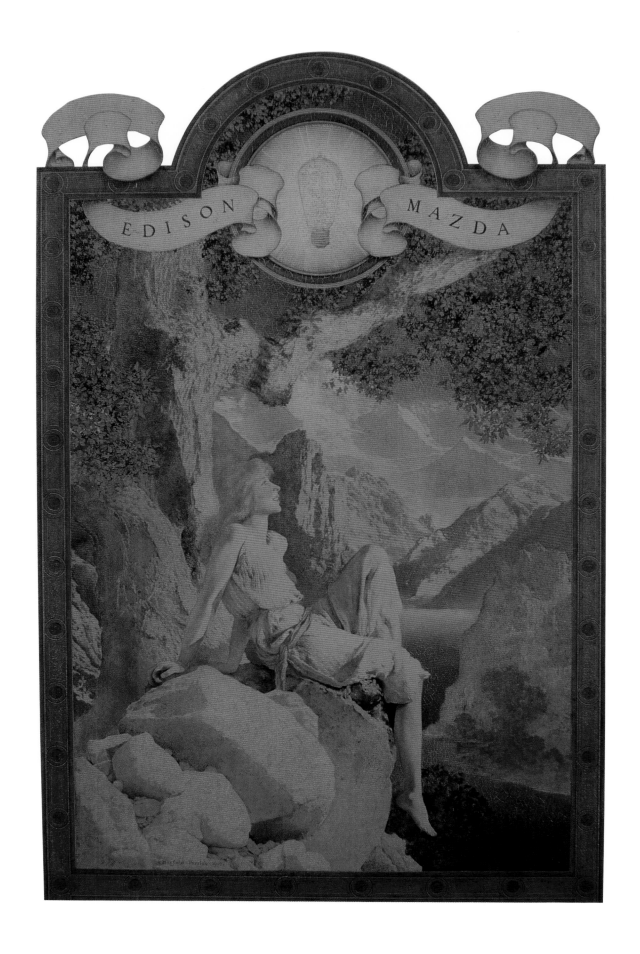

Fig. 5.2

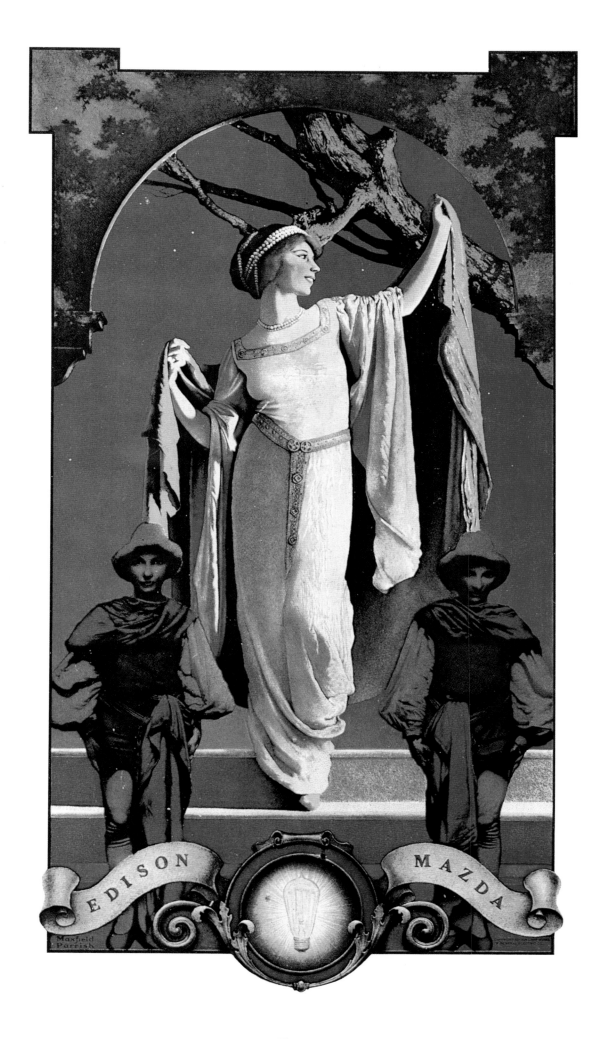

Fig. 5.3

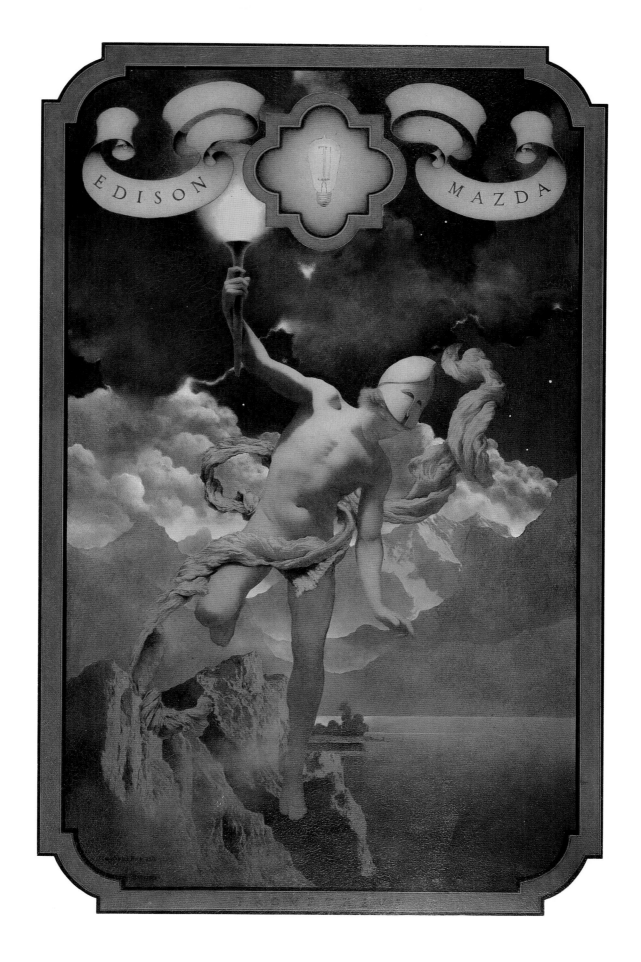

Fig. 5.4

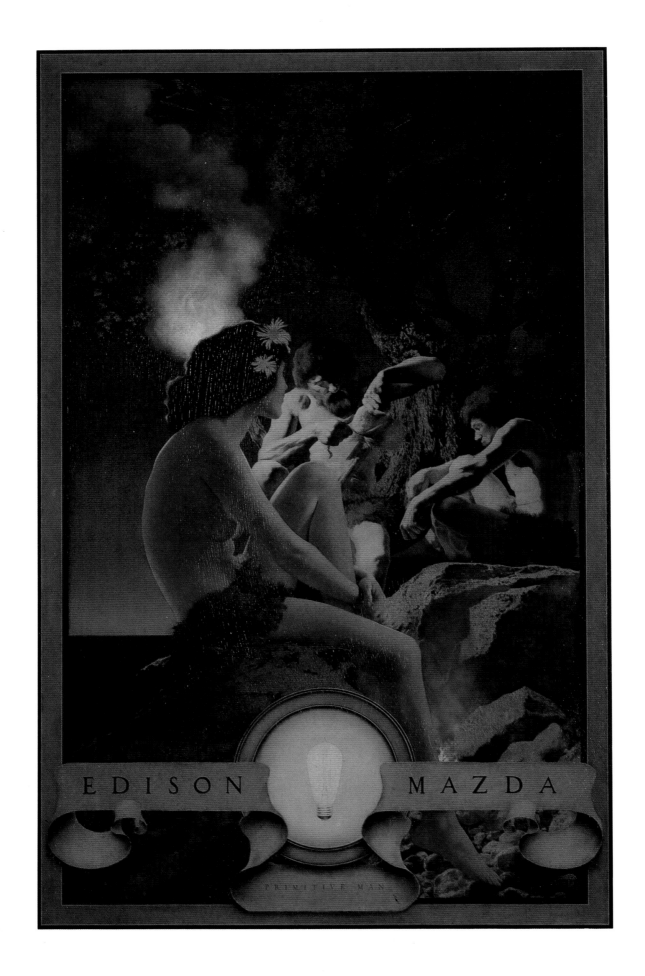

EDISON MAZDA

PRIMITIVE MAN

Fig. 5.5

102

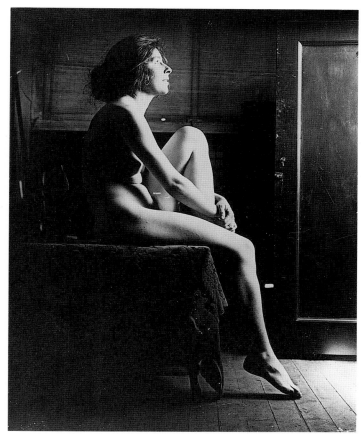

Fig. 5.18

For the next calendar, *Primitive Man* (see fig. 5.5), Parrish depicted the glow of humankind's first fires shining in the night. There is a beautiful photograph (fig. 5.18) of Susan Lewin posing nude for this image, the first of six Mazda calendars for which she modeled; the others were *Egypt, Lampsellers of Bagdad, Venetian Lamplighters, Dreamlight,* and *Enchantment,* in which Lewin is the blonde Cinderella descending the steps.

The paintings for the calendars *Egypt* and *Lampsellers of Bagdad* (figs. 5.6–5.7) described the use of oil lamps in early days. *Venetian Lamplighters* (fig. 5.8) was painted for the last of the history-of-light calendars for Mazda.

Parrish next explored the moods created by light with such paintings as *Dreamlight* (1925), *Enchantment* (1926), *Reveries* (1927), *Contentment* (1928), and *Ecstasy* (1930; see figs. 5.9–5.12 and 5.14). The subtle tonalities of *Dreamlight* and *Enchantment,* and the gentler ambiance each evokes, strike a powerful contrast to the glorious triumph of light in *Contentment* and *Ecstasy.*

Parrish once wrote that light filtering through the atmosphere in New England touched and gilded everything with a richness rarely found elsewhere in the United States. "There is an intense blue in New England. Put a mountain here, against the east, in a clear sunset glow, and it would be more startling than in Arizona."[11]

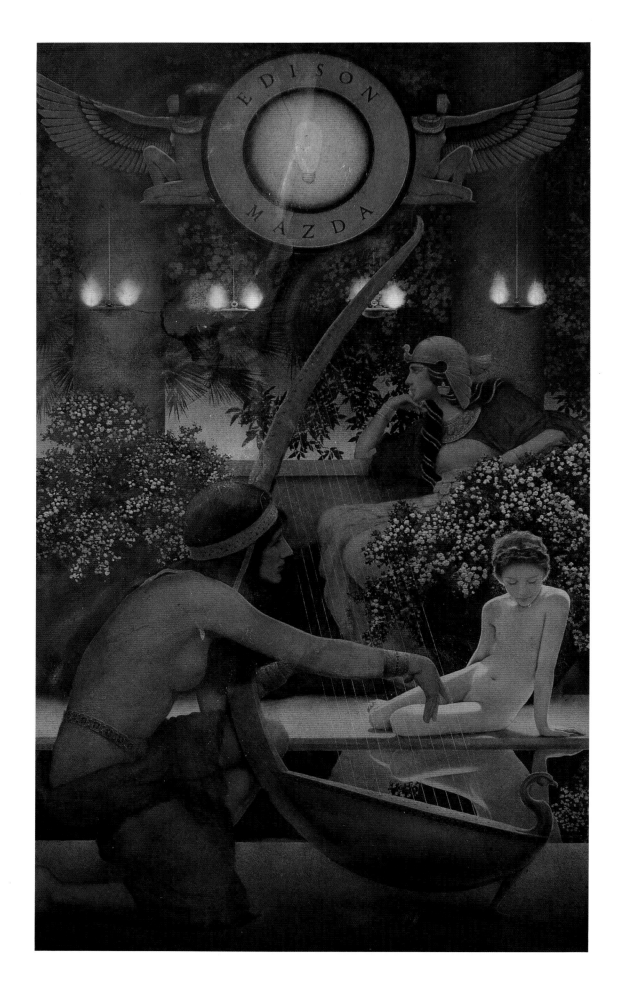

Fig. 5.6

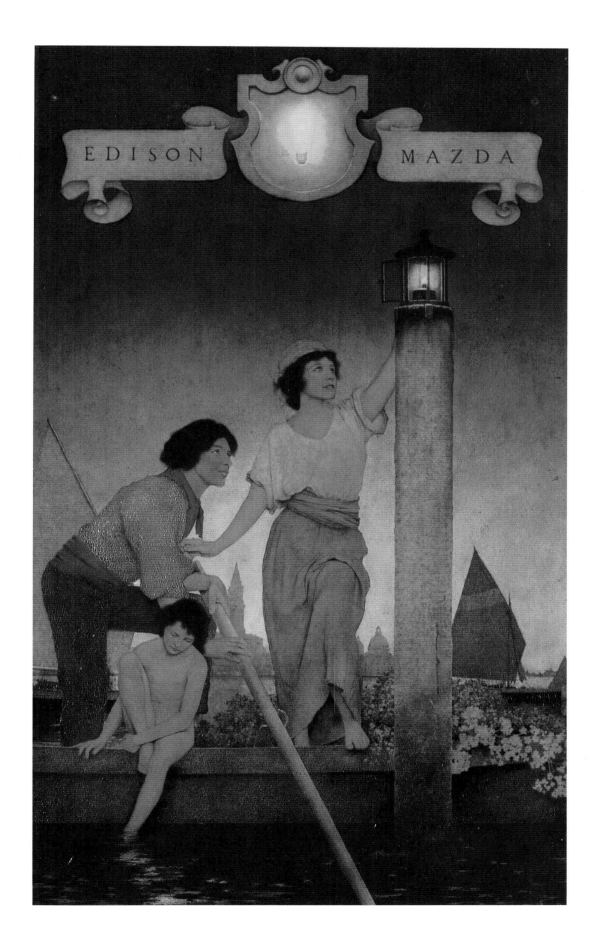

Fig. 5.8

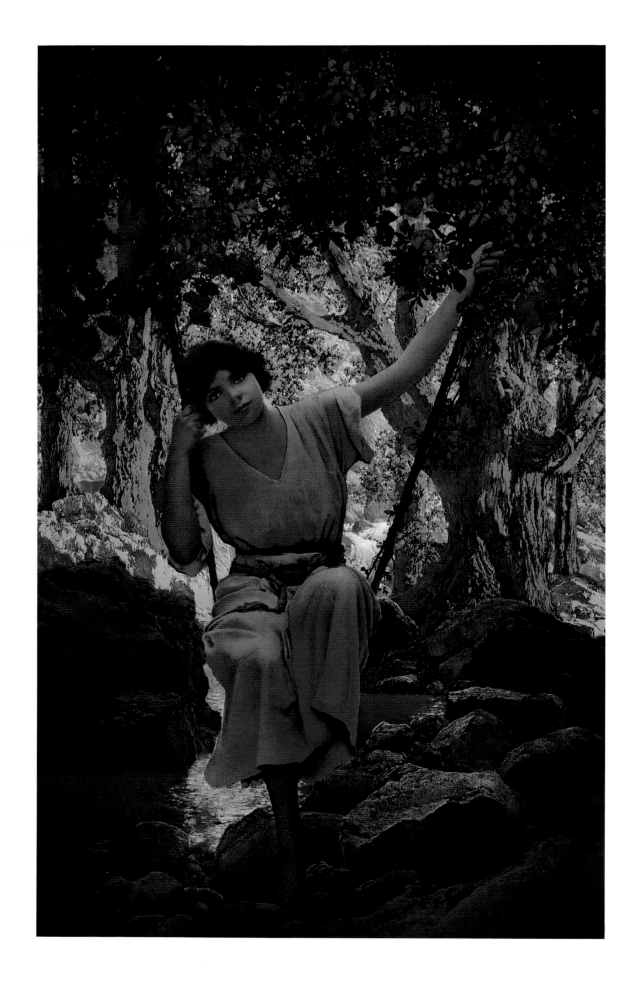

Fig. 5.9

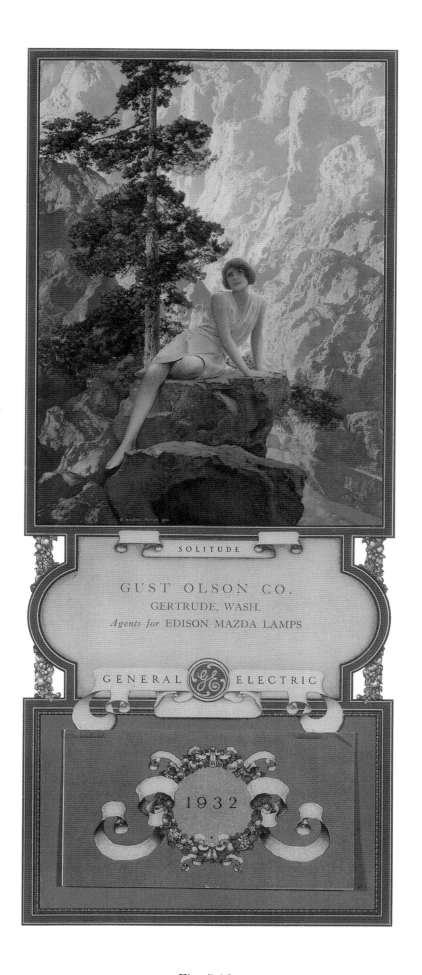

SOLITUDE

GUST OLSON CO.

GERTRUDE, WASH.

Agents for EDISON MAZDA LAMPS

GENERAL ⓖⓔ ELECTRIC

1932

Fig. 5.16

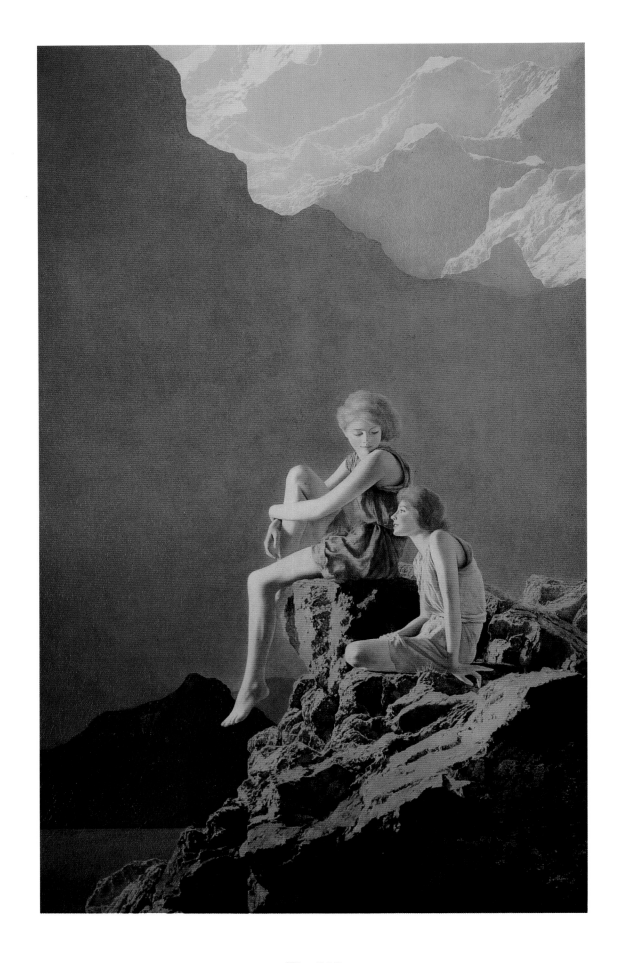

Fig. 5.12

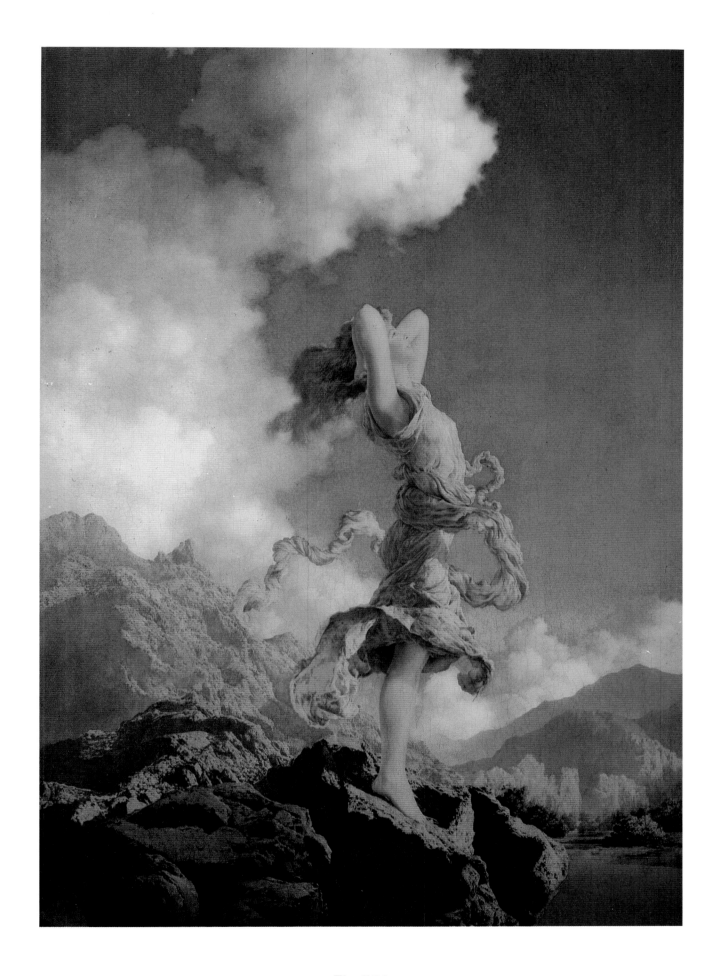

Fig. 5.14

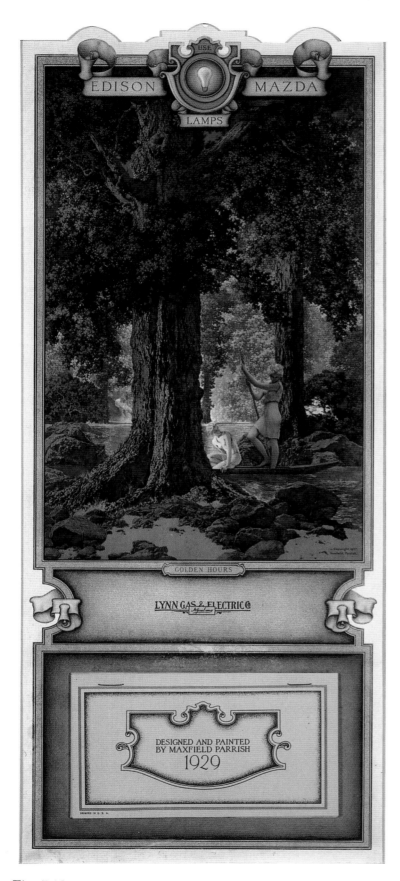

Fig. 5.13

Paintings for the Mazda series such as *Golden Hours* (1929), *Waterfall* (1931), and *Moonlight* (1934) explored the spectrums of light in nature, captured on clouds, rocks, mountains, trees, and water (see figs. 5.13, 5.15, and 5.1).

Besides the paintings mentioned before for which Susan is known to have modeled, there is strong evidence that she also posed for *Ecstasy.* The work was done at a time when Parrish and Susan were very much a "twosome" and the New Hampshire townspeople either expressed polite dismay at the "unseemly living arrangements" or simply pretended not to see what was occurring between Parrish and his model.

Other models who posed for the Mazda series included the beautiful daughters of Supreme Court justice Learned Hand, who summered in Cornish and was a good friend of the Parrishes. The Hand girls posed for *Contentment, Golden Hours, Sunrise,* and *Waterfall.* Another young model, Kathleen Read, who posed for the final Mazda painting, *Moonlight,* was heartbroken to find that her figure was painted out by Parrish in 1935 (see fig. 8.1), shortly after the calendar came out (in the smallest edition printed, at only 750,000). Parrish also painted out the figures of Learned Hand's daughters in the 1933 oil *Sunrise,* and turned both paintings into spectacular landscapes.

After painting out the figure of Kathleen Read from *Moonlight,* Parrish realized that he had lost interest in painting figures for calendar subjects and that he preferred to paint pure landscapes. He had by then given his famous "Girl-on-the-Rock" interview with the Associated Press:

Fig. 5.15

Fig. 5.17

I'm done with girls on rocks! I've painted them for thirteen years and I could paint them and sell them for thirteen more. That's the peril of the commercial art game. It tempts a man to repeat himself. It's an awful thing to get to be a rubber stamp. I'm quitting my rut now while I'm still able.

My present guess is that landscapes are coming in for magazine covers, advertisements and illustrations. . . . There are always pretty girls on every city street, but a man can't step out of the subway and watch the clouds playing with the top of Mt. Ascutney. It's the unattainable that appeals. Next best thing to seeing the ocean or the hills or the woods is enjoying a painting of them.[12]

Today, prices for early Parrish calendar prints have escalated to dizzying heights. Denis C. Jackson, in his publication *The Price and Identification Guide to Maxfield Parrish* (seventh edition, May 1991), quotes the following prices for the large and complete Edison Mazda calendars:

Night Is Fled $1,500
Spirit of the Night $1,950
Prometheus $1,800
Primitive Man $1,400
Egypt $2,000

Although, generally speaking, California print prices are higher than those that Jackson quotes, prices for the Parrish paintings are lower in California than on the East Coast. For example, a Parrish oil that may have sold for $2,000 during the artist's lifetime is now approximately $200,000 in the West and $300,000 in New York.

List of Figures for Chapter 5

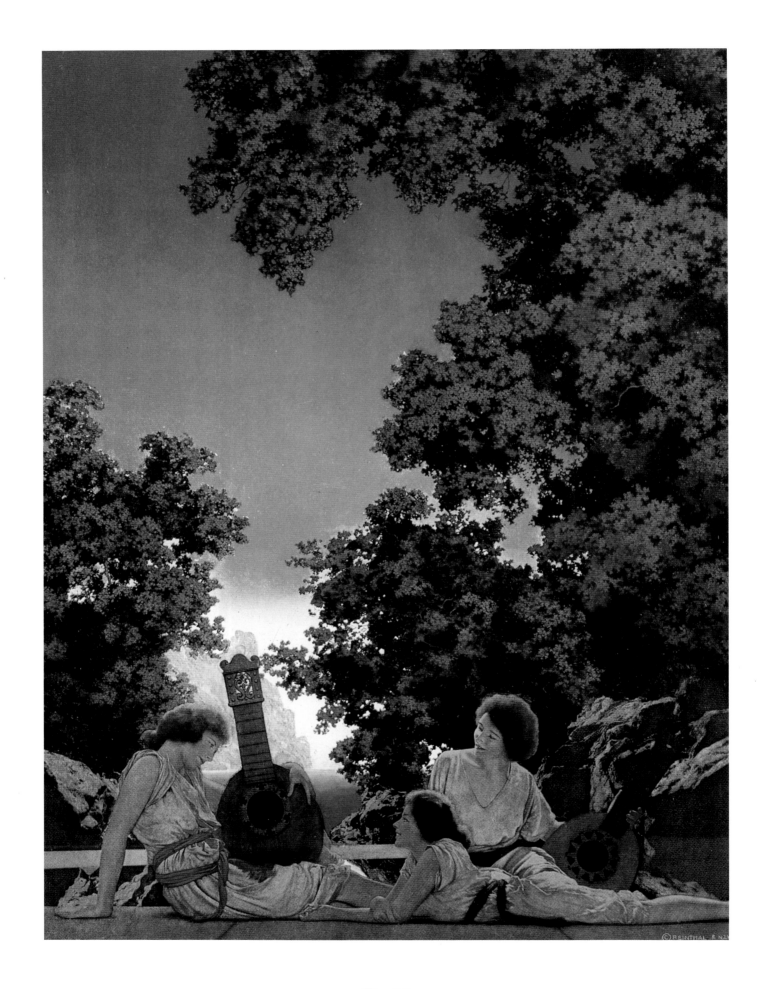

Fig. 6.5

T H E M U R A L S

(1 8 9 5 - 1 9 5 3)

Some of the most ambitious work that Maxfield Parrish accomplished, with much of his astonishing claim to fame, was in his mural paintings, especially the projects he did for the Curtis Publishing Company between 1911 and 1916: the *Florentine Fête* murals and the *Dream Garden* mosaic executed by Louis Comfort Tiffany.

Parrish was commissioned in 1894 at the age of twenty-four to install his first mural at the prestigious Mask and Wig Club in Philadelphia, as well as to decorate the proscenium arch of the stage and a ticket window (his work there would lead to his recommendation to the head of the art department at *Harper's* magazine). Parrish's first mural, measuring five feet high by twelve feet long, divided into three panels, is titled *Old King Cole* (not to be confused with the later mural done for the Knickerbocker Hotel and presently owned and displayed by the St. Regis

Hotel in New York; see fig. 6.4, a lithograph based on the latter mural). The hues of the mural in the Mask and Wig Club are still undiminished despite many a smoky night over the bar and in the club room. (I had the good fortune to be called to Philadelphia to view and appraise the mural, the stage decoration, and the wonderful cartoonlike drawings over beer mug pegs denoting the names of club members in the Mask and Wig's grillroom; while I was reviewing Parrish's early work there, I was delighted to discover a small drawing in watercolor and oil that had been used for a program cover for their 1889–1898 Decennial Anniversary.)

Between 1895 and 1933, Parrish received twelve mural commissions. Some of the murals were made up of three or four panels. The commission from the Curtis Publishing Company comprised eighteen panels, plus a presentation piece, as well as the oil *Dream Garden,* upon which Louis Tiffany based the only mosaic mural that he did in this country.

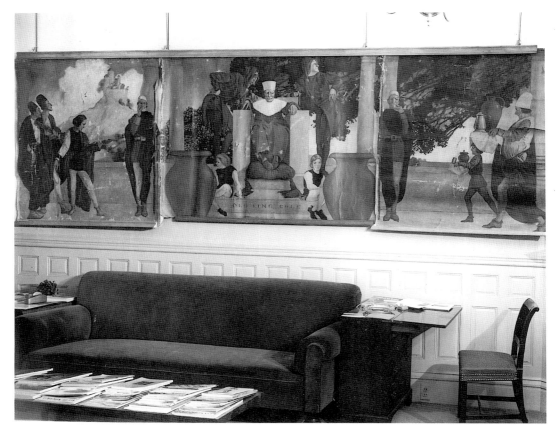

Fig. 6.1

The following chronology lists all of Parrish's mural works:

1895 *Old King Cole,* Mask and Wig Club, Philadelphia (5' × 12')

1898 *My Duty towards God and My Neighbor,* Trinity Episcopal Church, Lenox, Massachusetts (2'9" × 2')

1906 *Old King Cole,* Knickerbocker Hotel, New York (8' × 30')

1908 *Dream Castle in the Sky,* James J. Storrow residence, Lincoln, Massachusetts (2'1½" × 6'6")

1909 *The Pied Piper,* Sheraton Palace Hotel, San Francisco, California (7' × 16')

1910 *Sing a Song of Sixpence,* Sherman House Hotel, Chicago, Illinois (5'8" × 13'9")

1911–1916 *Florentine Fête,* eighteen panels plus a presentation piece, as well as the design for *Dream Garden,* the Tiffany mosaic, Curtis Publishing Company, Philadelphia, Pennsylvania

1914–1918 *Four Murals: Untitled,* residence of Mrs. Harry Payne Whitney (Gertrude Vanderbilt), Wheatley Hills, Long Island, New York (each 5'6" × 18'6")

1920 *Untitled,* overmantel mural, residence of Philip S. Collins, Wyncote, Pennsylvania (3'5" × 7'10")

1922 *Interlude,* Eastman Theatre, Rochester, New York (6'11" × 4'11")

1933 *Du Pont Mural,* Irénée Du Pont residence, Granogue, Delaware (7' × 12')

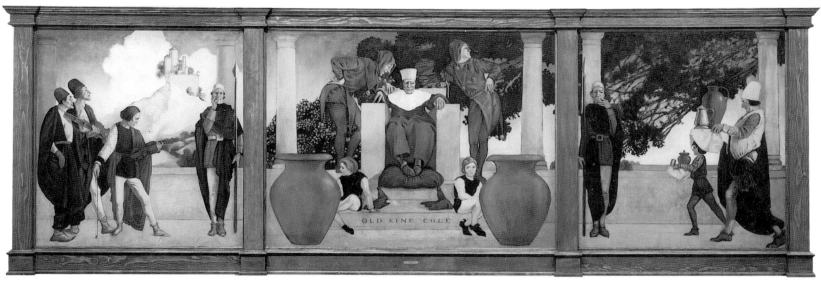

Fig. 6.1

Old King Cole (1906), *The Pied Piper* (1909), the *Florentine Fête* murals and the Tiffany mosaic for the Curtis Publishing Company (1911–1916), *Interlude* (1922), and the *Du Pont Mural* (1933) are clearly among Parrish's masterpieces.

OLD KING COLE (1906)

Parrish received the commission from John Jacob Astor's Knickerbocker Hotel in New York in 1905. He was approached by Nicholas Biddle, a friend of Parrish's who advised him to set aside the Quaker sensibilities that might have prevented him from doing a painting for a bar. From all indications, John Jacob Astor was somewhat pompous in instructing Parrish that, since he was "dishing out" a fee of $5,000 for the mural (a princely sum in

1905), he should be included in the painting, perhaps as the major character, Old King Cole (see fig. 6.4).

Although Parrish later assured all who questioned him, "my intentions when painting the mural had been 110% pure," he acquiesced and indeed included Mr. Astor's face as that of Old King Cole. Here, as perpetuated by tales told by scores of bartenders, is the socially relevant interpretation of the mural:

> *The monarch (as portrayed by Mr. Astor) appears to have been caught in a socially embarrassing situation: He has just passed wind (loudly). Embarrassed, the monarch appears to be blushing and curling his toes in chagrin. The two jesters at his side guffaw*

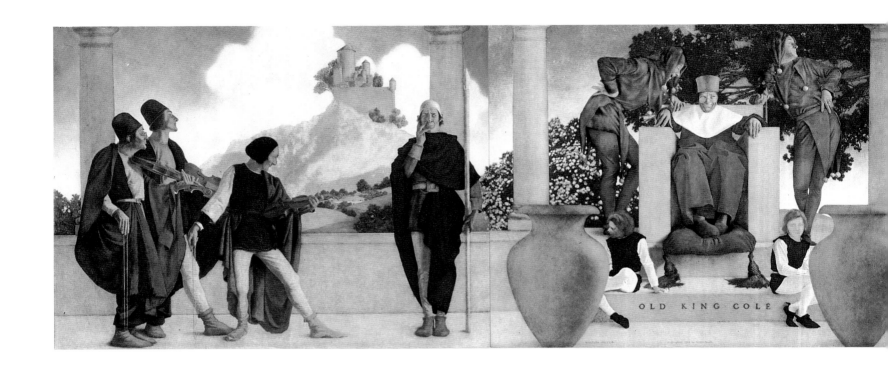

OLD KING COLE

Fig. 6.4

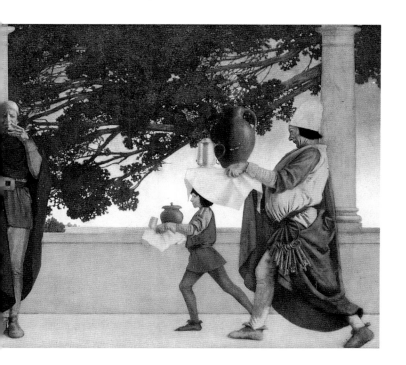

in unabashed delight. The two less sophisticated young pages sitting at the king's feet react, one by blushing and turning away, the other by blanching and staring dead ahead in mortification. The two guards register amusement and concern at the breach of etiquette . . . and the musicians, aghast at the rude explosion, abruptly stop playing and lower their instruments, momentarily at a loss.[13]

Mr. Astor really received his money's worth. His image (albeit that of a flatulent monarch) lives on, along with Parrish's amused 110 percent disclaimer.

The mural was not cemented to the wall, and after the Knickerbocker was sold, *Old King Cole* was transferred in 1935 to its present location at the St. Regis Hotel in New York.

Fig. 6.7

Fig. 6.8

THE PIED PIPER (1909)

The owners of the prestigious Palace Hotel in San Francisco decided that they, too, wanted a mural in their establishment (one wonders if they had heard the rumors of the origins of *Old King Cole*?). Unlike the owner of the Knickerbocker, they are not known to have requested that the patron be immortalized in the mural. Parrish depicted himself in the seven-by-sixteen-foot oil on canvas (fig. 6.3) as the Pied Piper leading a group of twenty-seven children from the city of Hamelin into the mountains. Susan Lewin is seen three or four times in the mural (figs. 6.7–6.8). The artist's sons Dillwyn and Maxfield, Jr. (the latter the towheaded, determined three-year-old beside the Pied Piper, doggedly marching ahead), as well as a number of neighboring children, were pressed into modeling for the mural.

Parrish sent a study image of the mural to the owners of the Palace, who had requested "something in color" to get an idea of what color schemes would work in the room where the painting was to be installed. Parrish took a photograph of the mural in progress, enlarged the print, and (there being no color photography, much less Polaroids, in 1909), painted in a rough idea of the colors. This saved Parrish composition and drawing time. He sent the colored photograph along with a quick note detailing the method of shipment that he would employ when he sent the mural itself. Many years later, the painted photograph, titled *Study for the Pied Piper* (fig. 6.2), was found rolled up, its colors beginning to run into each other because of changes in temperature, tucked away in the corner of Parrish's attic directly above his mural painting studio. Also discovered at this time (by one of my own children playing hide-and-seek in the attic) were the three

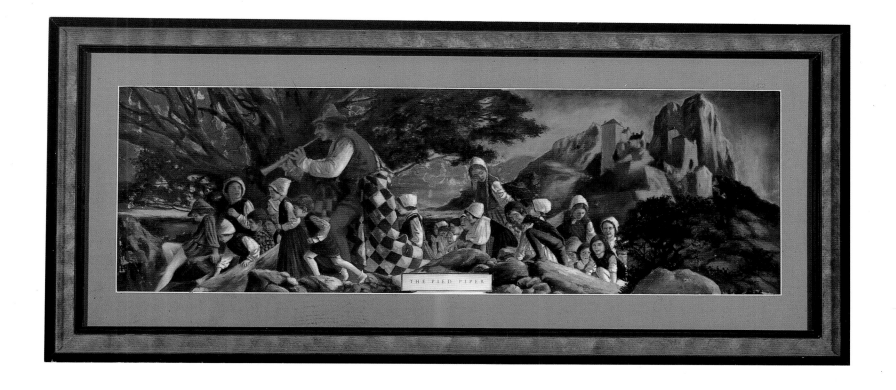

THE PIED PIPER

Fig. 6.2

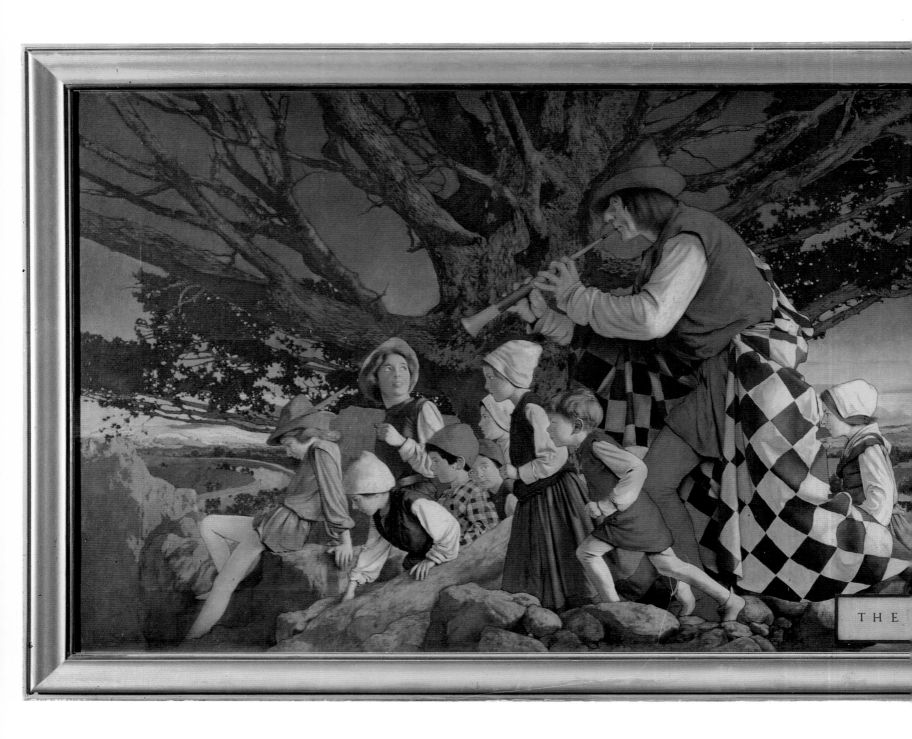

Fig. 6.3

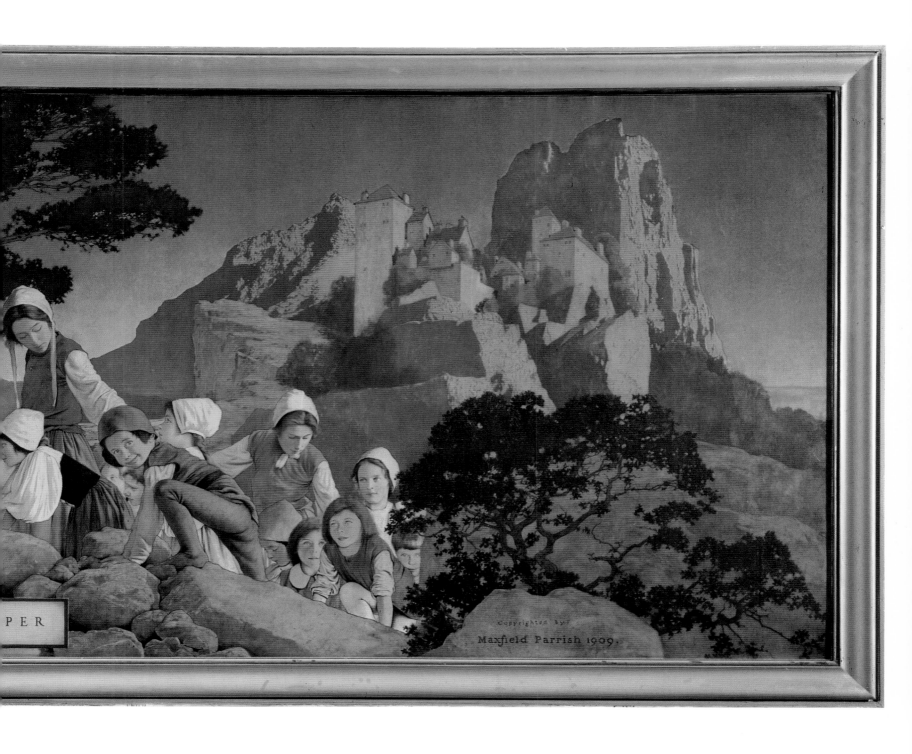

original panels for the *Du Pont Mural,* which Parrish had replaced, and a half-finished panel for Mrs. Whitney's overmantel commission. Parrish always insisted on having his studies or painted photographs returned to him after they were viewed by the prospective purchaser. His method is seen again with the *Villa Caprarola,* illustrated in chapter 2 (fig. 2.9), which was published in *Italian Villas and Their Gardens* as a retouched photograph.

The Pied Piper has hung above the bar of the Palace Hotel since 1909 except for its brief stay (1989–1991) at the De Young Museum in San Francisco during the historic $150 million restoration of the hotel. The mural was reinstalled in the room adjacent to where it had hung for nearly eighty-three years. The old Pied Piper Room was renamed "Maxfield's" and turned into a restaurant. *The Pied Piper,* in its new location at the Palace and with its new cleaning and improved lighting, again shines resplendent for all who come in pilgrimage to see this venerable San Francisco landmark.

We wonder if, indeed, bartenders still heed Mr. Parrish's admonishment, written in a letter to Helen Hess: "When customers can no longer tell how many children they can count on the [*Pied Piper*] mural, send them home to their families. A guest drawing a glass is apt to note a child in the painting that resembles a little one at home and then and there cancel their wish for an additional glass."[14]

INTERLUDE (1922)

In 1922, the Eastman Theatre in Rochester, New York commissioned Parrish to paint a large (6'11" by 4'11") oil on canvas. The work, *Interlude* (fig. 6.5), a beautiful vertical study of three young women, two holding lutes, was placed in a recess in the wall of a stairwell at the University of Rochester's Eastman School of Music. The House of Art wanted to publish the image, but preferred a horizontal print, which was to be titled *Lute Players* to distinguish it from the mural.

The canvas was cemented to the wall over a stair landing, and the initial color photography for the prints was unsatisfactory because of the difficulty of getting a uniformly lit exposure.

A photograph was sent to Parrish, who pasted it onto a piece of pulp board and painted over it, just as he had for the *Study for the Pied Piper* and *Villa Caprarola.* After repainting in oils so that it would reproduce with the proper colors, Parrish returned the photograph to the printers, who used it as a master from which to correct their color separation plates. Then they returned it to him, and the House of Art issued the beautiful print entitled *Lute Players.* Many years later, when Parrish ran across the painted photograph, he was baffled as to what it was. He wrote a friend: "It is a poor father who does not know his own children."

To prevent any further confusion, Max, Jr., recorded the following information on the back of the painted photograph: "The picture in this frame is a paper print of the Eastman Theatre Mural, Rochester, N.Y., the original of which was painted by Maxfield Parrish in 1922. It had various titles such as 'Music,' 'Interlude' and 'Lute Players', the last being its name as it appeared in reproductions."[15]

THE DU PONT MURAL (1933)

Parrish executed four 5'6" by 18'6" panels between 1914 and 1918 for the residence of Gertrude Vanderbilt (Mrs. Harry Payne Whitney). They were installed above the wainscoting in her music room, but Parrish based his dimensions on incorrect measurements sent to him and one of the

Fig. 6.6

panels did not fit. Parrish returned $4,000, the price of one panel; the Whitneys accepted the refund but did not return the piece. (An unfinished study for one of the panels was found in the attic of his studio.) Parrish was not very happy about accepting other commissions for murals for private homes, and he hesitated before accepting the commission for the music room of the home of Irénée Du Pont in Granogue, Delaware.

Parrish relented at last because this mural was requested to be a beautiful mountain landscape devoid of figures just at the time when the artist was in his "I'm-done-with-the-girl-on-the-rock" period. He executed a breathtakingly beautiful study (fig. 6.6), an oil on board measuring 23″ by 32″ which he sent to the Du Ponts on approval. They accepted it immediately, and asked to purchase the study as well. (Parrish declined to sell the study and as usual kept it for his own collection.)

Parrish began work on the mural itself, a set of three 7′ by 4′ panels. Unfortunately, he encountered a problem with this commission as well. In the exacting technique of glazing that Parrish used, each layer of paint or glaze had to dry thoroughly before the next layer could be applied. The work was done in the second-story mural room, which was surrounded by windows on three sides to allow maximum use of natural light. The murals had to be painted there, because it was the only room in the studio that allowed a ceiling height to accommodate the large works (Parrish had built an aperture in the floor so that the panels could be slipped out to the ground level). This large, airy space did not provide optimum painting conditions during winter months, since the room could not be adequately heated, affecting the critical and problematic drying time.

Maxfield Parrish, Jr., told me how his father had rigged up a series of fans to carry heat from a large potbellied stove in the central part of the studio through hallways and corridors back to the mural room. Dillwyn was left in charge of keeping a fire in the potbellied stove during one particularly cold winter week when Parrish had to absent himself from the studio. Evidently, Dillwyn, who was the least reliable of the Parrish children and who sometimes suffered from a drinking problem, neglected his fire-tending duties and the Du Pont mural panels did not dry properly. When Parrish returned, confident that his instructions for heating the mural room had been followed, he resumed applying the many layers of oils as was his custom, not knowing that the initial layer was not properly dried.

Twenty years later, in the early 1950s, the installed murals began to fleck and peel. Parrish attempted to rectify the work, but when he saw the uniform damage to the three panels, he decided to replace them altogether. "I stand by my work," he told the Du Ponts. At the age of eighty-three, the diminutive artist (Parrish's height was five feet, two inches) climbed on a ladder and painted three new panels, which remain in place, beautiful as the day he installed them at the Du Pont residence.

The three original panels were returned to The Oaks and stored in the attic. There they were found many years later, lying facedown on the attic floor. I would have dearly loved to have had the panels restored, but the Parrish Museum, which rightfully owned them, had little funds for everyday upkeep, and none for restoration. When I closed the Museum in 1985, I donated the three panels to the Precision Museum in Windsor, Vermont, with the hope that they might someday find the funds to restore them.

THE TIFFANY MOSAIC (1913)

The decision to ask Louis Comfort Tiffany to execute a mosaic made of exquisite Favrile glass and gold leaf, based on Parrish's design, was made by Edward Bok and Cyrus Curtis in October 1913. *Dream Garden* was painted by Parrish in 1914. The oil painting, measuring 26″ by 78″, was photographed in several sections, which, enlarged many times over, made up the cartoon for the mosaic. Although it was understood that Parrish would have the final word on any question regarding the translation of his painting into glass, he trusted the ability of Tiffany's artisans and, after checking the photographs of his study to see if the scale had been preserved in the enlargements, he left the rest of the project to them.[22]

In June 1914, Tiffany began the work of translating Parrish's vision of a world without time, trouble, or tension, into the luminous beauty of this glass mosaic. The images are rendered in Favrile glass following a complex hand-firing process developed by Tiffany to produce over 100,000 pieces of glass in 260 color tones. Since the completed mosaic (fig. 6.9) would weigh four tons, most of the glass was set into twenty-four panels in Tiffany's New York studios. After its completion, the mural was exhibited in Tiffany's studios for a month, and more than seven thousand people came to admire the glittering, iridescent composition. Then the mural was disassembled and transferred to the Curtis Publishing Company building.

Installing the panels took all of six months. The finished work was hailed by art critics as "a veritable wonderpiece" at the official unveiling in 1916. The amazing variety of opaque glass, entirely illuminated from the light in the lobby, achieves perspective effects that have never been duplicated.[23]

On his way to Philadelphia after inspecting the glass mural for the first time at the Tiffany studios in New York, Parrish wrote to his wife in August 1915: "Dearest Lydia: . . . called at Tiffany's this morning and they have the thing done and in grand style for the exhibition. They turn all sorts of concealed lights on it. The effect is truly unusual. The whole panel can be made to change from dusk to orange glow. . . . Tiff [Tiffany] could not go abroad, so they finished the mosaic much sooner than planned."[24]

When the Kevin F. Donohoe Company began the $82 million restoration and renovation efforts on the Curtis Publishing building in 1985–1986, the project involved close cooperation between the developer, contractor, craftspersons, and art conservators from Philadelphia and the Metropolitan Museum of Art in New York. As a result, *Dream Garden* continues to fulfill the wishes of Tiffany and Parrish that "it may stand in the years to come for a development in glass making and its application to art."[25]

When I met with John W. Merriam, the owner of *Dream Garden*, the value of the mosaic was brought up. When one considers the price of gold today, roughly $367 per ounce, the melt-down price alone for the gold Tiffany used in this four-ton mosaic would push the price of the mural up considerably. Some Tiffany experts have suggested an appraisal of $8 to $10 million. Consider the value of the Parrish contribution, the creative collaboration and artistic innovation on a grand scale in what is unequivocally the most beautiful mosaic in America, and the mind staggers in trying to reach an arbitrary value. Irreplaceable? Without doubt. Valuable? Without question. Perhaps Louis Tiffany's own words best put the mural into proper perspective:

When Mr. Maxfield Parrish's painting was shown to me, with all its beauty of suggestion, I saw the opportunity of translating it into a mosaic which would bring to those who could see or understand, an appreciation of the real significance of this picture.

In translating the painting so that its poetical and luminous idealism should find its way even to the comparatively uneducated eye, the medium used is of supreme importance; and it seemed impossible to secure the effect deserved on canvas and with paint. In glass, however, selecting the lustrous, the transparent, the opaque and the opalescent, each with its own texture, a result is secured which does illustrate the mystery, and it tells the story, giving play to imagination, which is the message it seeks to convey. As a matter of fact it is practically a new art. Never before has it been possible to give the perspective in mosaic as it is shown in the picture, and the most remarkable and beautiful effect is secured when different lights play upon the completed mosaic.

It will be found that the mountains recede, the trees and foliage stand out distinctly and, as the light changes, the purple shadows will creep slowly from the base of the mountain to its top; that the canyons and the waterfalls, the thickets and the flowers all tell their story and interpret Mr. Parrish's dream.

I trust it may stand in the years to come as a development in glassmaking and its application to art which will give to students a feeling that in this year of 1916 something worthy has been produced for the betterment of mankind, and that it may serve as an incentive to others to carry even further the true mission of the mosaic.[26]

(Fig. 6.9 follows)

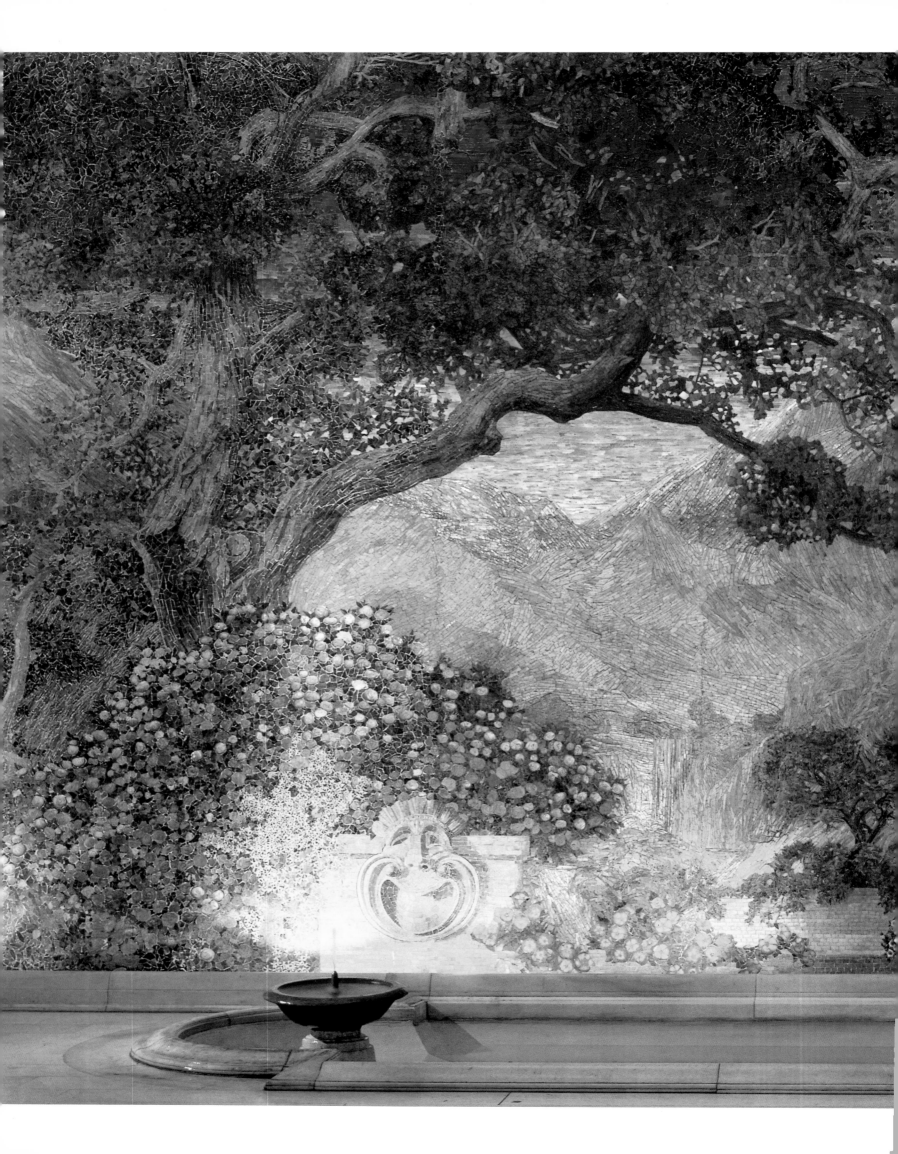

THE FLORENTINE FÊTE MURALS (1911–1916)

There can be no question that the eighteen panels of the *Florentine Fête* murals (plus the initial *Presentation Piece*) painted by Parrish for the Curtis Publishing Company represent one of the most significant achievements of his career (figs. 6.10–6.28).

Cyrus H. K. Curtis, the business genius behind such tremendously successful mass circulation magazines as the *Ladies' Home Journal* and the *Saturday Evening Post,* was also a visionary when it came to the development of his corporate headquarters and magazine production facility. He purchased a full city block in Philadelphia's historic Independence Square for slightly more than one million dollars in 1910. He commissioned the construction of a magnificent brick and marble building at a cost of three million dollars. It was then, as it is now in the nineties after its renovation, one of the most beautifully appointed buildings on the East Coast.

The main entrance to the Curtis Center is framed by a colonnade of fourteen thirty-two-foot, one-piece Vermont marble columns that required special train cars to transport them to Philadelphia and custom rigging for their installation. Within the Curtis Center were housed some of the great treasures of twentieth-century American art: the eighteen mural panels of the *Florentine Fête* by Parrish and a 15' by 49' Tiffany glass mosaic titled *Dream Garden* painted by Parrish and executed in Favrile glass by Louis Comfort Tiffany in 1914.

Edward Bok, the editor of the *Ladies' Home Journal,* was responsible for commissioning Parrish to paint the murals for the Girls' Dining Room at the top floor of the building. The company employed many young women and decided to build "the most beautiful dining room in America."[16]

Bok asked Parrish to complete the murals within a year. After agreeing to a figure of $2,000 per panel, Parrish sent an initial painting (*The Presentation Piece,* fig. 6.10) for the *Florentine Fête* mural series to Robert Seeler, the architect for the project, for his approval.

The theme of this first painting, which shows the figure of an older man with Parrish's features, was later used in the panel titled *A Call to Joy* (fig. 6.24) and later again for the *Ladies' Home Journal* Christmas 1912 issue. The eighteen panels would describe a Florentine Renaissance fête, one large canvas a depiction of the celebration, the others featuring happy young people en route to the gathering.

Parrish wrote Bok in 1912 saying the panels could not possibly be ready in a year. "It is now purely a question of drying. Sunday it was 35 below zero in the town of Windsor. Wood simply dissolves in the stove, it does not seem to burn and drying the paint is an uncertain affair. Therefore, I know it is wiser to say they cannot be ready. . . ."[17]

Susan Lewin posed for all but two of the nearly two hundred figures depicted in the panels. In the *Florentine Fête* title piece (fig. 6.28), the largest of all the panels, her face can be recognized on eighty figures, both male and female. Because of his painstaking detailing in the depiction of materials, the folds of costumes, the quality of light, Parrish worked from photographs with which he had captured Lewin's poses, rather than subjecting her to hours of painful immobility. It was at this time, the start of his biggest commission, that Parrish chose to leave the main house which he had shared with his wife and children and move permanently into the studio with Susan. The excuse offered to neighbors and friends was that Parrish needed to concentrate on the work at hand. The winter of 1911

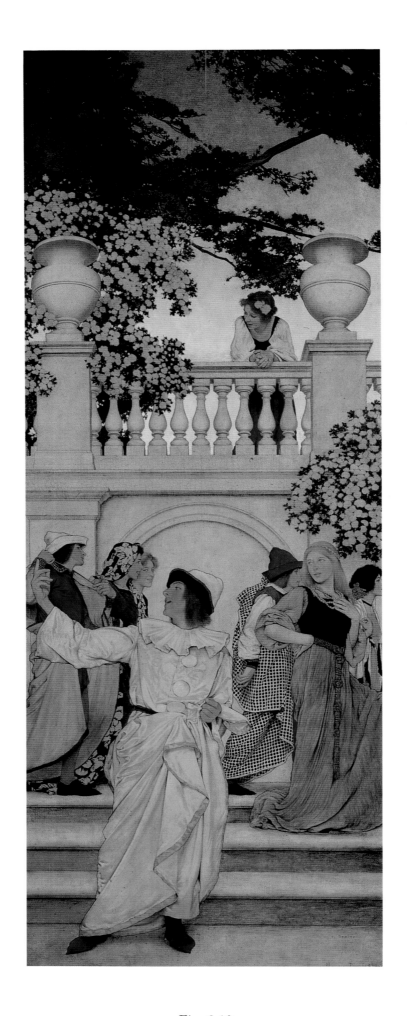

Fig. 6.10

marked the first time that Lydia began to winter alone or with the children on Saint Simons Island, Georgia.

Parrish steadfastly refused to name the panels for the *Florentine Fête*. The following are the titles that Curtis Publishing Company gave the eighteen oils (with their dates and measurements):

Lazy Land, 1911 (126″×39″) (fig. 6.11)
The Castle of Indolence, 1913 (126″×186″) (fig. 6.12)
The Arch Encounter, 1913 (126″×65″) (fig. 6.13)
Sweet Nothings, 1912 (126″×64″) (fig. 6.14)
The Whispering Gallery, 1913 (126″×64″) (fig. 6.15)
Journey's End, 1912 (126″×58″) (fig. 6.16)
A Stairway to Summer, 1912 (126″×58″) (fig. 6.17)
The Garden of Opportunity, 1913 (126″×64″) (fig. 6.18)
The Vale of Love, 1913 (126″×64″) (fig. 6.19)
The Boughs of Courtship, 1912 (126″×56″) (fig. 6.20)
Buds below the Roses, 1912 (126″×65″) (fig. 6.21)
Roses of Romance, 1912 (126″×39″) (fig. 6.22)
A Shower of Fragrance, 1911 (126″×39″) (fig. 6.23)
A Call to Joy, 1911 (126″×39″) (fig. 6.24)
Love's Pilgrimage, 1911 (126″×39″) (fig. 6.25)
A Word in Passing, 1911 (126″×39″) (fig. 6.26)
A Rose for Reward, 1911 (126″×39″) (fig. 6.27)
Florentine Fête, 1916 (126″×240″) (fig. 6.28)

The seventeen smaller panels were completed within two years, the last ones arriving in Philadelphia in March 1913. They were installed by cementing the canvases directly to the walls. *Castle of Indolence* was in the northwest corner and comprised two panels. The large canvas for the south side, the title piece *Florentine Fête,* was not cemented to the wall. It was mounted on stretcher bars and put in place in 1916. This is the panel that depicts Susan in over eighty figures. On April 19, 1915, Edward Bok wrote to Parrish: "My dear Parrish: I have just seen the large panel, and I want to congratulate you upon it. It is very cleverly conceived and beautifully executed. With such strong architectural interest as you were bound to give the

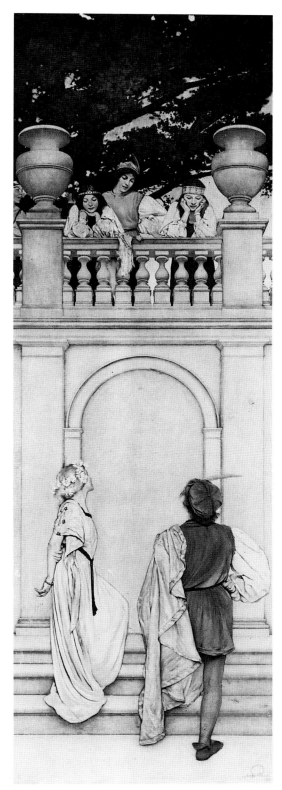

Fig. 6.11

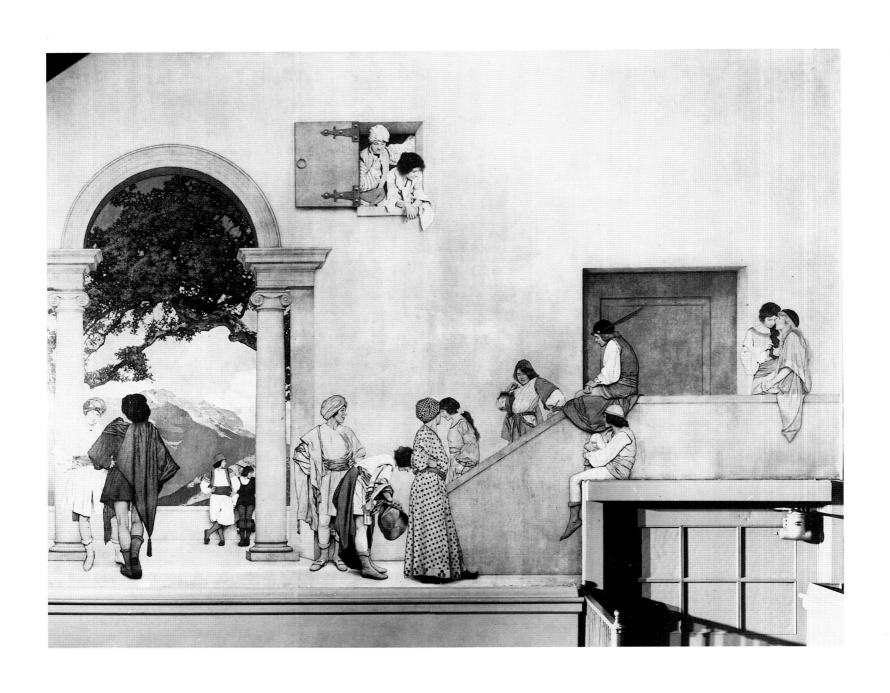

Fig. 6.12

picture, I think you have put that all in the background, with the human interest in the foreground, and the whole thing hangs together remarkably well."[18]

In anticipation of the completed panels, the *Ladies' Home Journal* informed their readers in 1912:

> *The paintings are ten and a half feet high, and vary from three and a half to five feet in girth. There will be sixteen [sic] in all, and then a long painting ten and a half feet high and seventeen feet wide. . . . The dining room is one hundred and seventy-six feet long, with fourteen colonial windows, most of which overlook the beautiful verdure of Independence Square. In each one of the sixteen spaces alongside of these windows will fit one of Mr. Parrish's beautiful paintings, all these leading up to the main picture at the end of the room. . . . The panels are all complete in themselves, and yet each is connected with the others. . . . The loggia and steps are crowded with youths and maidens in fête costumes. All is happiness and beauty. Everyone is young. It seems to be a land where nobody is old. The whole will be a wonderfully successful result of the artist's idea to present a series of paintings that will freshen and "youthen" the spirit and yet will not tire the eye.*[19]

Parrish was questioned by many viewers, including Edward Bok, about what the murals meant. The artist responded: ". . . what is the meaning of it all? It doesn't mean an earthly thing, not even a ghost of an allegory. The endeavor is to present a painting which will give pleasure without tiring the intellect: something beautiful to look upon. A good place to be in. Nothing more!"[20]

It is my opinion that in this, one of Parrish's most ambitious projects, the artist left abundant clues about his feelings for the young woman who had become his full-time companion and who was depicted nearly two hundred times in these murals.

Close examination of the figures reveals that most of them wear wedding rings. If, then, the panels show us a myriad of young people in the act of courtship, it is rather provocative to find so many of them wearing rings on the third finger of the left hand. From 1911 to the time she left him, Sue Lewin wore what appears to be a wedding band on her left hand. It could be said that Lewin was the woman who "youthened" Maxfield Parrish's spirit and who so dominated his art and his thoughts during the midpoint of his life.[21] The images reveal the tremendous amount of work and love Parrish devoted to his creations, in the intricate patterns and textiles and the magnificent portraiture captured in the facial expressions.

The Curtis Publishing building was sold in 1960 to Philadelphia businessman and art patron John W. Merriam. Mr. Merriam recognized that the building required a renovation effort, and found a developer to take on the huge project of restoring the city-block-long building. Mr. Merriam did not wish to part with either the murals or the Tiffany mosaic. He undertook the expensive endeavor of hiring a firm to detach and restore the *Florentine Fête* murals. (The Tiffany mosaic, weighing four tons, was left in place.) Because the canvases had been cemented to the walls (with the exception of the last and largest panel), some of the murals were damaged by moisture and in the course of removal. On one of the occasions when I was in Philadelphia to appraise the mural at the Mask and Wig Club, Mr. Merriam invited me to view the *Florentine Fête* panels. When I saw them I knew they must be seen by all who love the work of Maxfield Parrish.

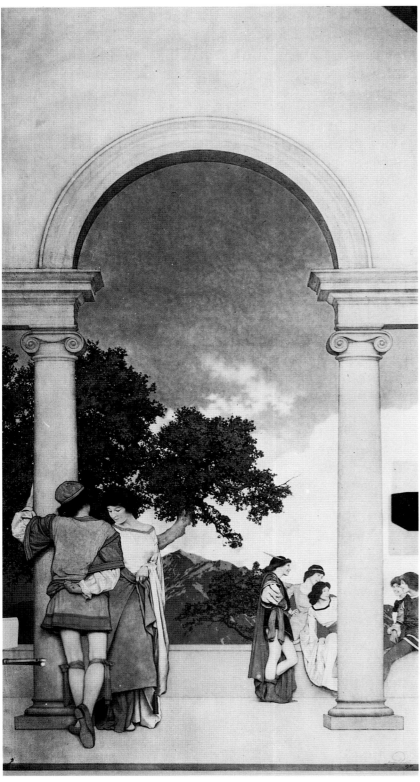

Fig. 6.13

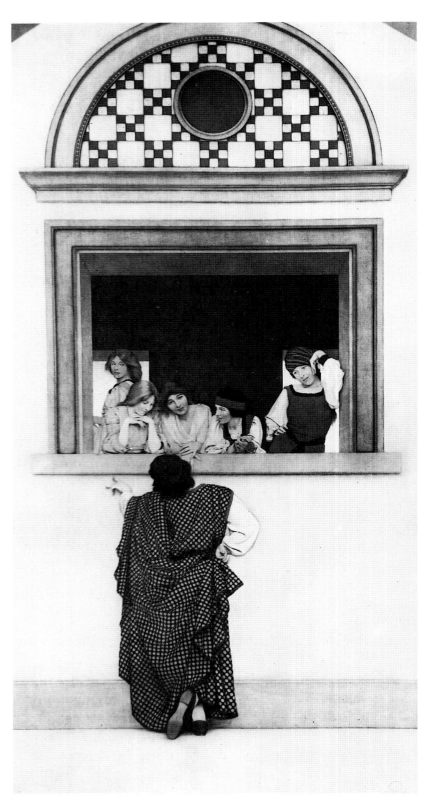

Fig. 6.14

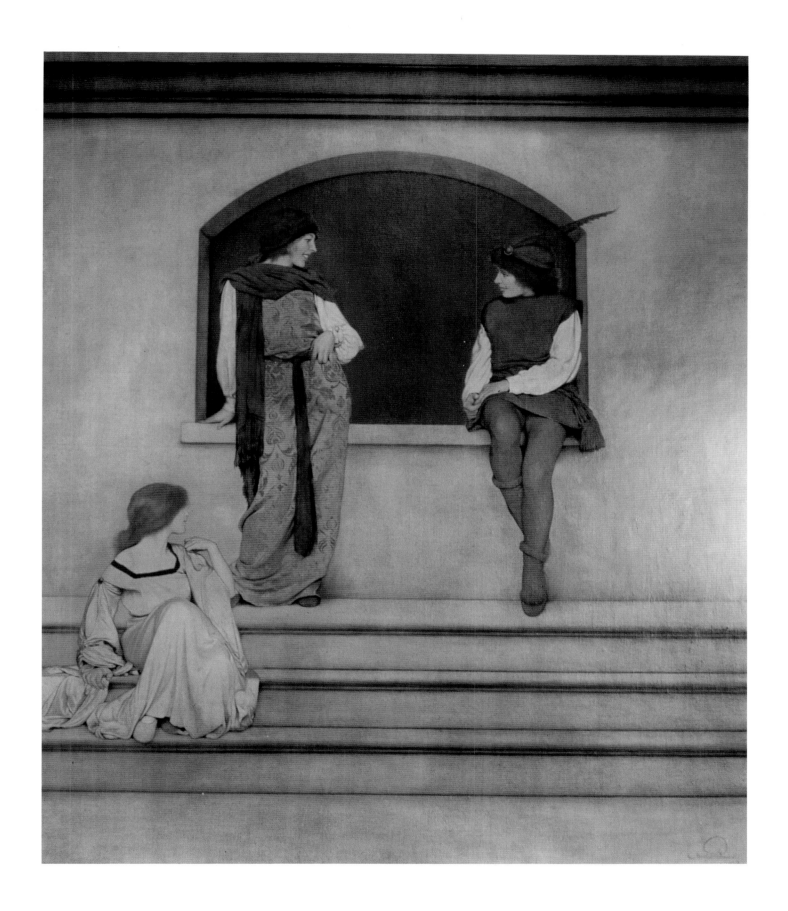

Fig. 6.15 (detail)

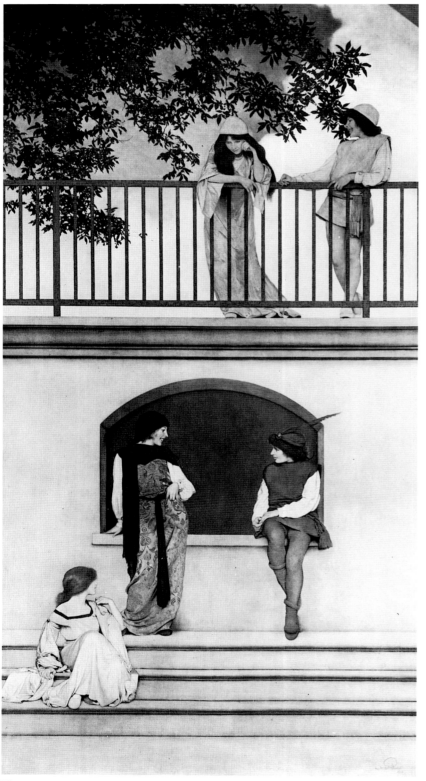

Fig. 6.15

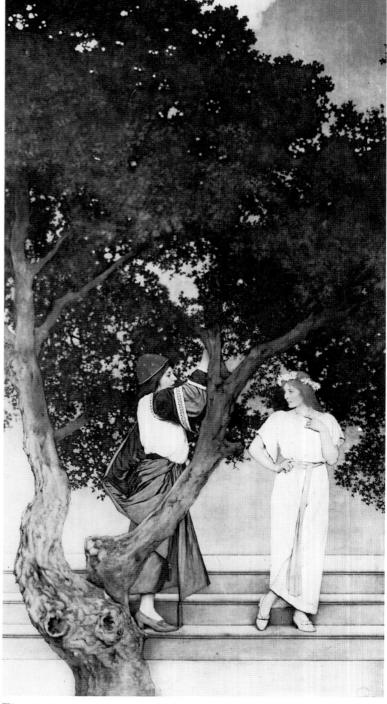

Fig. 6.16

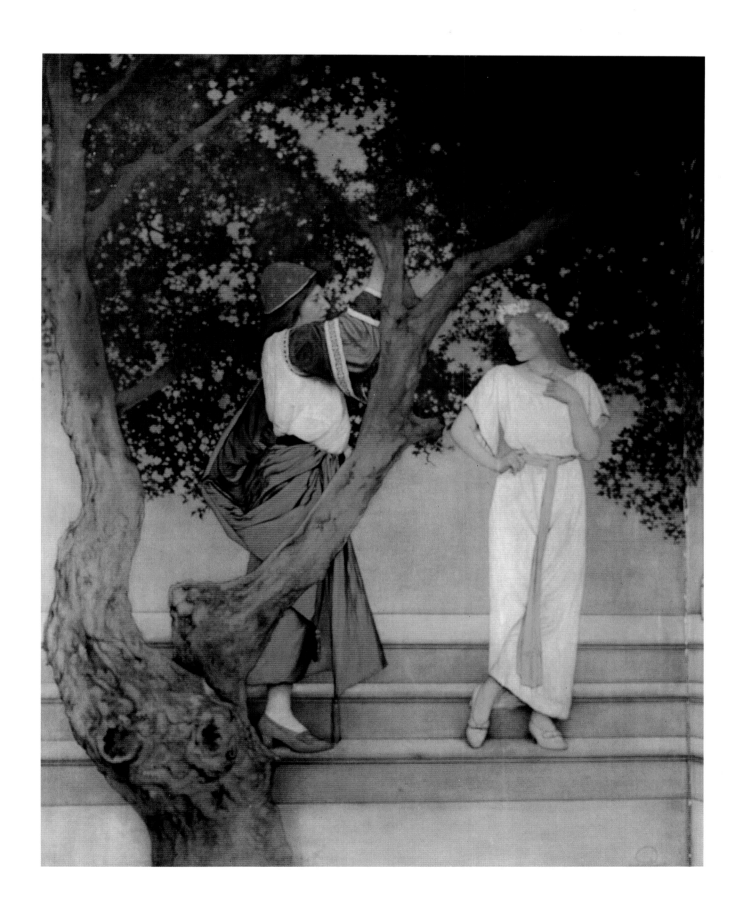

Fig. 6.16 (detail)

137

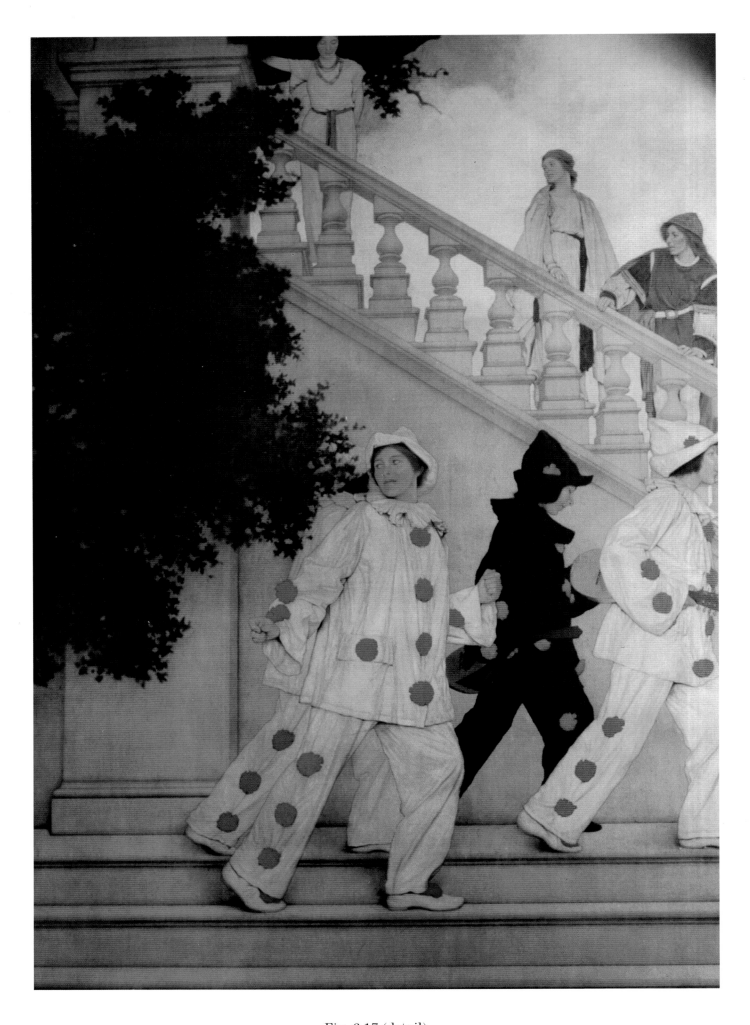

Fig. 6.17 (detail)

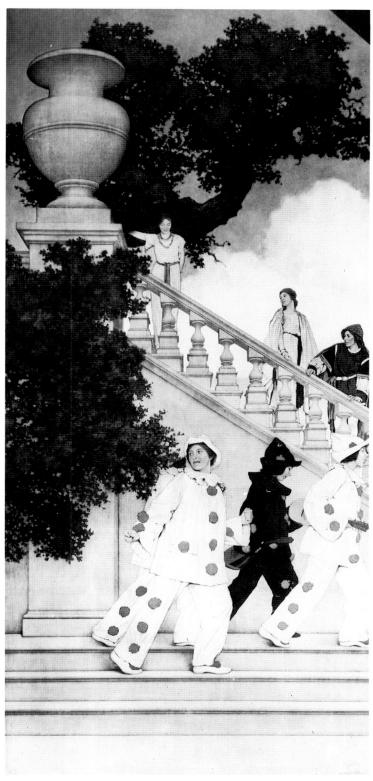

Fig. 6.17

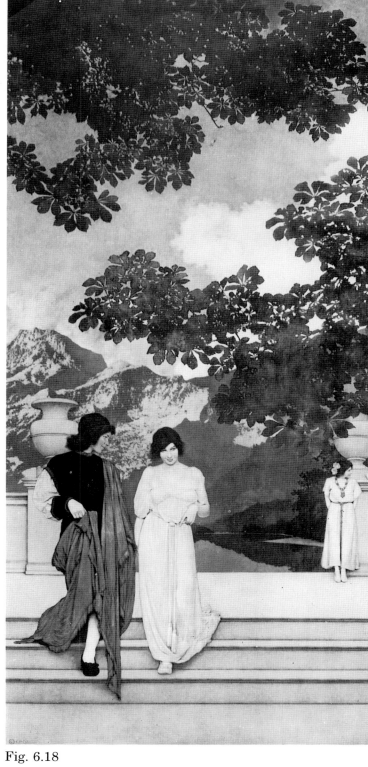

Fig. 6.18

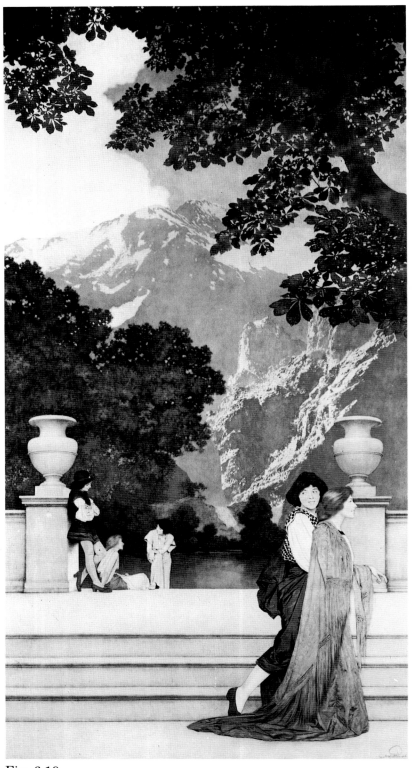

Fig. 6.19

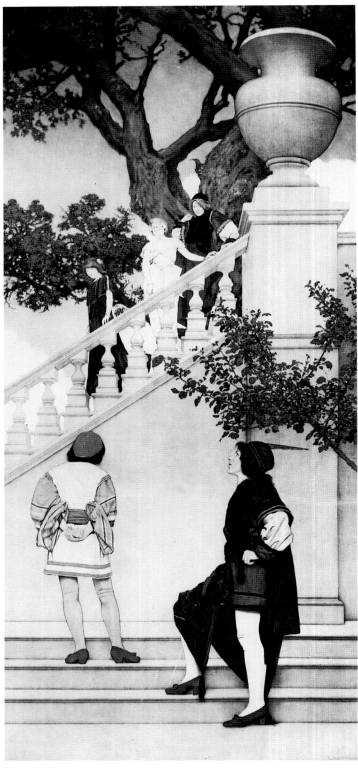

Fig. 6.20

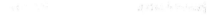

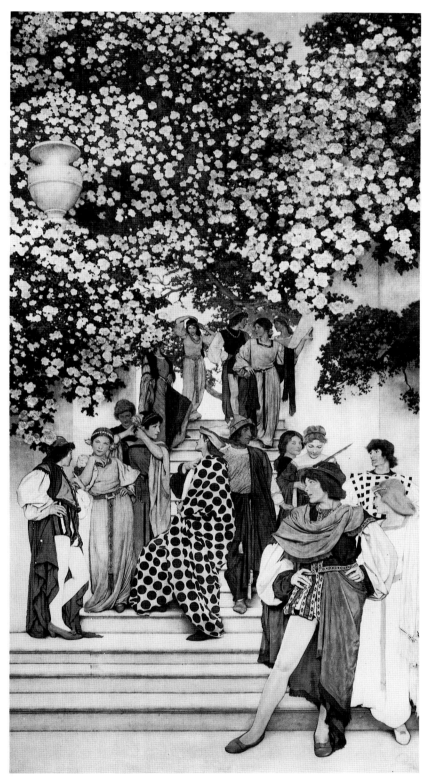

Fig. 6.21

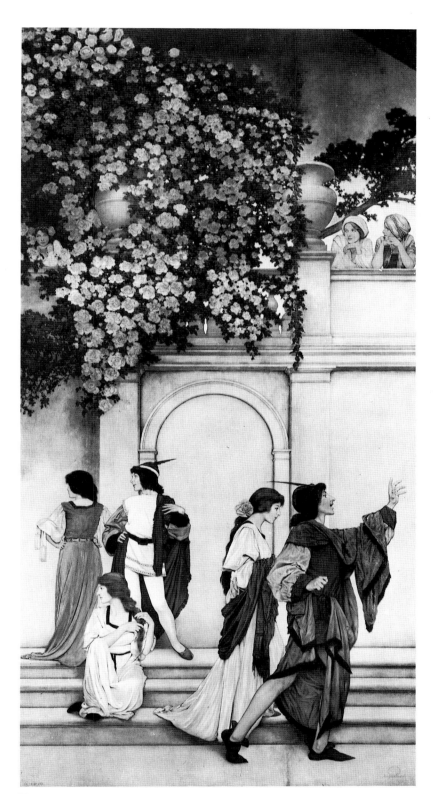

Fig. 6.22

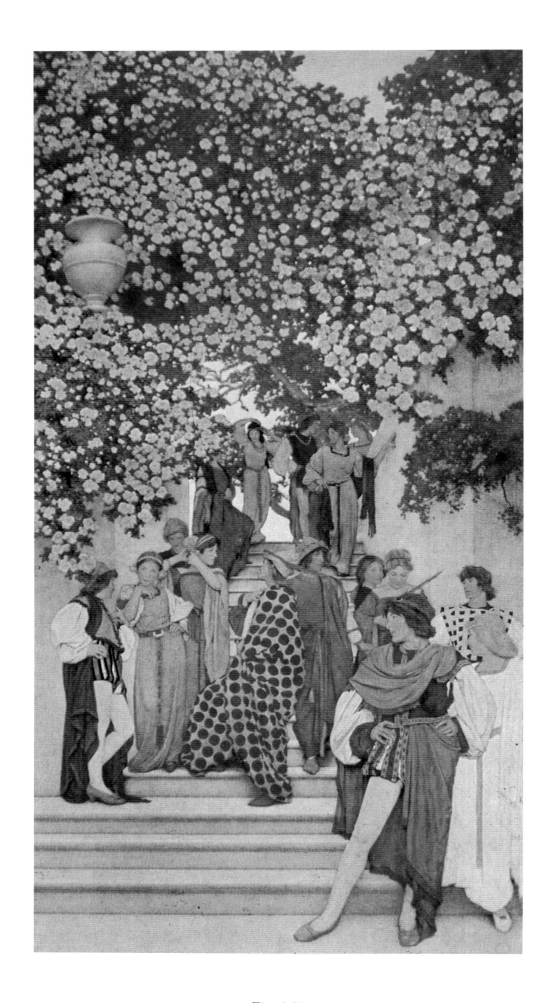

Fig. 6.21

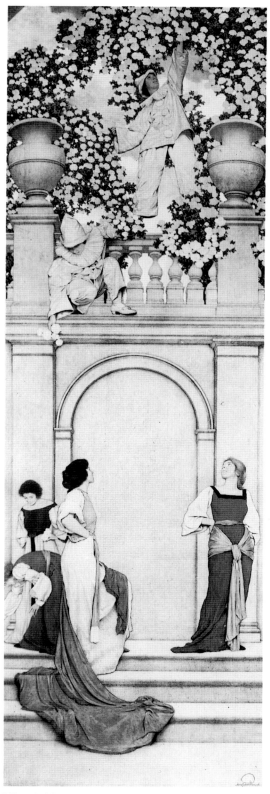

Fig. 6.23

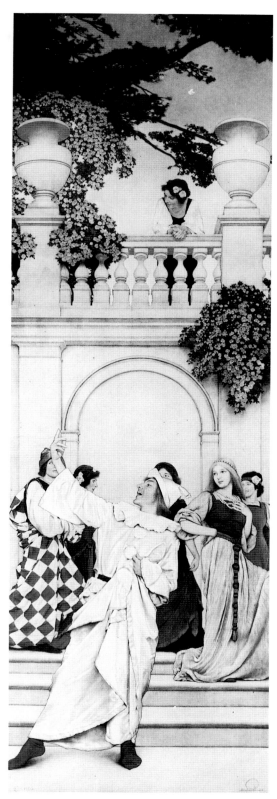

Fig. 6.24

143

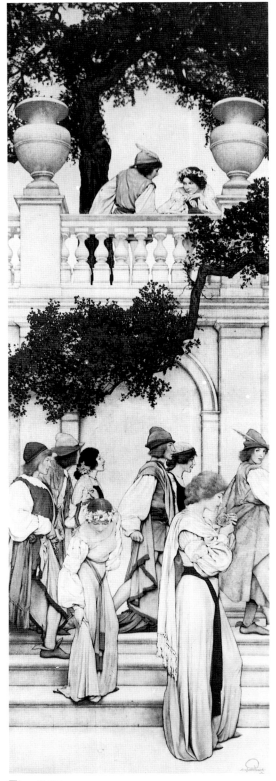

Fig. 6.25

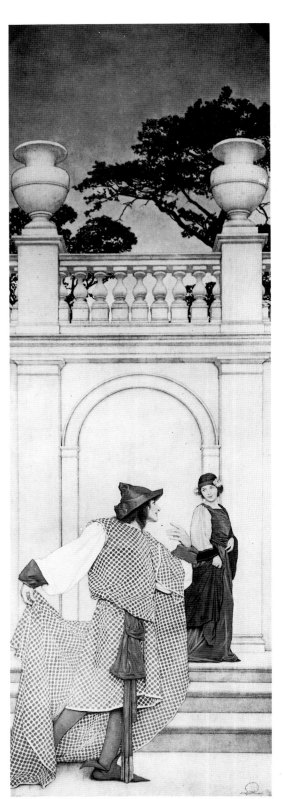

Fig. 6.26

144

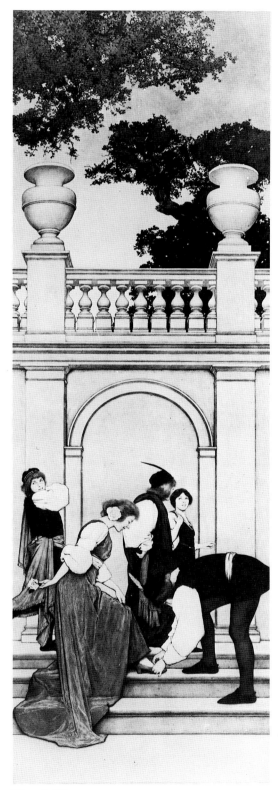

Fig. 6.27

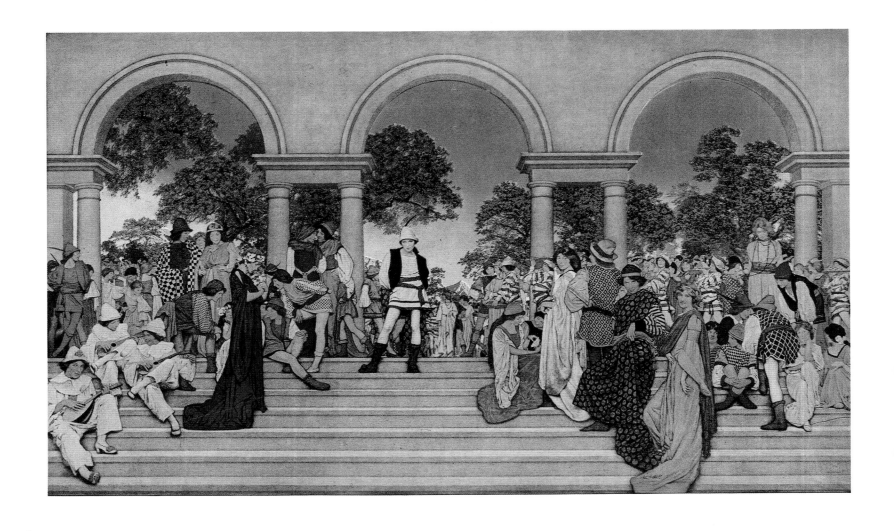

Fig. 6.28

List of Figures for Chapter 6

Florentine Fete panels collection of John W. Merriam, Philadelphia, Pennsylvania.
Black & white photos as well as all color transparencies of the *Florentine Fete* are courtesy of John W. Merriam, Philadelphia, Pennsylvania.

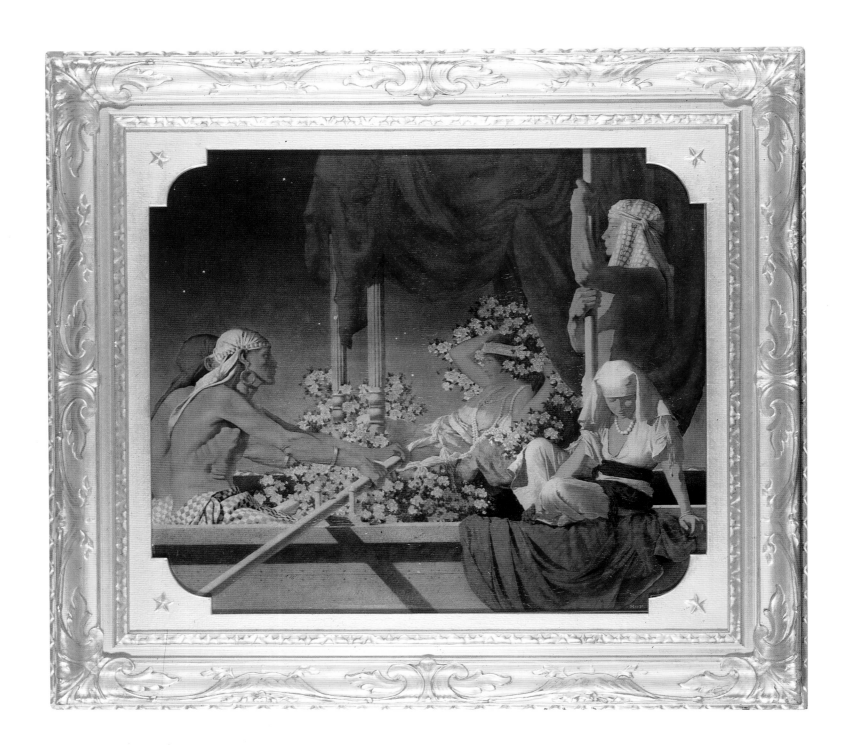

Fig. 7.2

THE HOUSE OF ART PRINTS
(1917–1937)

Parrish's success and his place in American art history evolved because the public's love for art reproductions grew with the refinement of color lithography at the turn of the century. With the new processes, reproductions of paintings became available at affordable prices.

Everything in Parrish's career seemed to fall into place with amazing fluidity. His first magazine cover (*Harper's*, 1895) came about because someone influential admired the work that he had completed for the Mask and Wig Club. This led to *Century's* commissions, which led to the books (*Italian Villas and Their Gardens* and *Arabian Nights*), which in turn led to the Southwest series, the Tanglewood series, then the *Collier's* commissions, the Curtis Publishing murals, and the Mazda calendars.

The artist's work with Reinthal and Newman's House of Art catapulted Parrish to the status of most-reproduced artist ever. No artist before or since has enjoyed the amazing popularity in print media that Parrish achieved. His association with the House of Art came about through a series of events that snowballed to a veritable avalanche. The events can be traced back to 1904, when the *Ladies' Home Journal*, to generate publicity for its 250th issue, announced a cover design competition with a first prize of $1,000. Six prominent illustrators participated. Among the others were Jessie Wilcox Smith and Harrison Fisher, who received second and third prizes, respectively. Parrish was awarded the coveted first prize for his painting *Air Castles*. Additional color reproductions of his paintings were offered to readers for ten cents. This was the beginning of what would become an avalanche of demand for Parrish prints.

Charles Scribner's followed by issuing color prints from Eugene Field's *Poems of Childhood*. The Dodge Publishing Company struck a deal with *Collier's* for some of the covers and reproductions that Parrish had done for them.

But it was not a publisher or magazine that finally convinced Parrish to engage the art market with paintings created for the purpose of reproduction as art prints. It was a candy manufacturer, Clarence Crane, who pointed the way. Crane asked Parrish to produce a painting that would convert his candy boxes into works of art (thereby raising the price of the candy). Each box would carry an order blank inside so that customers could send for additional reproductions of the paintings. Parrish painted the *Rubaiyat* (see fig. 7.1) in 1916, for the first of three candy boxes for Crane.

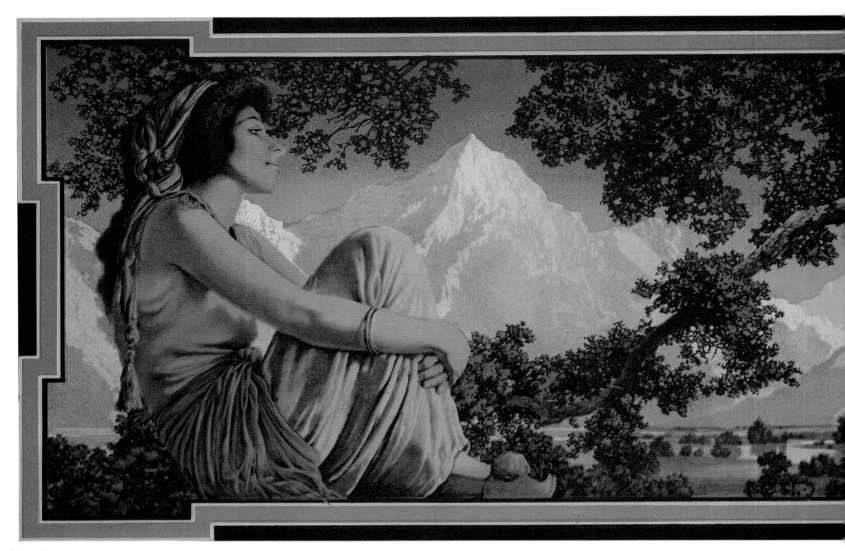

Fig. 7.1

Crane thought that he owned the reproduction rights because he had purchased the painting, and initially Parrish received no royalties for the first or even the second candy box, which reproduced the 1917 painting *Cleopatra* (fig. 7.2). Before he would undertake the third commission, Parrish announced to Crane that he would not continue with the arrangement. He insisted on latitude in choosing his subject, plus fifty percent royalties for each print sold (the arrangement under which he had allowed the magazines to sell his prints). Crane consented and the third candy box top was graced with the image of the painting that, next to *Daybreak,* brought Parrish his greatest fame and revenues. The painting was *Garden of Allah* (fig. 7.3).

The candy boxes inadvertently played a major role in Parrish's ability to give up

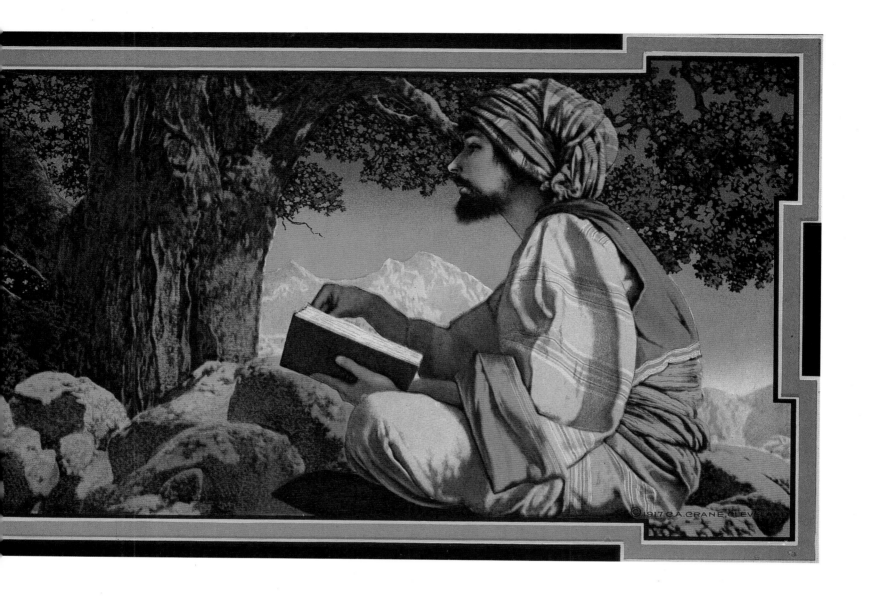

advertising to concentrate on landscape painting. Parrish received nearly $50,000 in royalties from the sale of prints of those three subjects. Crane's little order blanks for the Parrish prints created an unprecedented demand for his reproductions, a demand which gained gigantic momentum.

The House of Art asked to reproduce *Garden of Allah, Rubaiyat,* and *Cleopatra,* becoming in 1920 the exclusive publisher of all Parrish works designed for color reproduction for the art print market. (This was when Parrish was still creating the calendars for General Electric Mazda lamps.) The next two prints after the Crane reproductions were two *Life* covers: *Morning* and *Evening* (fig. 4.21). Anxious for another, larger print while awaiting the completion

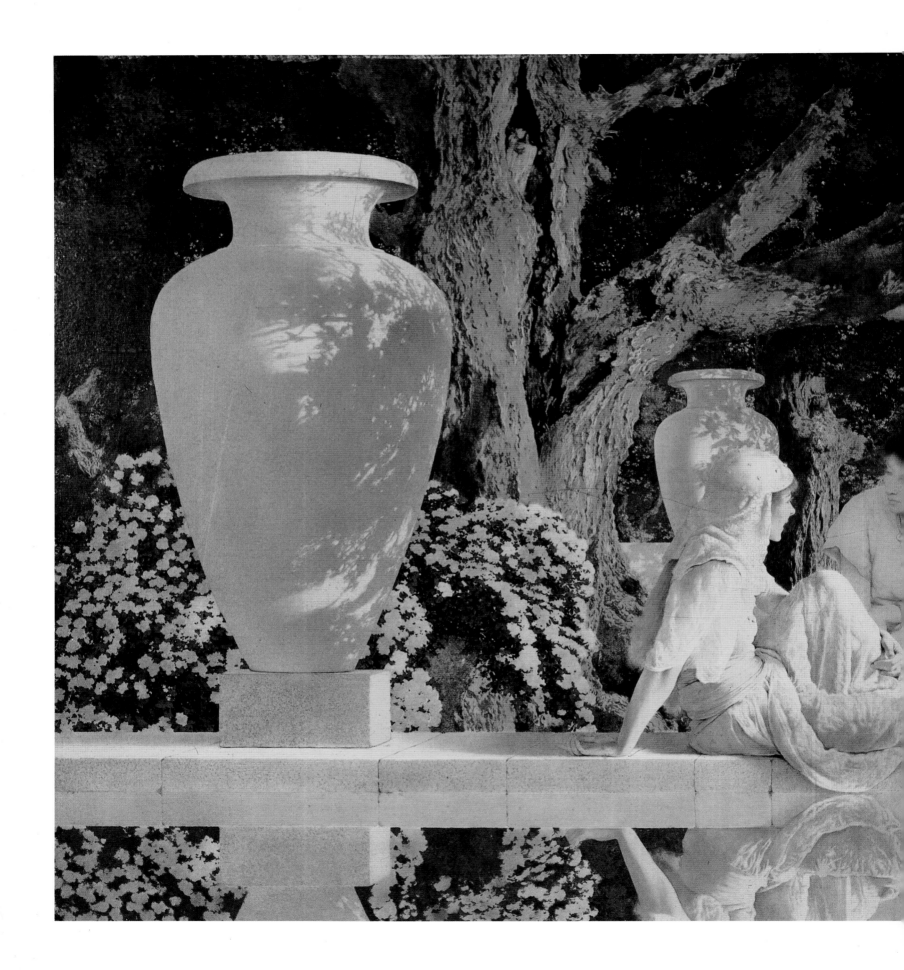

Fig. 7.3

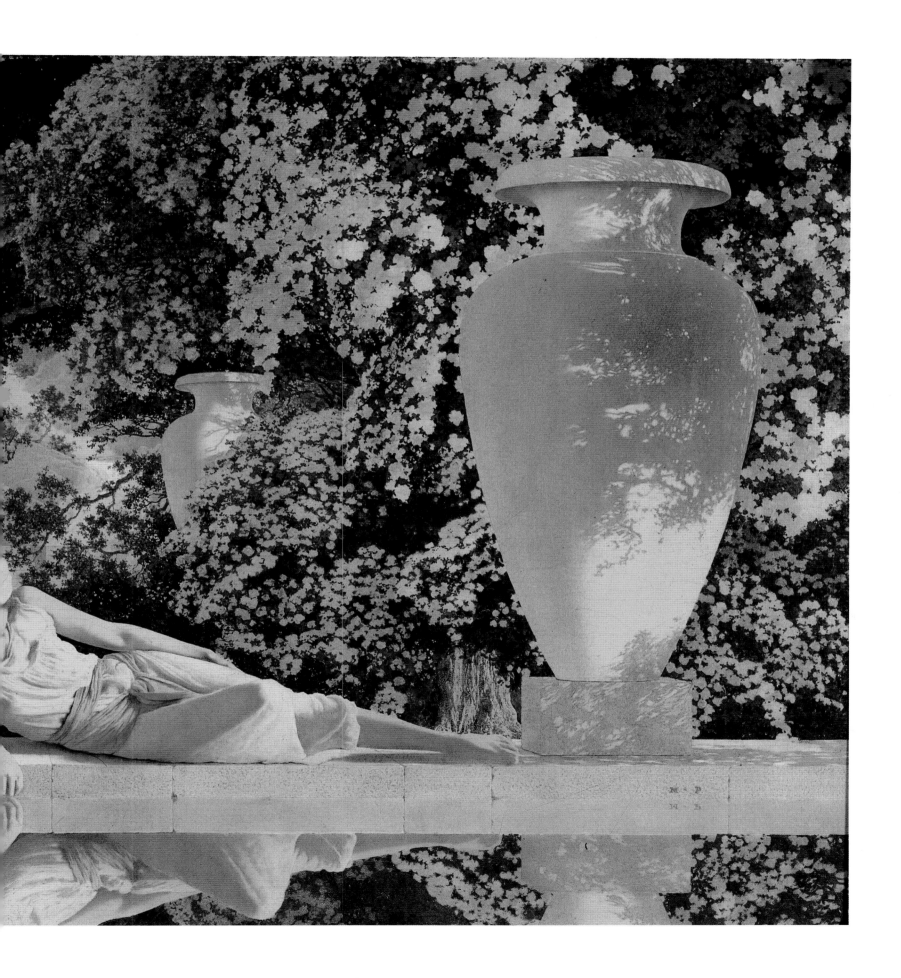

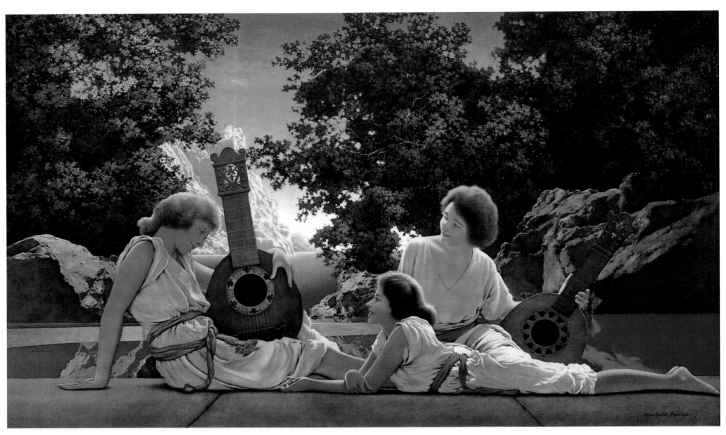

Fig. 7.4

of what was to be Parrish's magnum opus, the House of Art received permission from the Eastman Theatre in Rochester to reproduce the mural *Interlude* (fig. 6.5) in a horizontal version titled *Lute Players* (fig. 7.4); Parrish and the Eastman Theatre would split the royalties.

The first painting created exclusively for the House of Art was *Daybreak,* discussed below. Other major prints done for the House of Art that belong among Parrish's masterworks are *Wild Geese* (1924), *Stars* (1926), *Hilltop* (1927), and *Dreaming* (1928; see figs. 7.5–7.8). *Dreaming* was another example of a piece that Parrish finished and later changed by painting out its human subject, turning it into a pure landscape. *Dreaming/October,* as it is now called (fig. 10.1), remains in its dual states a unique example of his technique. He had

originally painted a small nude sitting beneath a large tree (the House of Art believed that refined nudity enhanced the sale of color reproductions). Decades later, Parrish, never having been pleased with the figure, painted out the right half of the composition. The painting was renamed *Dreaming/October* in honor of the landscape that Parrish had in mind in the transformation of the work, though it remained unfinished at the time of his death.

The House of Art issued nineteen reproductions for Parrish between 1917 (*Rubaiyat*) and 1937 (*Twilight*); their editions included prints that had been published earlier in magazines and books, such as *Romance, The Prince,* and *The Page* from *Knave of Hearts,* and four calendars, *Reveries, White Birch, Tranquility,* and *Twilight.*

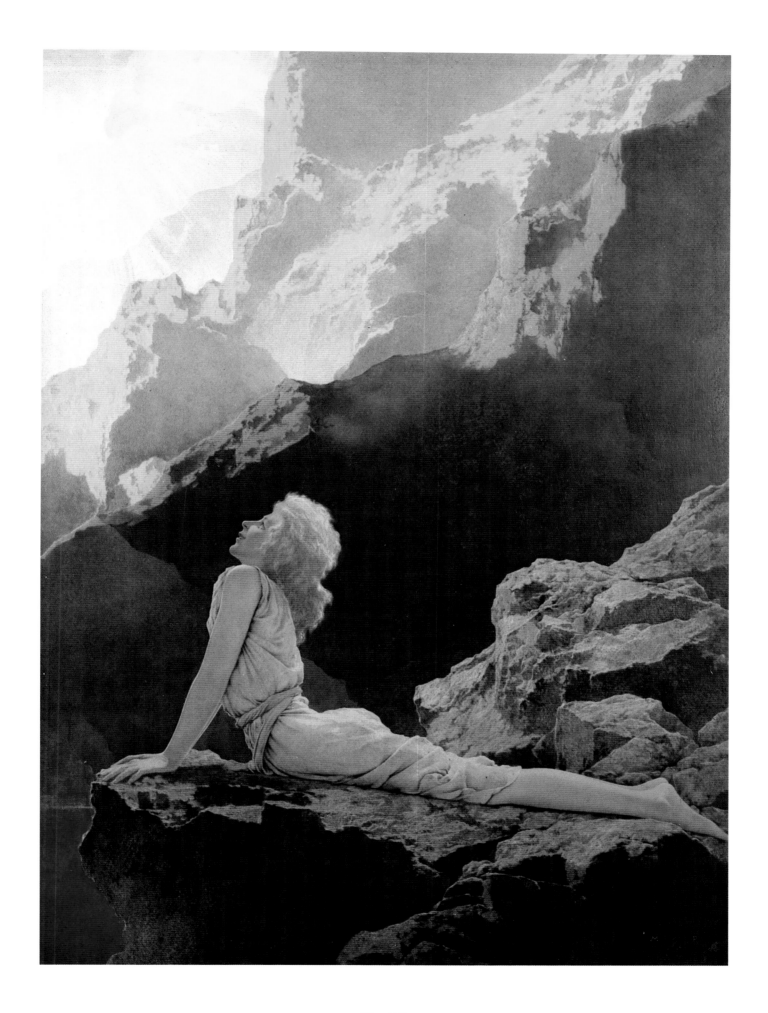

Fig. 7.5

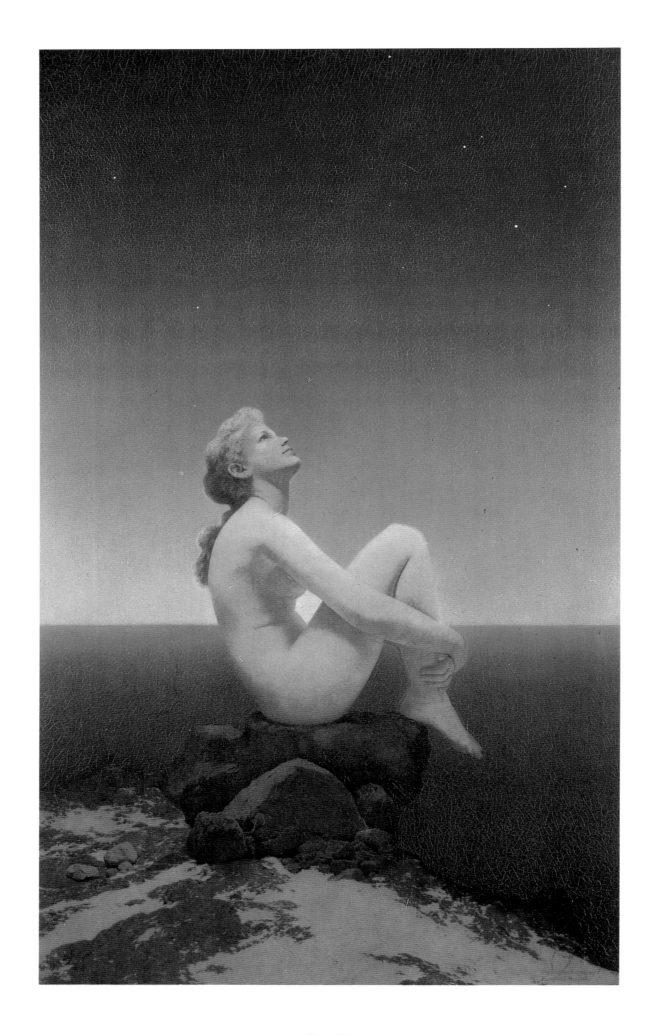

Fig. 7.6

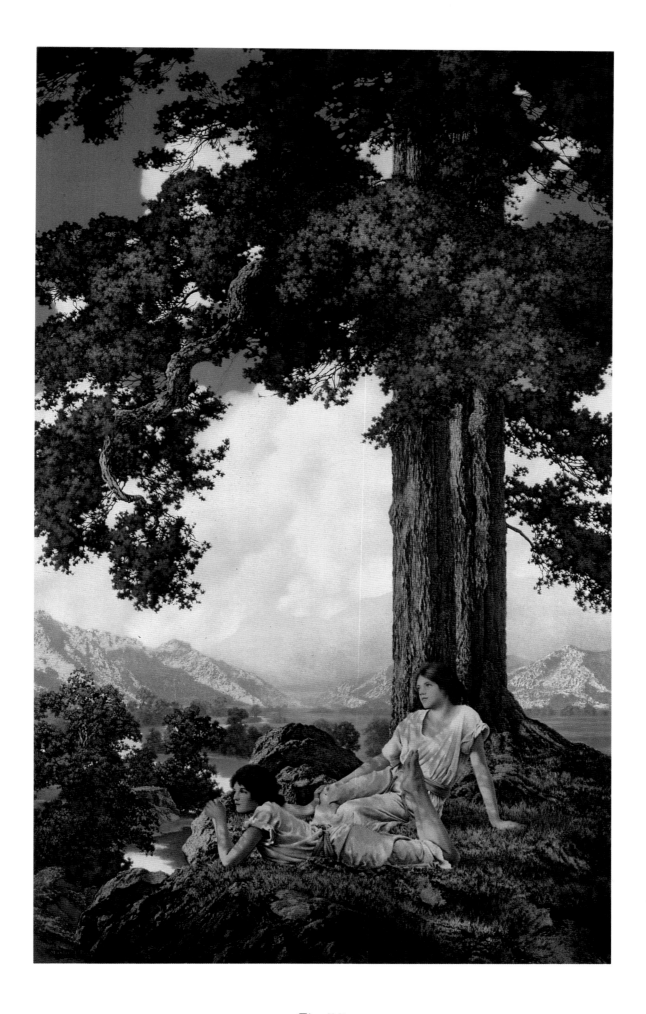

Fig. 7.7

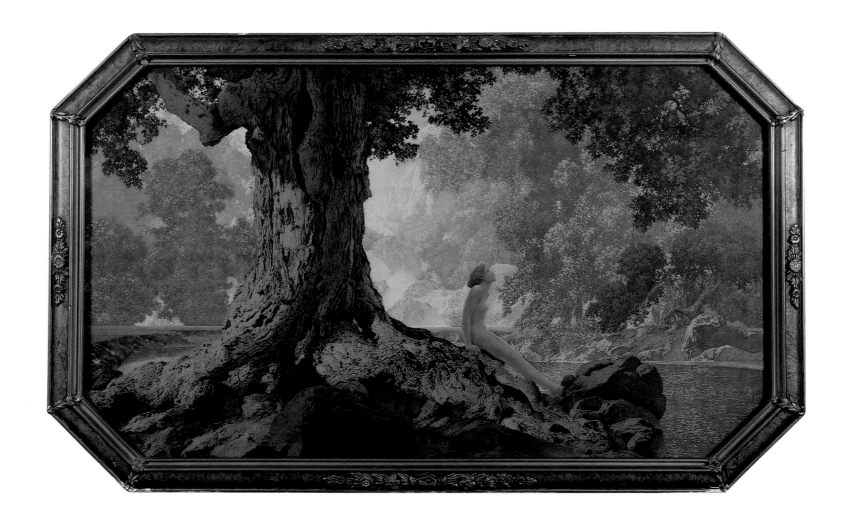

Fig. 7.8

Fig. 7.9

Fig. 7.10

THE MAGNUM OPUS

The first painting that Parrish targeted for the House of Art, to be created for them exclusively as a reproduction piece, took almost two years to complete (fig. 7.12). In March 1921 the artist wrote to the publishers Reinthal and Newman, "as to the 'great painting,' its beautiful white panel is always on the wall before me, and I am thinking great things into it. I have thought so many beautiful things into it that it ought to make a good print just as it is. Have patience!"[27]

Early in the work, Parrish had decided to paint a scene of three young women by a beautiful lake with a spectacular backdrop of mountains, framed by two columns. The models were Jean Parrish, the artist's ten-year-old daughter; her friend Kitty Owen (the granddaughter of William Jennings Bryan) as the reclining figure; and

Sue Lewin as a third figure, making a perfect symmetrical composition using Jay Hambidge's theory of Dynamic Symmetry.[28] There are photographs of the initial cutout of Susan in the third figure's pose as well as an early watercolor of the three figures (see figs. 7.10–7.11). Another photograph taken by Parrish shows Susan reclining in Kitty Owen's pose.

Because of the strained relationship between Parrish and his wife, it was natural for their daughter to resent Susan Lewin's presence in the painting of *Daybreak*. Jean viewed Susan as a member of her mother's staff who was always at her father's beck and call. The Parrish boys probably took little note, but Parrish's young daughter was more aware than her brothers of the time her father spent with Susan. Although no mention of impropriety is known to have been made, it was probably difficult for Jean

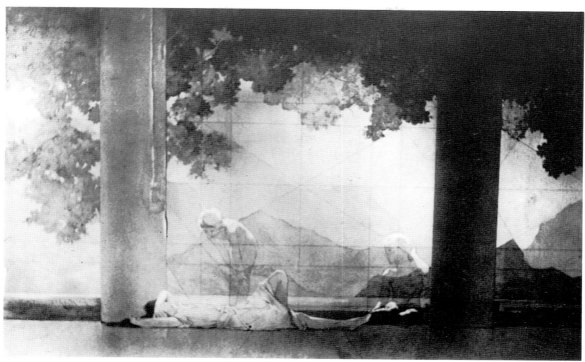

Fig. 7.11

to accept the living arrangements, with Lydia and the children in the main house, Parrish and Susan in the studio. Jean could not but notice Lydia's discomfiture.

Anne Bennett Parrish, Dillwyn Parrish's wife, was quoted recently by the *New York–Pennsylvania Collector* in an article on Parrish: "Sue lived in the maid's quarters in the main house for forty years. I realized that Sue was his mistress, but followed family custom by being discreet, not telling my own children until they were adults." Her son, Gordon, Dillwyn's adopted child, describes in the same paper the Parrish house, which he visited as a youngster: "I remember another secret passageway John [Dillwyn] showed us in the main house, behind the door. It went from the master bedroom up a back stairway to the maid's [Sue's] quarters. Maxfield never seemed to mind that we would run

at galloping speed throughout the hidden passageways."[29]

Jean must have been instrumental in Parrish's final decision to strike the third figure, of Susan, from *Daybreak*. Parrish had the last laugh, though. Although Susan's face is not depicted in the painting, her body still is; the reclining figure is hers, with the facial features of Kitty Owen superimposed.

When the painting was finished, the job of reproducing it went to Brett Lithographic Company, in Long Island, New Jersey, in April 1923. Parrish went to New York in July to review the proofs of the large (18″ by 30″) reproduction of *Daybreak*, making sure that the final results measured up to his expectations.

The popularity of the color reproductions went beyond even Parrish's or the House of Art's wildest expectations. When-

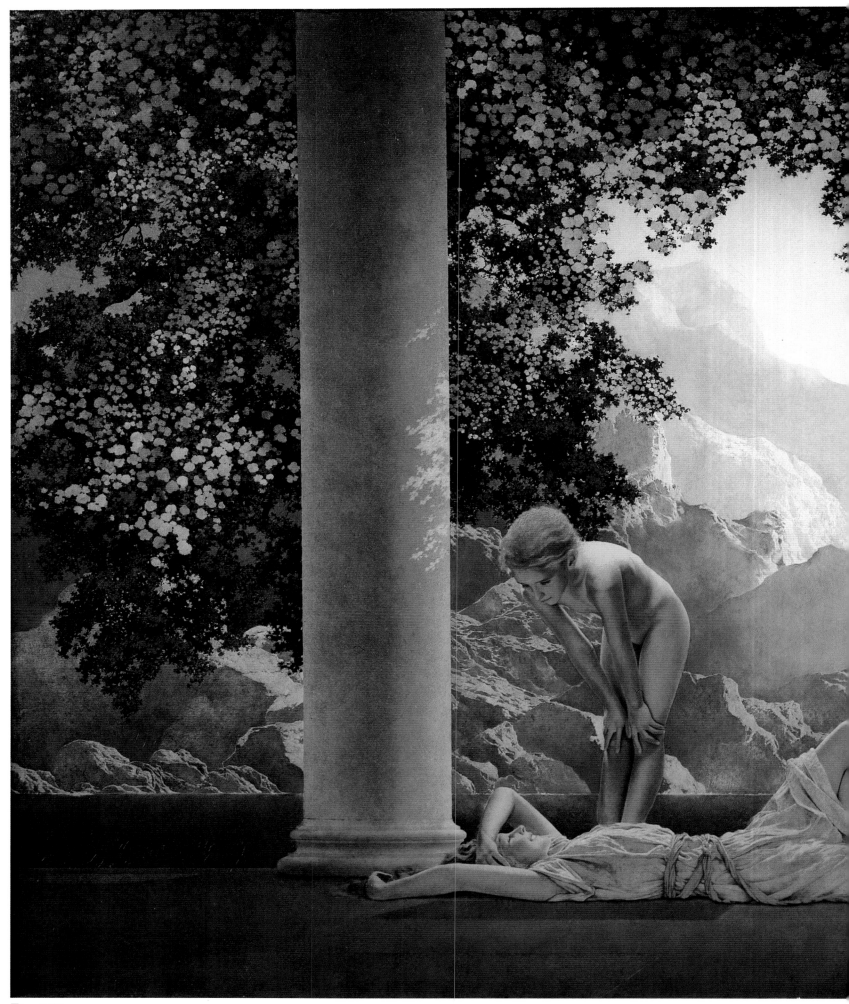

Fig. 7.12

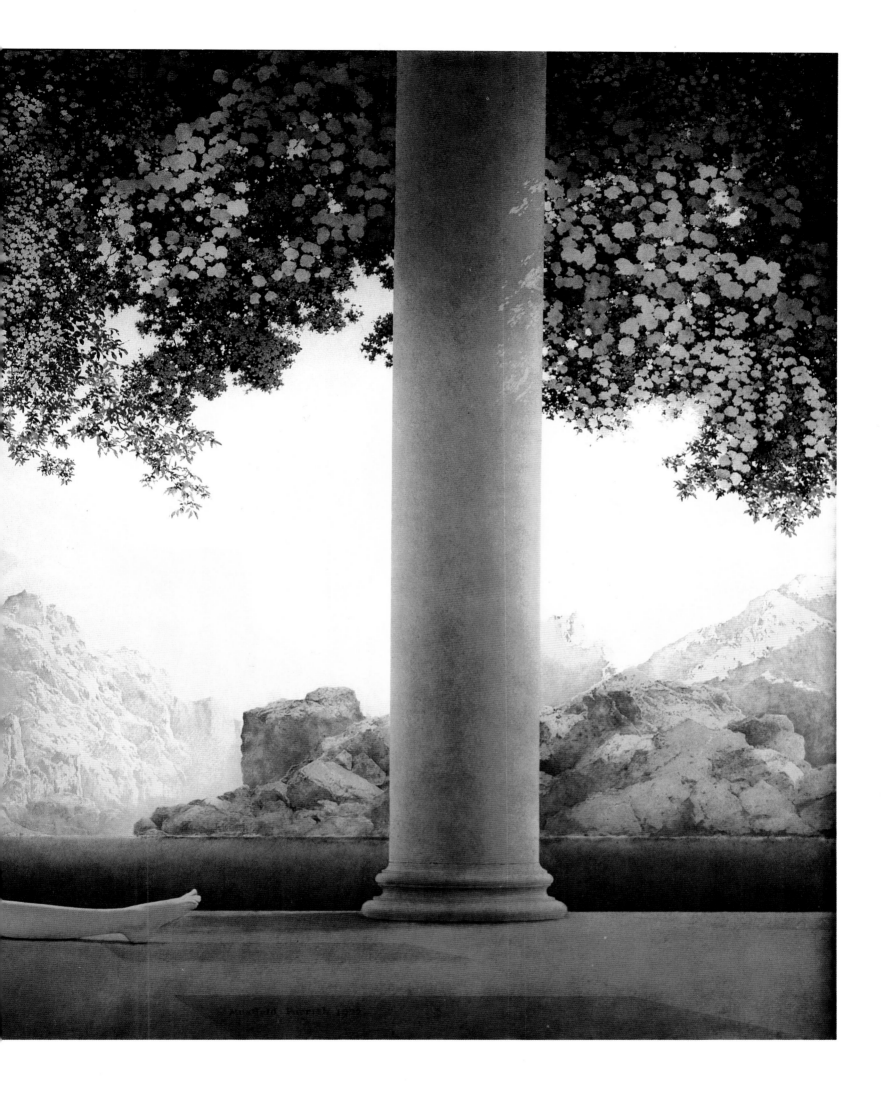

ever the print was displayed in storefronts, crowds would gather to gape, and admire, and buy. According to some of the comments quoted in the Parrish Museum Oral Histories, Parrish received fan mail from as far away as South Africa.

At the end of 1923, after *Daybreak* had been on the market for only a few months, Parrish's royalties on that print alone exceeded $25,000. This escalated until in 1925 his royalties amounted to $75,000 for that year. Considering that a house could be purchased for $2,000 at the time, $75,000 was a handsome sum. The House of Art estimated that one out of every four households in America had purchased the *Daybreak* print.

In 1925, the Scott and Fowler Galleries in New York held a prestigious sale of Parrish oils, among them the famous *Daybreak*. All fifty paintings shown in the exhibition were sold. *Daybreak, Garden of Allah,* and *Romance* each sold for $10,000—a record at the time for the work of a living American artist.

One of the art world's best-kept se-crets began at that time: Who had purchased *Daybreak*? Where had it gone? The Scott and Fowler Galleries had been sworn to secrecy. If Parrish knew who had purchased it, he never let anyone know. For nearly fifty years the whereabouts of the magnum opus were unknown to the world.

News of the sale and the disappearance of the painting caused a great stir, which, in turn, sold more and more reproductions. If people could not see the original, at least they could buy the reproductions. Millions of prints were sold. *Daybreak* became the most-reproduced painting in the history of art . . . and yet its whereabouts remained a mystery.

Almost exactly fifty years later, I was fortunate beyond belief. I came across the fabled painting, and miracle of miracles . . . I was able to purchase it. But that part of the story of *Daybreak* belongs in another chapter, so it must keep until then. Suffice it to say that Parrish's term "magnum opus" could not be considered a misnomer: *Daybreak* would become one of the world's most popular paintings.

List of Figures for Chapter 7

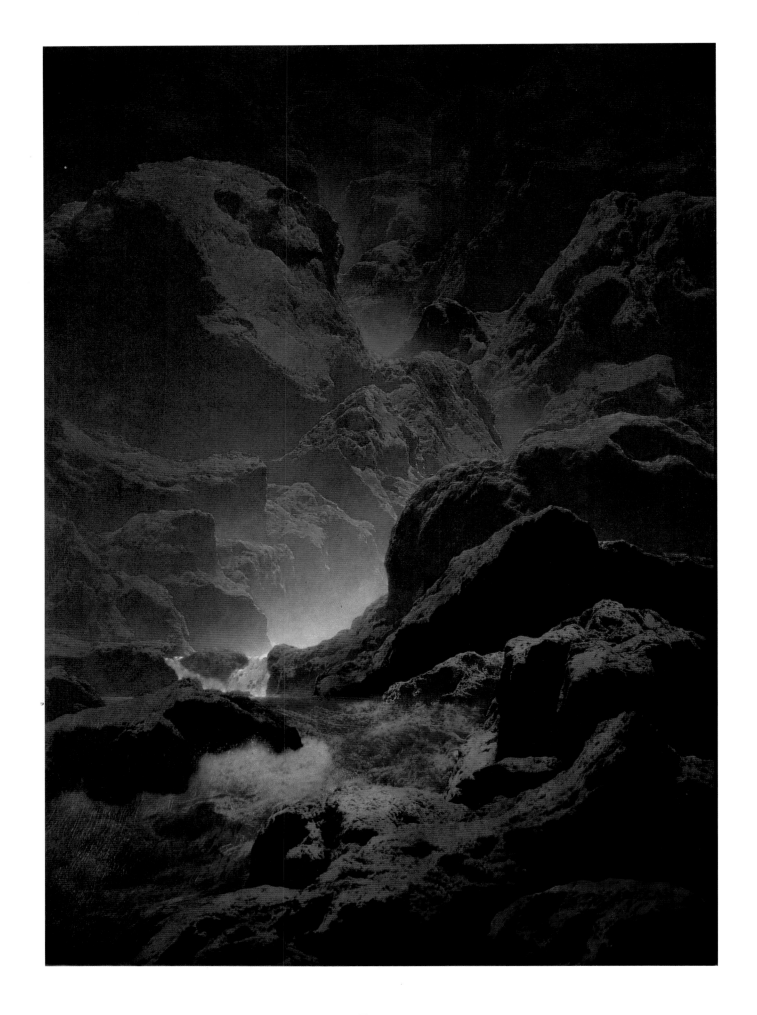

Fig. 8.1

L A N D S C A P E S :
T H E F I N A L W O R K S
(1 9 3 4 - 1 9 6 2)

Parrish's skill as a colorist developed with his interest in landscapes from very early on. The dramatic hues of the Southwest colored the palette in his mind for the rest of his life. In the *Great Southwest* series, in the *Villas,* in the advertising designs, even in the Mazda calendars, the landscape—always his first love in painting—is seen even if only tucked away in a corner of a painting or glimpsed through an open arch or a window.

During the time when Parrish was painting for Edison Mazda, the firm of Brown and Bigelow (a calendar and greeting card company in St. Paul, Minnesota) approached him to do another series of calendars, with summer and winter scenes of his own choosing. Parrish was sorely tempted, but he felt an obligation to remain with the Edison Mazda people until 1934, when the last calendar, *Moonlight,* was issued.

The transformation of *Moonlight* in 1934, from a figurative painting and advertisement into pure, magnificent landscape (fig. 8.1), marked the beginning of Parrish's transition to a pursuit of unabashed joy in landscape painting. "He contacted me by a note," wrote Kathleen Philbrick Read, the model who had posed for *Moonlight,* "and

said that he had decided to paint my figure out and make the scene totally into a landscape. It was sure nice of him to let me know, beforehand, though."[30]

The giant figure in *Atlas,* 1907, from *Tanglewood Tales* was painted out in 1935. Replacing the figure of the legendary Atlas, a magnificent oak was painted against the golden burnished sky (fig. 8.15). The upper part of the painting was cut away and the canvas was mounted in a smaller, horizontal frame. It was retitled *Atlas Landscape* and hung in Mr. Parrish's studio until the time of his death.

Dreaming, painted in 1928 (fig. 7.8), also lost its little nude, in 1960. The right-hand side of the painting was just taking form under its new name, *Dreaming/October* (fig. 7.9), when Parrish inexplicably stopped, leaving the blue outline of a huge tree suspended as a lasting study for all students of his art.

In 1934, at the age of sixty-four, Parrish began new work as a landscape artist when he accepted the offer from Brown and Bigelow. His first calendar painting for them was titled *Peaceful Valley;* it depicted the faraway spires of a country church in Windsor, Vermont, across the mirrorlike stillness of the Connecticut River. The giant elm in this painting reveals Parrish's great love of trees, and his skill in capturing the natural

Fig. 8.6

splendor all about him. His comment, "Only God can make a tree, true enough, but I'd like to see Him paint one," was widely quoted during this period.[31]

During the last thirty years of his life, Parrish gave full rein to his preferred subject. From 1934 to 1963 (although Parrish had painted it earlier, the last of the calendars was published in 1963), Brown and Bigelow reproduced fifty landscape paintings. Parrish painted nearly fifty more that were never published, including *Arizona* (1950), *New Hampshire Landscape* (1944), *Ottaqueeche River* (1947; fig. 8.9), *Autumn Brook* (1948), and *River at Ascutney* (1952).

His landscapes found an instant response in the viewing audience. Clair Fry of Brown and Bigelow wrote to Parrish in 1955 detailing the elements that made a picture a good calendar subject: "The three pictures that stacked up the greatest volume were 'Mill Pond' (1948), 'Evening Shadows' (1953) and 'Evening' (1947). In comparing these three prints with all the rest of them, the thing that impresses me about them is the strength and simplicity of the color and value patterns.... The one thing I am

really sure of is that a successful calendar picture must have strength and simplicity that catch the attention and are comprehended at a glance. This is the one factor that is evident in every successful calendar picture in our experience."[32]

A number of subjects that Parrish painted captured the tranquil, idyllic settings of the spectacularly picturesque New England area where he lived, such as the Freeman Farm, which he immortalized by painting repeatedly. Another was *Little Brook Farm,* a 1942 oil which Brown and Bigelow retitled *Sunup.* Parrish liked the house so much that he constructed a model of it in his studio (fig. 8.6).

Parrish wrote in 1950: "Once in a while, it is fun to make a scale model of a farm with its group of buildings: one especially at the foot of the hill, an attractive courtyard facing the road. Then it can be placed in any light desired, with shadows cast as they should be when I get ready to paint it . . ."[33]

Once Fry asked Parrish to put a little more excitement into a bucolic farm landscape that Parrish was painting, to which

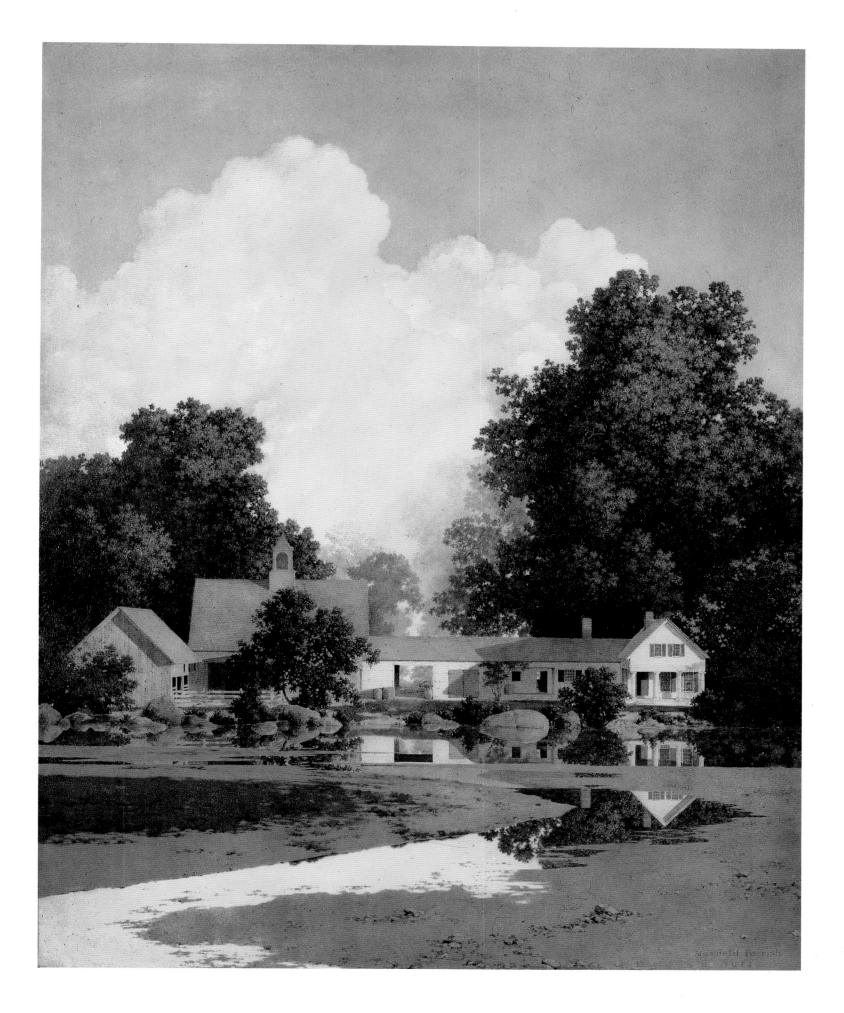

Fig. 8.5

the octogenarian testily replied: "The only way I can make this picture more exciting is to set this here barn on fire."[34]

Parrish frequently said that he put too much into his landscapes because he liked painting too much to stop. When in 1952 he was asked to sum up his philosophy on realism as it applied to landscape painting, he wrote:

> *You should mention "realism": that, I think, is a term which has to be defined: realism should never be the end in view. My theory is that you should use all the objects in nature, trees, hills, skies, rivers and all, just as stage properties on which to hang your idea, the end in view, the elusive quality of a day, in fact all the qualities that give a body the delights of out of doors. You cannot sit down and paint such things: they are not there, or do not last but for a moment. "Realism" of impression, the MOOD of the moment, yes, but not the realism of THINGS. The colored photograph can do that better. That is the trouble with so much art today, it is factual, and stops right there.[35]*

Parrish's last landscape was a beautiful, jewel-like oil measuring 10″ by 12″. A small farmhouse sits on top of a hill; evening shadows descend on it. Within, one brave little light shines in a single window. Titled *Getting Away from It All,* never published, the last painting completed by the ninety-one-year-old artist perhaps reflected Parrish's sentiments and the realization that his life was drawing to a close.

Maxfield Parrish, Jr., told me that his father's eyesight remained strong even to an advanced age, but that he stopped painting because his hands trembled, preventing his brushes from accomplishing the minute, intricate details his mind and talent commanded.

Out of Parrish's one hundred landscapes I have chosen the following (listed chronologically) to be included among his masterworks. Before listing them, I call to mind an anecdote about one of the paintings. I had been asked to appraise a Parrish oil that was going to be brought in by a lady who sounded over the phone as if she might be somewhat elderly. When the appointed time came, in walked a very gracious individual in her early eighties, accompanied by a very solicitous grandchild carrying a wrapped picture. When I opened it, I saw the magnificent painting *Twilight* (1935), considered by many to be one of Parrish's most popular calendar subjects. The woman said, "I bought this painting for $3,000 during the thirties. It was probably an entire year's salary for me at that time. Everybody thought I had lost my mind to spend all my teacher's salary on a painting, but I wanted it more than any other thing I ever bought. I have enjoyed it every day since then. Everyone who has visited with me has also benefited from that enjoyment. Now I want my grandchildren to have something that has given me such singular pleasure. I want to pass this painting down to them while I'm still around to enjoy their satisfaction."

The granddaughter in tow nodded her agreement happily. Both women were staggered to find how much the painting had increased in value. In 1978 I appraised it for them at $35,000. Today it is easily worth $175,000.

I have been privileged to own, sell, or display many of the major Parrish landscapes. These are my choices for the masterworks:

Moonlight, 1932 (fig. 8.1)
Twilight, 1935 (fig. 8.2)
Old White Birch, 1940 (fig. 8.3)
New Hampshire Winter, 1940 (fig. 8.4)
Sunup, 1942 (fig. 8.5)
Evening, 1944 (fig. 8.7)
Millpond, 1945 (fig. 8.8)
Ottaqueeche River, 1947 (fig. 8.9)
Winter Sunrise, 1949 (fig. 10.1)
Evening Shadows, 1950 (fig. 8.10)
Hunt Farm, 1951 (fig. 8.11)
White Birches in the Snow, 1952 (fig. 8.12)
Sunlight, 1958 (fig. 8.13)

Like the artists Albert Bierstadt, Charles Moran, and Frederic Church, Maxfield Parrish has left an indelible mark, a brilliant page in American landscape painting, a chapter that will be long remembered.

In the last years of his life, from 1964 to 1966, Parrish employed a live-in nurse. He refused to be moved from his beloved Oaks. On March 30, 1966, he died quietly. He passed away on a lovely early spring day with crocuses poking their heads bravely through the vestiges of a late snowfall and the sky tinged with the lovely palette he was so fond of depicting in his beloved landscapes. It was as if nature itself were bidding a last salute to one who had so enjoyed painting it.[36]

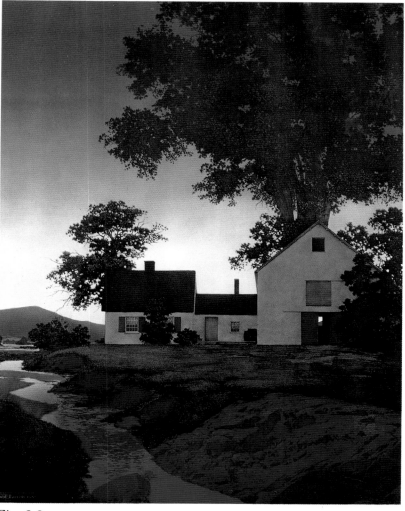

Fig. 8.2

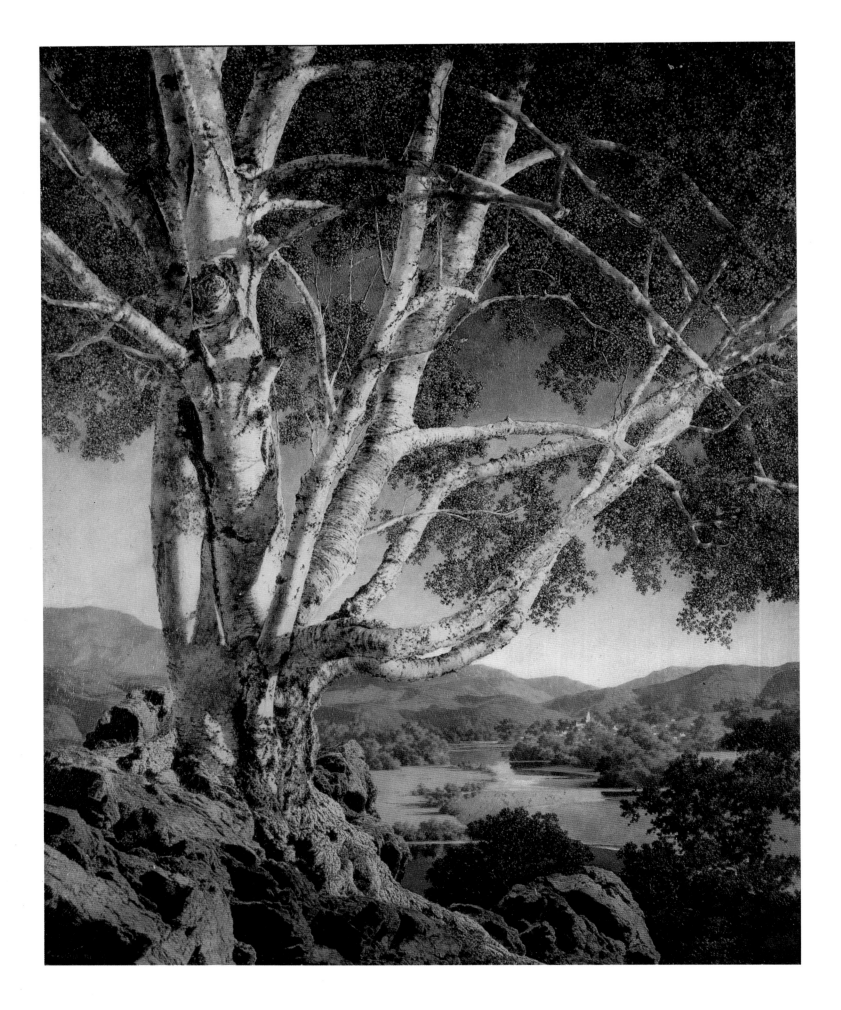

Fig. 8.3

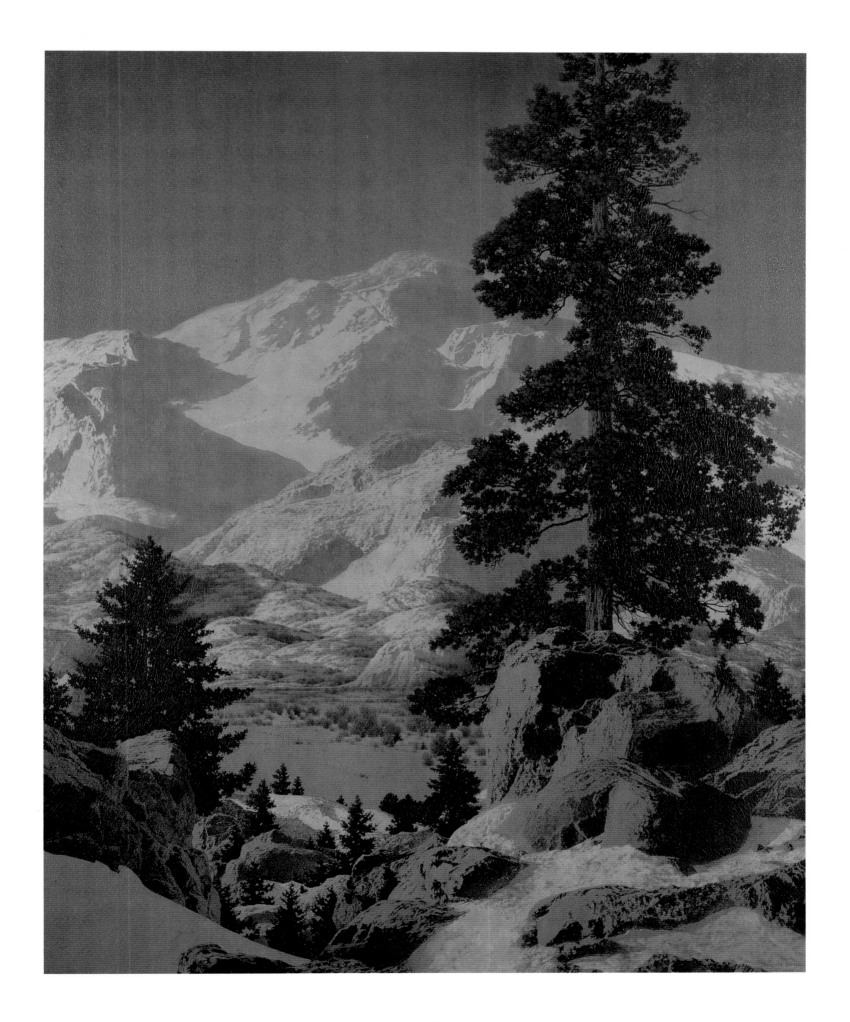

Fig. 8.4

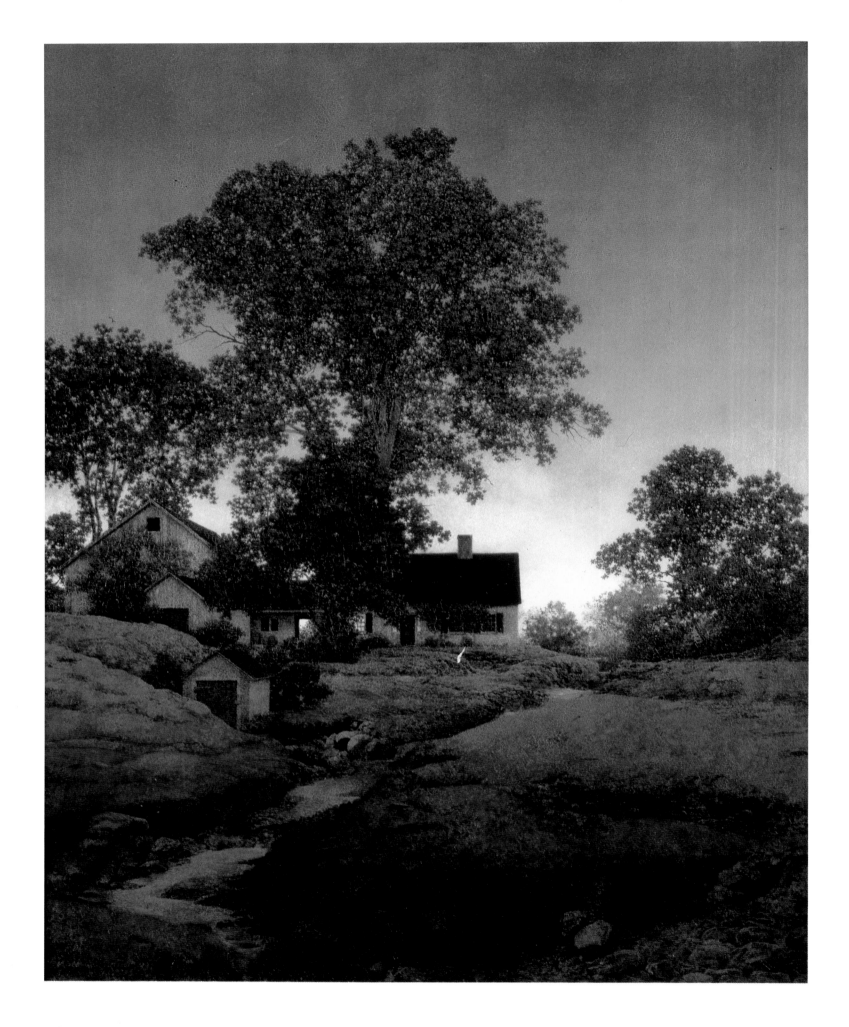

Fig. 8.7

174

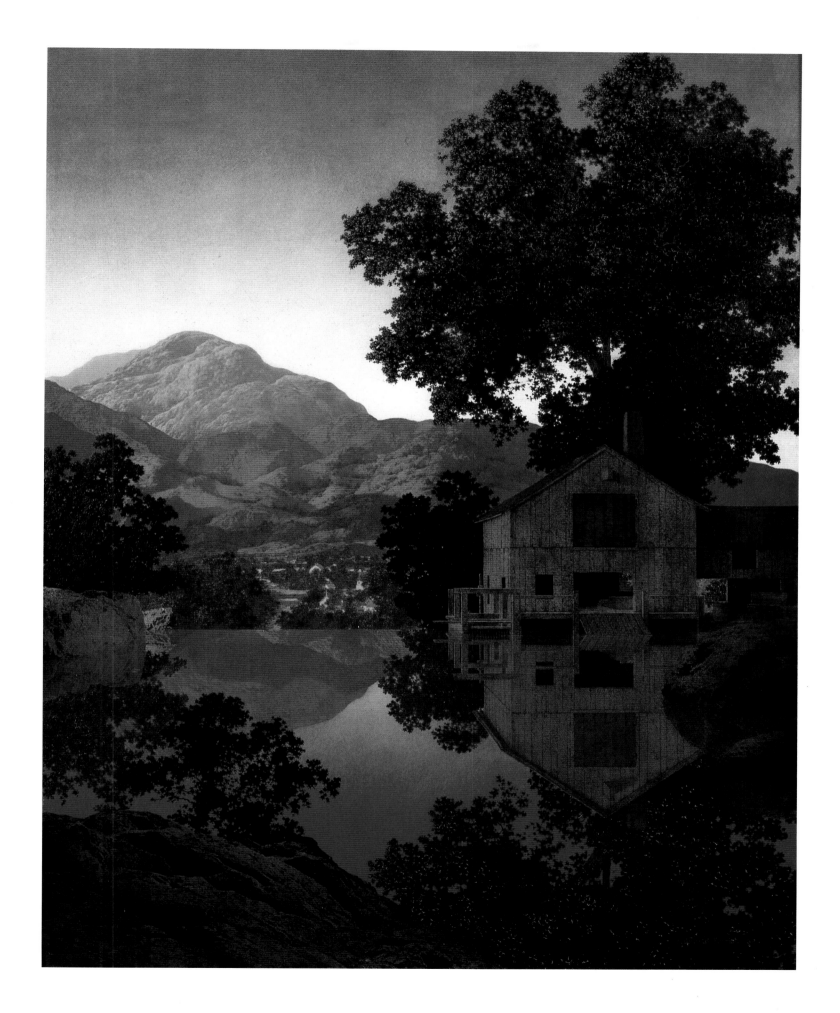

Fig. 8.8

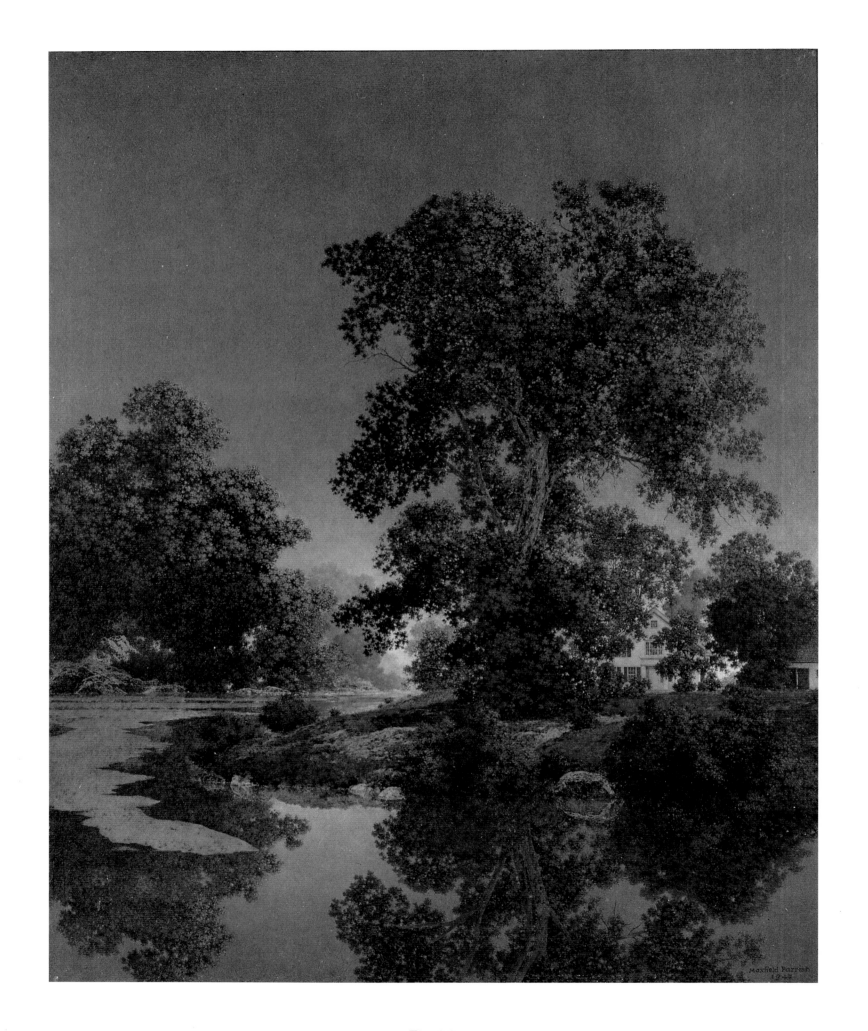

Fig. 8.9

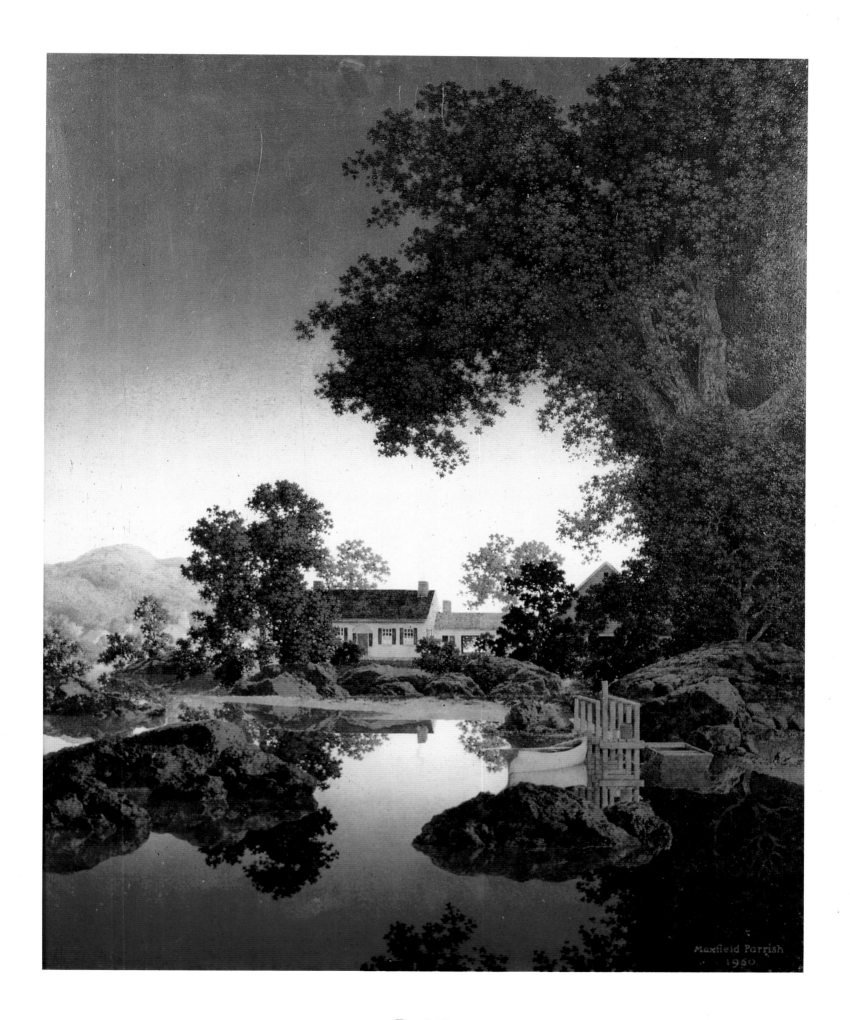

Fig. 8.10

177

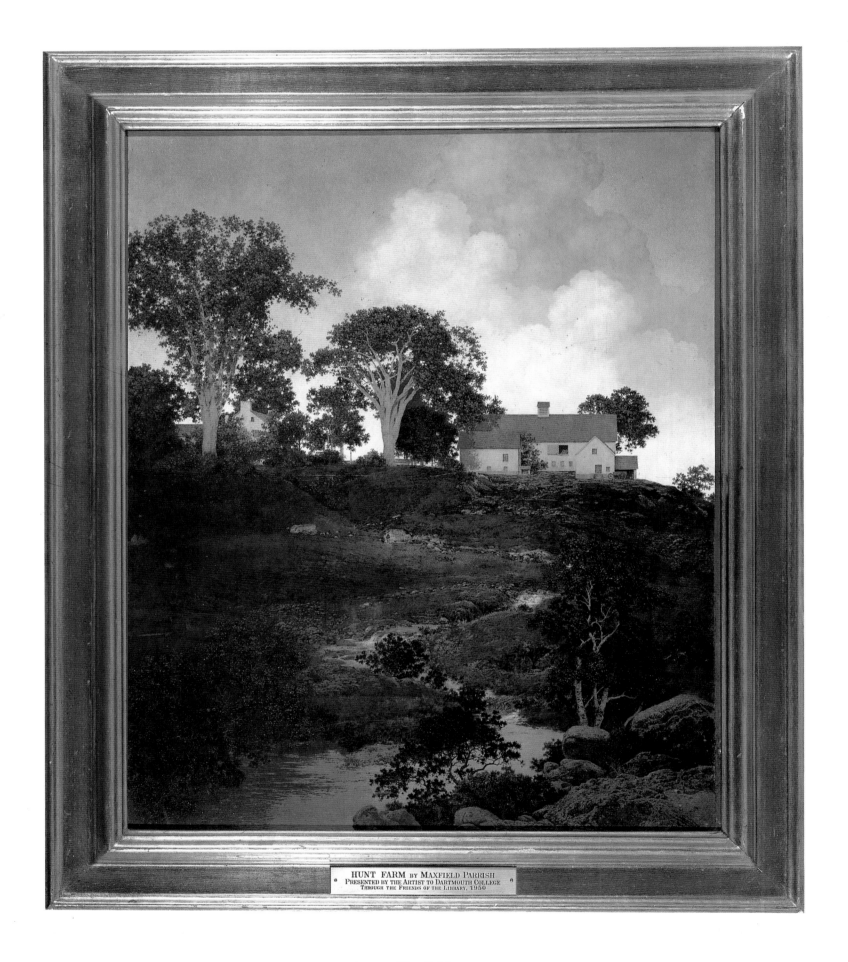

HUNT FARM BY MAXFIELD PARRISH
PRESENTED BY THE ARTIST TO DARTMOUTH COLLEGE
THROUGH THE FRIENDS OF THE LIBRARY, 1950

Fig. 8.11

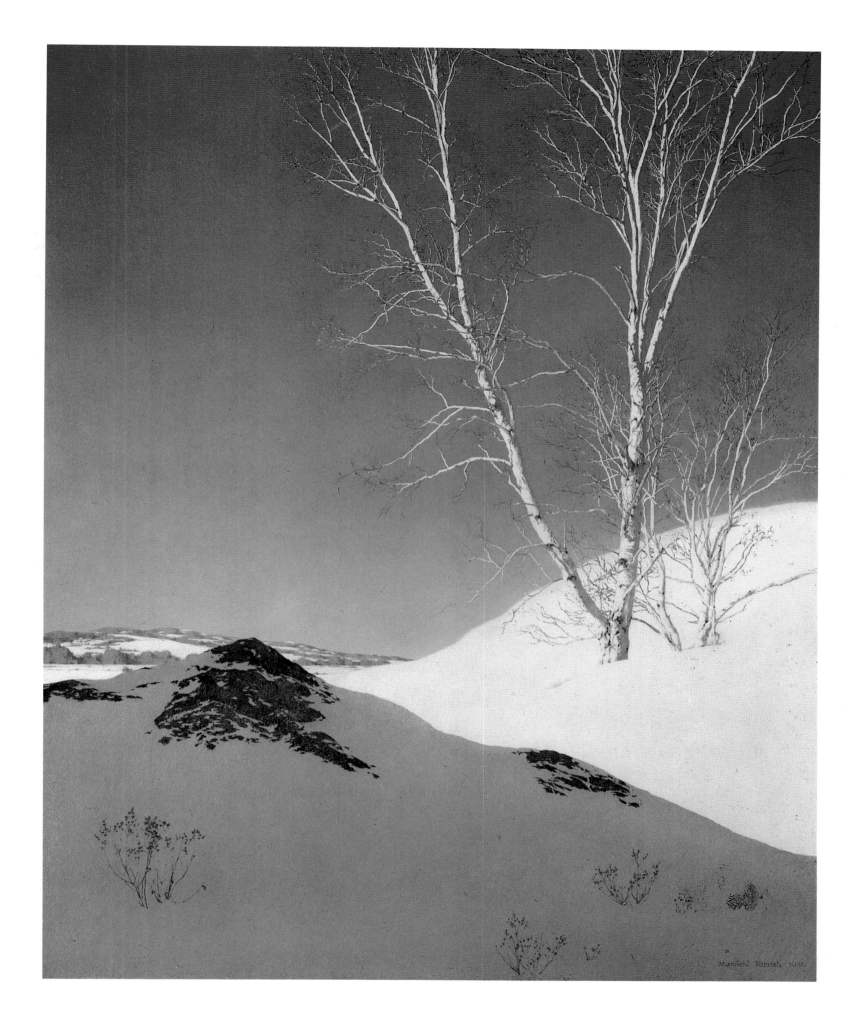

Fig. 8.12

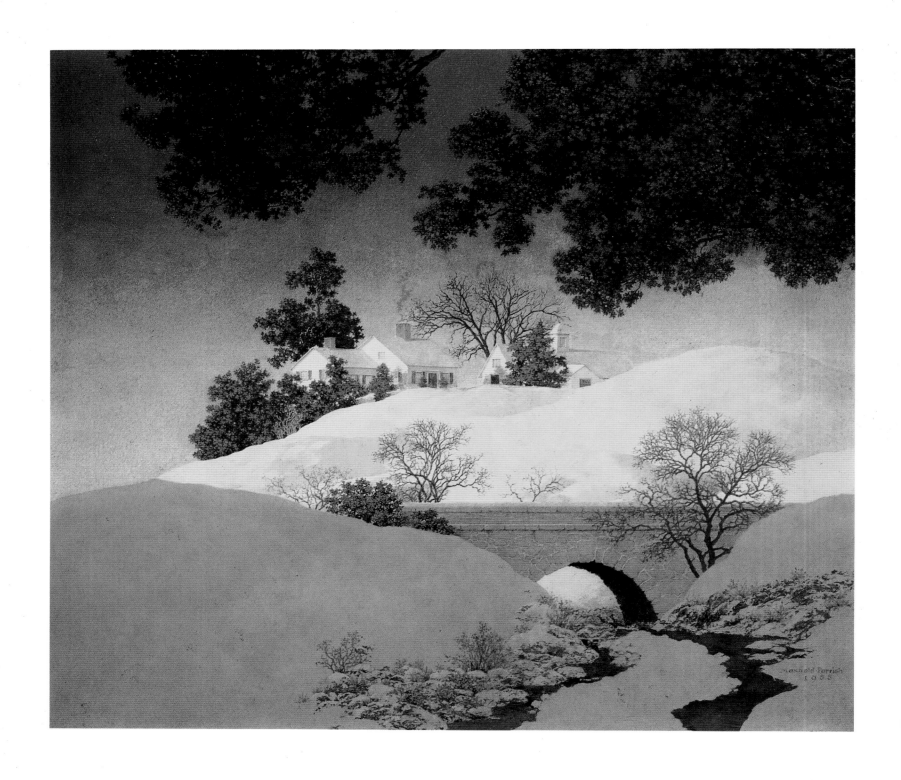

Fig. 8.13

WHEN EARTH'S LAST PICTURE
by
Rudyard Kipling

When Earth's last picture is painted and the tubes are twisted and dried,
When the oldest colours have faded, and the youngest critic has died,
We shall rest, and, faith, we shall need it—lie down for an aeon or two,
Till the Master of All Good Workmen shall put us to work anew.
And those that were good shall be happy: they shall sit in a golden chair;
They shall splash at a ten-league canvas with brushes of comet's hair.
And only The Master shall praise us, and only The Master shall blame;
And no one shall work for money, and no one shall work for fame,
But each for the joy of working, and each, in his separate star,
Shall draw the Thing as he sees It for the God of Things as they are![37]

List of Figures for Chapter 8

Fig. 9.1

THE PAST THIRTY YEARS

(1961-1991)

Early in the 1960s, when Parrish was putting down his brushes for the last time, several things were happening in America with regard to his art work. In his late eighties and early nineties, he had not been active on the painting scene other than to provide Brown and Bigelow with landscapes for their calendars and greeting cards, and to paint for his own enjoyment.

Although Parrish's paintings had continued to have popular appeal, they had been dismissed by his detractors as "commercial art," which at the time was considered poles apart from "fine art." Parrish was also criticized for daring to paint carefully detailed landscapes, giving the entire surface of the painting minute attention, during a time when abstract art was in the ascendancy. (With a couple of slashes here—a dot there—DONE! Another masterpiece for several million dollars hits the modern market!) Despite the criticism and with resolute dedication to his own ideals, he continued to paint the subjects he preferred in his own style and in his own manner, impervious to the swirling trends of modernism going on around him.

Circumstances began to change in the early 1960s. The Pop Art movement, spearheaded by Andy Warhol (who collected Parrish paintings, including *Young King of the Black Isles* and *The Glen*), embraced the imagery of commercial art and reintroduced into American painting the figurative and objective elements that had been put aside by abstract artists. At the same time, Parrish's work began to be accepted again by critics. One newspaper headline, commenting on Parrish's work, then being shown at the New York Gallery of Modern Art, proclaimed: PARRISH: GRAND-POP OF ART!

A survey of dealers who specialized in costly color reproductions stated that they all agreed on the three most popular artists in the world—Van Gogh, Cézanne, and . . . Parrish! (Works by Van Gogh and Cézanne have sold lately for between $40 and $50 million. This year, a major Parrish oil such as *Daybreak* will probably be sold for over a million dollars.)

Major retrospective exhibitions at Bennington College (May 1964) and at the Museum of Modern Art in New York (June 1964) gave Parrish the recognition from institutions that previously had been denied to him. His relation to modern abstractionists such as Jackson Pollock and to realists such as Vasarely began to be recognized in regard to the complex mathematical and optical effects utilized by Parrish as early as 1909 in the series of paintings for magazine

Fig. 4.4

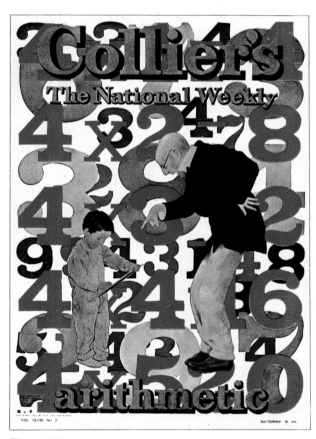

Fig. 4.36

covers for *Collier's* (*The Idiot, Scottish Soldier, Arithmetic,* and *The Alphabet*; see figs. 4.5, 9.2, 4.36, 4.4). Parrish was also recognized as a forerunner of Dalí and other surrealists in terms of his precise objectivity and his smooth high-color surfaces and unorthodox color intensities.

After Parrish's death, his son, Maxfield Parrish, Jr., put his father's estate up for sale in 1966. In a letter to Robert Korey, Max, Jr., wrote:

> I sold the old house, "The Oaks" in a considerable hurry; the owners [Parrish's neighbor, Ambassador Burlings's son and daughter-in-law] wanted to move in right away and start remodeling. They said I could take my time removing and looking for "stuff." I took them at their word, but somehow or other they became disenchanted with the place.
>
> Because of this quick sale, I didn't have a chance to go and look for "stuff" as you can see from having seen the place since. I assume you bought the stage set my Dad built for "Snow White" from the Wells. Well, anyway, you have the three most important parts of the stage set, and I'm tickled at that. Yours in haste to get this off by tomorrow's mail. Sincerely, Maxfield Parrish, Jr.[38]

The reason for the Burlingses' "disenchantment" was that Dillwyn Parrish, who had been allowed by the Burlingses to remain on the property as caretaker, committed suicide on the premises on January 4, 1969. Distraught over their friend's suicide, the Burlingses decided to resell the property immediately. It was subsequently purchased by Rosalind and Thomas Wells. Max, Jr., who fortunately had been able to remove the

Fig. 9.2

paintings and had catalogued over 150 items of his father's estate prior to the coming of the Wellses, sold his father's works to pay the hefty inheritance taxes that an estate such as The Oaks commanded. Max chose one of the best and most respected galleries in the United States to sell his father's paintings, the Vose Galleries of Boston.

It was from the Vose Galleries that I acquired my first seventeen Parrish paintings. My purchase brought the paintings to California and led to a new surge of collectors who were seeing Parrish originals for the first time. In the late sixties, there had been a sale of Parrish works in California at the Willoughby-Toschi Galleries in San Francisco. Perhaps the time was not yet ripe, for relatively few paintings were sold at the time. Five years later when I began to sell Parrishes, the market changed drastically and the paintings began to sell like the proverbial hotcakes. At this point my life became irrevocably intertwined with the Parrish revival phenomenon.

In 1974, James Duff, curator of the Brandywine Museum in Chadds Ford, Pennsylvania, asked me to locate a number of Parrish paintings, which I had sold previously, for a Parrish exhibition to be titled *Master of Make Believe*. I helped gather over thirty paintings, and was gratified to learn that the show broke the museum's attendance records.

A high point in Parrish prices came later that year when the artist's most famous painting, *Daybreak* (fig. 7.12), surfaced after fifty years in virtual hiding. The painting had been brought to the Vose Galleries to be sold, and the Voses offered it to the Metropolitan Museum of Art in New York. *Daybreak* had been in the estate of Kitty Owen, who, readers will recall, was the young woman who had originally posed for the reclining figure in the painting. The mystery buyer in 1925 turned out to have been Kitty Owen's grandfather, William Jennings Bryan. Mr. Bryan, who was very much in the political field at the time of the purchase, was keenly aware that he had just bought what amounted to the most popular painting in the history of American art. He knew that the large sum that he had paid ($10,000 in 1925 dollars would amount to approximately a million dollars today) set a record, for the time, as the highest price paid for a work of a living American artist.

Bryan directed the Scott and Fowler Galleries not to divulge who had purchased the work. Because his house was always in the political spotlight, Bryan decided to install *Daybreak* on his yacht, to keep his purchase a secret from the world. He moored the vessel off the coast of Boston, installed the painting in a climate-controlled stateroom, and allowed only a few intimate friends into his secret. Thus the whereabouts of what became the most sought-after and reproduced painting in the history of art remained a secret for almost fifty years. Finally in 1974 it reappeared and it was again for sale. I had to purchase *Daybreak*! Obviously, my financial means were far less than those of the Metropolitan, but I played my cards right, and moved faster. A museum's decisions involve lengthy committee actions; I was a committee of one and knew I would make the purchase, no matter what.

I offered Mr. Vose a sum in excess of what the Metropolitan had quoted. My offer was to be good for only forty-eight hours, I said. After that I would revert to second place behind the Metropolitan. Knowing full well that the estate was going to (properly) maximize the sums obtained for its client, I knew that they had to contact the Metropolitan to see if the museum would be interested in raising the ante. I sat and waited. Well, not quite sat, really. I was busy informing my husband, my banker, and any

and all friends who could help me gather the necessary funds together within forty-eight hours. Needless to say, when I made the offer, I did not have the money ready to buy the painting. Certainly the Metropolitan could have raised the ante without batting an eye, but not in forty-eight hours. Two days later, at noon on a Saturday morning, the call came from Mr. Vose. The time had elapsed, the Metropolitan had not been able to respond, *Daybreak* was mine.

Twin emotions engulfed me: "Thank you, God!" and "Oh, my gosh, where am I going to get the money?" Fortunately, my banker had seen my track record in selling Parrishes, had placed calls to several museums inquiring what the value of *Daybreak* might be, and was prepared to make a temporary loan for a portion of the purchase.

The arrival of the painting was trumpeted throughout the San Francisco Bay Area by the newspapers and in Herb Caen's column. *Daybreak* appeared for sale at my January 1975 exhibition. It sold within three days to a California executive who delivered her check in full payment for the painting that same month. My bank and everyone else who had helped me gather the funds necessary to purchase *Daybreak* could now be paid off. The gamble was won.

At the time that *Daybreak* surfaced, there had been mention of one or two other copies of that painting in existence. When the newspaper articles appeared trumpeting the discovery of *Daybreak,* I received a letter from a man named Dietrich in the Chicago area claiming to have a copy of *Daybreak*. Maxfield Parrish, Jr., put the idea of any other authentic *Daybreak* to rest with his letter to me of October 9, 1974:

> *Again I am writing at Robert C. Vose's request to reassure you that the painting you recently bought from him is the real, the only, and the genuine "Daybreak," painted by Maxfield Parrish. To the best of my knowledge, there were no copies of it by dad. The 7 foot long "copy"(?), reportedly owned by a man whose name I think is Dietrich, is probably not a forgery, but an honest copy made by some amateur artist who did it from a print. I would be very interested in seeing and studying a photograph of it, if you have any, just to keep current on copies, forgeries, and imitations of dad's work now floating around. Even a black and white photo tells me at a glance which are genuine and which are not.*
>
> *Bob Vose called me when "Daybreak" had arrived in his gallery, and I drove in to see it, taking in with me a 10 power magnifying glass to check on a number of things, condition, surface etc. It was in amazingly good shape, and needed only the most superficial cleaning.*
>
> *I had not seen it for over 50 years, but it still looks just about as I remember it. I, as well as all the rest of the world, tends to remember this painting from the many prints made of it, all of which, even the very earliest ones tended to render it a little bit on the bluish greenish side in over all tonality, and in the later ones, this blue green cast became a lot more pronounced. But the original "Daybreak" did not have this blue green tinge, as you can see by looking at it.*
>
> *The size of it, around 24" × 40", checks with what I remember, and also the fact that it was painted on a Masonite "Prest-*

Fig. 9.3

wood" panel, a surface to paint on that dad preferred, and few other artists used in those days. The acid test, however, is the exquisite skill and care dad used in painting details, the hands, faces, toes, and flowers, and the shadows as they related to the folds in the drapery.[39]

Again in November 1974, Max, Jr., wrote me:

> *. . . Further corroboration of the authenticity of your "Daybreak" came from dad's housekeeper, studio assistant, and cook for the years 1917 to 1958 or so [Sue Lewin], who wrote me in reply to my question, "Did dad paint another and larger (7 foot long) copy of 'Daybreak' during the time you worked for him?"—"I am sure Maxfield Parrish painted only one 'Daybreak' " (she always referred to him as M. P., as did we all, but that is the only change in my quote).*[40]

The sale of *Daybreak* set off a seismic wave of Parrish buying at Sotheby's and Christie's auction houses. Many other dealers, notably New York and foreign dealers, jumped onto the bandwagon. I guess the large New York galleries were miffed that an unknown upstart California gallery had beat them to the punch. When New York galleries came into the Parrish market the prices for his works really took off. *Egypt*, for which I paid $19,000 at auction in 1974, now sold for $68,000 at Sotheby's a scant two years later.

In 1975 I helped organize an exhibition of the three best-known American painters, to travel through Japan in honor of the U.S. bicentennial. The three were Andrew Wyeth, Maxfield Parrish, and Norman Rockwell. The first book in Japanese on the works of Maxfield Parrish appeared at the same time, published by Parco, with the figure of *Ecstasy* on its cover.

In 1977, after selling everything that the Parrish family had left behind in the Parrish studio, the Wellses became disillusioned with their idea of an inn and restaurant in the main Parrish house, so they instructed Marian Garrand, a local realtor, to seek a buyer for the property. Garrand, who had heard about me and my fascination for Parrish called me on the West Coast and asked, since I was buying all the Parrish works of art, how about buying the Parrish house? She reasoned that the house was a Parrish original since he had built it himself with the help of his carpenter friend George Ruggles. The thought sounded a little too farfetched even for a California Parrish dealer. What could I possibly want with a home clear across the country, in a little rural area of New Hampshire? Because, after all, it was the Parrish home, I consented to see it and made an appointment for the next time I would be bidding at auction in New York. I could catch a commuter flight from New York and be in New Hampshire in an hour.

My first mistake was to make that appointment in early October at the height of what is the most spectacular color season in the United States. My second mistake was to visit the house, and to impulsively fall in love with everything that I had ever seen in the Parrish landscapes (it truly was all there) and God help me! . . . to commit to buy it.

Negotiations took us through February 1978. One snowy day, when no other offers had come in, the Wellses finally accepted my offer and sold me the property.

The thought of buying it was not as impractical as it might appear at first

Fig. 9.4

glance. I was determined to turn the studio into a Parrish museum, and to fund it with income from the inn and restaurant in the main house. I had by then sold a good number of the major paintings, including *Daybreak*. I knew who owned them and I was sure the owners would lend them to the museum. The plan sounded feasible. I was to be in charge of acquiring the paintings for the museum and I'd spend summers working there. It was a long shot, but it just might

work. Unfortunately, my long shot fell short of its goal.

My plans to fund the payments for the mortgage and upkeep of the museum through the commercial venture of the inn and restaurant went up in smoke. Literally. On February 24, 1979, a devastating fire started at The Oaks when a wooden beam in the attic ignited through a crack in the chimney's mortar. Flames quickly spread throughout the attic of the main house and

completely burned the area where the inn and restaurant were operating. Newspaper accounts list it as the worst fire in New England in over fifty years. We had twenty people in the house, but fortunately, no one was hurt, and all works of art in the main house, save but one small drawing of Mr. Parrish, were rescued. The last painting carried out of the burning house was *Griselda*. Looking back, it seems ironic: Sue Lewin, who posed for the painting, stayed with Parrish for so long; her portrait was the last to leave the burning building.

Fire fighters from five surrounding towns tried to save the house. The water supply came from outside wells; the night of the fire was one of the coldest on record, and our water lines were frozen. We had to watch in horror as our house, our dreams, and the small fortune that we had sunk into its purchase burned to the ground on that bitterly cold, cruel New England night.

Fig. 9.6

Fig. 9.7

The site chosen by Parrish for building The Oaks was at the top of a hill. The fire fighters had to set up relay stations from their truck at the bottom of the hill, and in fighting the fire, we drained the entire water supply of the towns of Plainfield and Cornish, to no avail. The Oaks could be seen burning like a torch for miles around in the winter night.

Insurance was no help. Of course all of the paintings were heavily insured (and we had saved them). Insurance took care of the bank's mortgages. The building and the furnishings, which had been minimally insured, were gone.

I suppose that (speaking with hindsight) I should have quit at that point and returned to California. However, I chose to rebuild the main house, and to continue maintaining the museum. To do that, I put my house in California up for sale, moved my furniture, art, and my California art gallery to New Hampshire, and began the task of reconstructing the main house, while keeping the Parrish Museum open in the studio.

At first, the townspeople and community rallied around after the loss. When the months flew by and the newness of a museum that needed tending wore out, fewer and fewer volunteers showed up to work as docents and guides. The small donations of books, prints, and memorabilia stopped. The state of New Hampshire (ranked fiftieth among the states in its support of the arts under Governor Sununu), the Arts Council, and the National Endowment for the Arts under Mr. Reagan's administration, all presented unbeatable stumbling blocks rather than help in my quest to maintain the museum. In 1985 I finally had to close the museum because of lack of funds and support.

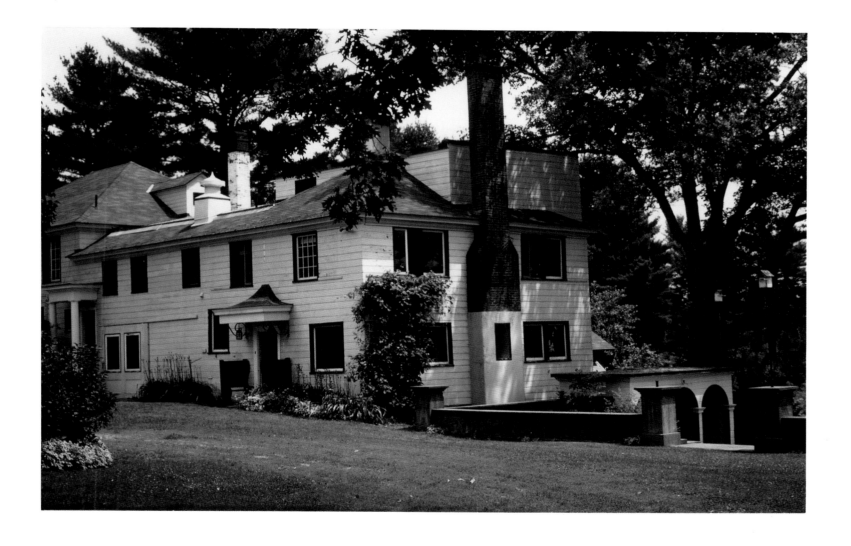

Fig. 9.8

Fig. 9.9

Fig. 9.10

The bulk of the Parrish Museum's art collection, which included everything I owned of Parrish (I had given it all to the museum to start the collection), as well as books, prints, and watercolors given by other donors, went to the Brandywine Museum in Chadds Ford, Pennsylvania. The Saint-Gaudens Historical Site received some material, as did the Precision Museum in nearby Windsor, Vermont.

The mortgage company reclaimed the Parrish property at a fraction of its value, and later sold it to a Boston developer who turned it into condominiums. I was wiped out financially and emotionally. I returned to California to begin again, reopened an art gallery under my own name, and resumed selling Parrishes.

Fortunately, more and more museums and individuals began acquiring the paintings. Exhibitions of Parrish's work in museums began to bring his originals into public view once again. In the last ten years, the values of Parrish paintings have escalated substantially. *Garden of Allah,* which I purchased from Sotheby's in 1974 for $35,000, sold in 1986 for $225,000. *Daybreak,* which I sold in 1975 for $115,000, is now valued in excess of one million dollars. A small oil entitled *Her Window,* sold by Butterfield and Butterfield in San Francisco for $19,000 in 1986, sold at Christie's in 1990 for $82,500; the big murals have all been appraised in the millions.

The last of the major paintings to surface in recent times—after sixty-seven years—was *Dinkey Bird,* (fig. 2.11) which Parrish had executed in 1905 for Eugene Field's *Poems of Childhood.* For years, I had searched auction catalogues, museums, and private collections for any word on the whereabouts of this, one of the three most recognizable Parrish oils.

Twice in the past twenty years, I had clients call to say that they had the original

Dinkey Bird. When they would bring the piece to be examined, I would be obliged to explain that they did not have an original, alas! just a well-preserved early print. In 1977, Maxfield Parrish, Jr., sent me a prophetic little drawing to wish me a successful Parrish exhibition. The drawing featured a facsimile of *Dinkey Bird* swinging out of its frame in wild abandon, knocking off a viewer's hat in the process, (fig. 9.11).

I had not given up hope of finding the painting. For many years I waited to hear about someone finding it. Deep down, it was as if I had some psychic connection with the work, almost as if I were sure that it would come to me eventually. My faith proved uncannily correct. In September 1991, *Dinkey Bird* appeared. It had been in the collection of the prominent Sage family of Albany, New York. Henry Sage, a noted financier, had purchased it early in the century. At the time of his death, it went to his wife, in Menands Village, Albany, New York. After her death, the painting was crated and stored in the basement of their home, and was forgotten until the present heirs discovered it and sent it for sale at Sotheby's.

Sotheby's selected *Dinkey Bird* for the cover of the catalogue for their prestigious sale of American art for autumn, 1991. In a tough economic year that had given way to dismal art sales, *Dinkey Bird* was the only painting in the catalogue to double its pre-auction estimates and sell in the low six-figure bracket. To acquire the piece, I gathered a cartel to fund its purchase. With a surge of triumphant exultation, I made the winning bid, and *Dinkey Bird* would at last come home to me. Next to the purchase of *Daybreak,* the acquisition of this piece stood as one of the proud achievements of my career.

The dramatic sale of *Dinkey Bird* illustrates how, in the years since Parrish's death, the art market has given ample tes-

Fig. 9.11

196

timony to the lasting impact of his work; after enriching American art for nearly one hundred years, Parrish has secured his place in the art history of his country.

From the crowded floors of the great auction houses where collectors and dealers vie for his works, to the humble rural American farmhouses, college dorms, and city apartments where his prints hang, cher-ished and passed down from generation to generation, Parrish lives on. His art is revered, enjoyed, and collected by generations of Americans who have had the joy of encountering it.

Dwelling in the minds, the hearts, the homes of others . . . isn't that what immortality is all about?

List of Figures for Chapter 9

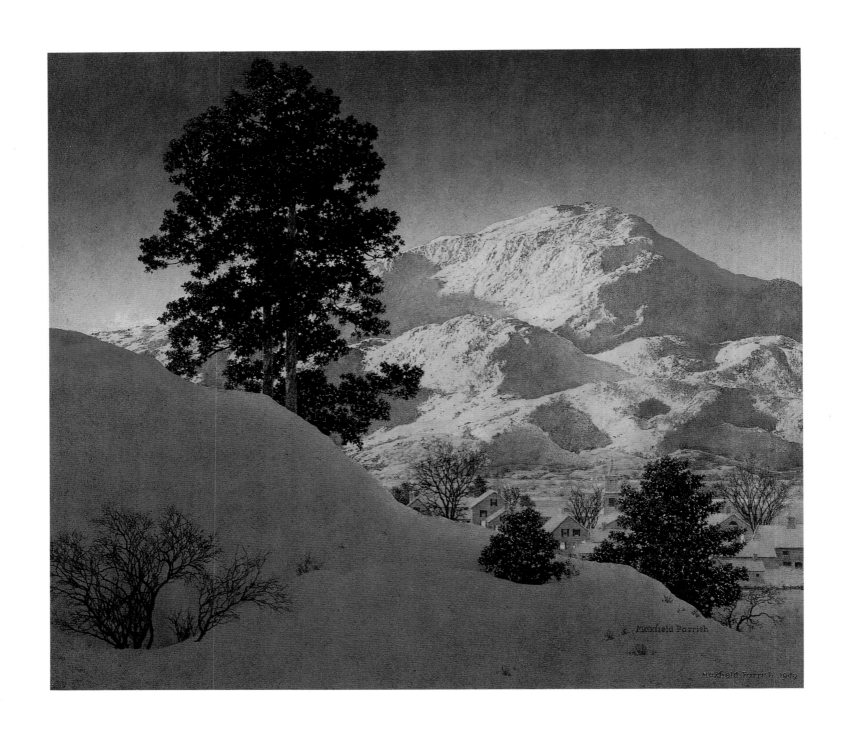

Fig. 10.1

C H A P T E R T E N

T E C H N I Q U E

Parrish was an accomplished draftsman and a great technician. His quest for perfection was based in his strong grounding in architectural and mechanical disciplines. In his early days, he fought against becoming too technical in his drawings, and strove for spontaneity. Many of the early works were done on Steinbach watercolor paper with pencils, inks, crayons, and lithographic pens; the pieces he did for the Mask and Wig Club in 1896–1898 (*Very Little Red Riding Hood, No Gentlemen of France, Kennilworth,* and *The 1889–1898 Decennial Anniversary*) are examples of these media.

From 1901 to 1904, when he worked on Edith Wharton's *Italian Villas and Their Gardens* and Eugene Field's *Poems of Childhood,* Parrish preferred using Whatman's paper that had been dampened and pulled taut over stretcher bars. He found that applying the colors progressively on the pure white of the paper, varnishing after each coat, gave the paintings a beautiful jewel-like appearance. Parrish enjoyed painting on paper, and he was fond of saying that he considered his work on paper, if done with proper regard to a thorough drying process, more permanent than painting on canvas.

In 1975, when we thought that *Dinkey Bird* (fig. 2.11)—one of the most famous pieces done on paper—might surface, Max, Jr., wrote to tell me what to expect:

> *. . . The possible come-uppance of the original of the "Dinkey Bird" is exciting news, and the fact that it was done on paper may serve to authenticate it more than not. Provided, that is, that it is painted on very thick taut paper. What dad did was take a heavily built strong frame specially put out by a certain manufacturer, and cut some paper big enough to wrap around this frame twice, plus double overlap on one end. The reason for all this work and seeming waste of paper is, he'd soak the paper overnight in water which made it soft and pliable, and it stretched a ½" in length. He'd drain the water off holding it up vertically for a few minutes, and while still wet, wrap it around the frame and glue all four edges to the frame and the paper itself at the overlap. The glue would harden up before the paper dried and shrank, so as it shrank it drew taut, like a drum head. This made a wonderful surface to draw and paint on.*[41]

From 1905 to 1909, Parrish worked on large paintings, including *Land of Make Believe, Jason and His Teacher, Cadmus Sowing the Dragon's Teeth,* and other important pieces for books. These works were done on canvas which he laid down on a Prestwood or Vehisote board. Other works such as *Garden of Allah* and *Rubaiyat* were painted on paper and then laid down on a composition board such as Upson's. After the mid-1930s Parrish painted almost exclusively on masonite panels of 5/16″ width. He would prepare the panel by applying a white ground of Permalban prepared by F. Weber Company of Philadelphia. He would wait until the Permalban dried, applying heat with 250-watt lamps or setting the board to dry near his mammoth potbellied stove in the studio. The drying process was crucial, particularly in the cold New Hampshire winter.

Parrish would lay out the outline of a composition and details in pencil. If he was going to put a figure in the painting, often the figure was designed on very heavy paper and then was worked into the composition. Max, Jr., wrote in 1976:

> *Dad very often did the sketching of important figures in a painting by using heavy paper and scissors, rather than pencil. All his life, when he was painting a picture with a human figure in it, the main figure was always first sketched with scissors using fairly thick paper. He felt more confident of the accuracy of scissors than a pencil, his theory being that scissors always point in the direction they are going to cut, but a pencil or pen has to be guided the whole way.*[42]

The first color Parrish used in a painting would be ultramarine blue. He waited until the paint dried completely, then, gently and meticulously, he used fine pumice to smooth the surface. He then applied a clear varnish, working against the minuscule particles of the board that he had raised with the pumice, so that the varnish would become a clear layer forming a barrier between colors, allowing each color's properties and nuances to shine undisturbed. He did not mix colors on his palette, but was known to apply color straight from the tube onto his painting surface (Winsor & Newton oils were his favorite). He waited until the varnish dried properly before adding the next color, repeating the steps in layers of glazing—paint, dry, pumice, varnish, dry, paint.

A wonderful example of Parrish's technique lives in the reworked but unfinished painting *Dreaming/October* (fig. 7.9), originally painted for reproduction as an art print (*Dreaming,* fig. 7.8), for the House of Art in 1928. In 1960, Parrish decided to change the composition to a pure landscape, removing the original nude figure under a tree and much of the right half of the painting, where he reinforced the white background and stenciled in with ultramarine blue glaze the imprimatur or underpainting for a second tree. With gray pigments he painted in the lower foreground the imprimatur for what probably was to have been an area of shaded grass. The repainting was never finished beyond the first layer of glaze and varnish, leaving a valuable example of Parrish's technique, finished and in progress.[43]

Parrish wrote a marvelous letter in 1950 to F. W. Weber, manufacturer of artists' colors and materials. The letter was recently made public by the family in an article in the August 8, 1991, issue of the *New York–Pennsylvania Collector.* The following excerpts are from this account by the artist himself.

You ask for a description of my technique? Well, the method of painting is very simple, and very ancient, and, no use denying, rather laborious, and by no means original. It is almost like the modern reproductions in four-color process halftones, where the various gradations are obtained by one color plate printed over another on a white ground. . . . In painting it is an ancient process as anyone can read in the many books written about the techniques of the Old Masters: telling how each one had his own particular way of going about it. Some beginning the first painting in monochromes, others carrying the first paintings somewhat further with a few colors added before the glazing with transparent colors.

Yes, it is rather laborious, but it has some advantages over the usual way of mixing colors together before applying them. It must be admitted that the most beautiful quality of color is its transparent state applied over a white ground with the light shining through it. Even better is a good modern Kodachrome, a delight to behold with its luminous deep color like stained glass. So many ask what is meant by transparent color, as though it was some special make.

Most colors that an artist uses [are] such; only a few are opaque. In the use of a color just as it comes from the tube, the original purity of each color is never lost: a purple is a pure madder glowing through a pure blue overglaze, or vice versa, the quality of each is never vitiated by mixing them

together. Mix a rose madder, let us say, with white, and a pink is the result, quite different from the original madder.

A case in point: one doesn't paint very long out of doors before it is realized that a green tree has a lot of red in it: it is hard to see, but it seems to be there, nevertheless. So, if you mix a red with the green you get a sort of mud, each color killing the other. But by this other method when the green is dry and a rose madder glazed over it, you are apt to get what is wanted without harming either color's purity, and have a richness and glow of one color playing through the other, not to be had by mixing. . . .

Imagine a Rembrandt if his magic browns were mixed together instead of glazed: the result would be a sort of chocolate. Then too, by this method some colors could be used that are quite taboo in mixtures. Verdigris, for instance, is a strange cold green of exceptional luminous quality, unusual in greens. If in contact with coal gas, not unknown in cities, it can turn black overnight, but if used all by itself, locked up in varnish, it lasts as long as any other. The same with alizarin orange, frowned upon by most color makers, yet I have examples of both of these painted forty years ago and as fresh and brilliant as the day they were used.

I used to begin a painting with a monochrome of raw umber, for some reason: possibly read that it was done in olden times. But now the start is made with transparent ultramarine blue, giving far more brilliance and depth, and

for all the world like a big blue dinner plate without the floral border. When this is thoroughly dry then the fun begins, and the rest is a sort of build up of a few primary colors until the end. It takes considerable planning ahead, to be sure, but so does pure watercolor, in order to get the pure transparent washes of that medium. It must be understood that when transparent color dries, it looks like nothing at all, and its life must be brought back again by a very thin coat of varnish. This also protects one glaze of color from another. And this varnishing is a craft all by itself and cannot be too carefully done: hurry it and put it too cold and too thick and disaster follows.

Fortunately, colors in their transparent state are dry when they feel dry, these glazes are extremely thin and have a chance to dry much faster than heavy impasto, whereas whites and opaque yellows seem to take forever to become thoroughly inert. Varnishing should be done in a very warm room where the painting and varnish have been exposed to the warmth for some hours. This is to drive off all invisible surface moisture and to make the varnish flow better and thinner, to be applied as thin as possible. Also the varnished surface should remain warm until set. Days should be waited until the varnish coat is thoroughly dry: then a light rubbing of pumice flour and water takes off dust particles and makes a surface somewhat better to apply the next process. . . . Copal Picture Varnish is the varnish used. . . .

. . . How do ideas come? What a question! If they come of their own accord, they are apt to arrive at the most unexpected time and place. For the most part the place is out of doors, for up in this northern wilderness when nature puts on a show it is an inspiring one. There seem to be magic days once in a while, with some rare quality of light that hold a body spellbound: In sub-zero weather there will be a burst of unbelievable color when the mountain turns a deep purple, a thing it refuses to do in summer. Then comes the hard part: how to plan a picture so as to give others what has happened to you. To render in paint an experience, to suggest the sense of light and color, air and space, there is no such thing as sitting down outside and trying to make a "portrait" of it. It lasts for only a minute, for one thing, and it isn't an inspiration that can be copied on the spot. . . .

Sometimes rough studies are made indoors mostly mere scribbles that soon go in the stove: sometimes sketches are more carefully worked out. Sometimes when the affair seems quite definite in our head, no studies at all. It all depends.

. . . How long to paint a picture? Well, that depends, too. . . . Once in a while a painting will go along easily, without snags, almost paints itself. Then others make trouble, no end of trouble, and floundering around makes them no better, and a fresh start is indicated. Two months might be called the minimum, if all goes well: not

actual painting time, but time-out for thorough drying between working on it. The worst thing that can happen is to make a good sketch: then your work is done, you have expressed yourself, and the large panel is just an enlargement with the good quality of the sketch left out. Fortunately, that rarely happens. . . .

. . . Photography in many cases helps a lot in the study of light and shade, especially where the illumination lasts but a short time, where the effect would be gone before a sketch started. . . . a great help in recording some of these ancient sugar maple trunks, splendid old characters they are with the most interesting anatomy. I used to visit a few I knew at sunrise and then again at late afternoon, and then again to find it gone, as like as not cut up in the owner's woodshed against a long winter.[44]

The following illustrations are from a booklet Illustrated Perspective Lesson *by Maxfield Parrish.*

Fig I. The picture plane intersects the cone of visual rays to the eye at right angles to the cone in a circle (a) which is similar to the circle A and is a true picture of the same.

Fig. II.

The picture plane cuts the cone of rays obliquely and the section thus made (provided B is a circle) is an ellipse. When the eye is at the apex of the cone the picture plane does not appear as an ellipse but as a circle. When the eye is elsewhere the picture plane b is an ellipse and not a true picture of B.

IMP. For the picture to be a true picture the picture plane must be perpendicular to the direction in which an object is seen.

The picture plane may be imagined as a transparent or translucent piece of glass on which the object is seen.

See fig 3 where the picture plane is used as a standard of Comparison.

Fig. 10.2-1

Fig 3.

If Two parallel and equal lines which are not foreshortened the nearer one is the longer and the length of the other or others varies inversely as the distance.

In fig 3. A.B.C. etc are equal distances apart.
It is seen that B appears ½ the length of A for B is twice as far off. C being 3 times as far off is ⅓ length of A and so on INVERSELY.

In fig 4. The nearest is the longest: the farthest is the shortest. The intermediate distances being proportional between them. On any retreating line all equal spaces appear unequal the near the longer.

Fig. 10.2-2

In Figs. all angles are equidistant from the eye.

Fig. 6. left verticle face is seen very narrow.

Also where the horizon is the diameter the convergency of homologous lines each side of horizon is equal.

IMP — Parallel retreating horizontal lines appear to vanish at the level of the eye.

Fig 7. Interior of room.

The vanishing point of 1234 is on the perpendicular plane opposite the eye (A). And on a level with the eye.

The vanishing point of any set of ∥ lines is in a parallel to them through the eye.

───

Fig. 8. represents cube placed so as the front face and top are seen, and when E and F make a rt. line. A B C are ∥.

D is > E although E is nearer the eye.

This figure shows that of two ∥ lines the nearer one appears shorter and the most distant line longer.

Fig. 9 —

Top view of Cube showing to the eye a horizontal square and a verticle picture plane. It goes to show that of two ∥ and = lines at unequal distances from the eye, the nearer AD appears the shorter, when its angle with the picture plane is greater than 45°. when at a less angle than 45° the nearer line appears the longer. as BD appears longer than AC.

It also shows that of two equal lines AD and BD perpendicular to each other and having a pt. B in common the one which makes the greatest angle with the picture plane appears the shorter or conversely the one nearest ∥ appears the longer. It also shows that if one limb of the rt. ∠ vanishes toward the left the other must vanish toward the right.

Fig 10.

Two equal lines ⊥ To each other and at = ∠ˢ to the picture plane appear of = length and will also vanish at equal angles —

Fig 11.

Cube with lower face on level with the eye. ∠ edges vertical and one face visible. Unless the eye is very near it appears practically of its Real shape

Fig. 10.2-5

Fig 12.

Cube placed below sheet of fig 11.
The receding horizontal edges vanish in O, the centre of the edge AB, because this edge is on the level of the eye, and the lines from this pt. to H to the edges.
The front face being below the eye will appear foreshortened so that its apparent height is less than its width.
The edge EF is farther from the eye than GH, and will ∴ appear shorter. Or length of 1 and 2.
The vertical edges will appear as inclined lines.
However in drawing models vertical edges must be represented by vertical lines

The AIM is to create a correct impression of the whole by sacrificing that truth of detail which may be necessary to do This.

Fig. 10.2-6

List of Figures for Chapter 10

10.1 *Winter Sunrise,* 1949, oil on board, 13″ × 15″. Private collection.
10.2 Six drawings from *Illustrated Perspective Lesson Five,* circa 1890–1892, published
 privately in 1980 in a booklet, edition of a 1,000, to raise funds for the Parrish Museum.
 Collection of the author.

LETTERS

Maxfield Parrish wrote witty, literate, beautifully descriptive letters. The dry humor, the turn of the phrase, give us a personal glimpse of the life and times of the reclusive, gentle artist.[45]

January 15, 1911, to eleven-year-old Austin Purves in answer to his query: Should he take up drawing lessons:

My dear Austin:

. . . You ask if you ought to take drawing lessons yet? Why, yes indeed, if you really want to. But mind you, draw all the things you like in between whiles. When you take lessons you have to draw a lot of things that are not very interesting: Blocks and things and plaster casts, because they perhaps train your eye and hand better than other things. But draw the things you like best, too: it doesn't make a bit of difference what they are: angels, ships, animals, soldiers: the fact that you want to is reason enough for doing it. Indeed, I do hope you will come here soon some day. I wish you were here now: we would have a good time. The snow

has stopped and there is a big horned owl up in the oak tree, and moonlight—such moonlight, it is like a blue day outside. And now I am going to leave you and walk to the top of the pasture before turning in. It's good to be up there: for a little while you forget that "painting pictures" is punk and that you're no good. You feel smaller than ever at night on top of this hill, but you feel very happy, and do not particularly care. Good night. Maxfield Parrish

Sunday, December 14, 1922, to son Dillwyn Parrish:

. . . Of local news I know but little or nothing of the outside either, for that matter. Windsor has been hit hard by the cross-word puzzle craze, and in every store the clerks are crouching down behind the counters with a dictionary. I don't quite see it myself, for after you have solved one, there are countless thousands more. People are being sent to jail so as to have uninterrupted quiet to work their puzzles out. . . . Lovingly, Dad

May 12, 1942, to Lydia and Dillwyn Parrish during wartime:

> . . . *Had a letter from Stanton Forbes asking for an introduction to Homer Saint-Gaudens, head of the U.S. Camouflage Division, as Stanton has been drafted and wanted to serve in that department. He wrote to Homer sometime ago but got no answer, possibly because Homer is still reading over Stanton's list of qualifications, a copy of which he sent me.*
>
> *Never have I read of so gifted a party: seems to me he'd done about everything but give bird imitations. Maybe it's camouflage. . . .*
>
> *Even [Shipley] got in, mind you, in spite of a shattered leg and teeth knocked out and other ailments. He kept at them again and again until, on account of his French-Spanish, they thought they could use him somewhere. . . . Here at home [The Oaks], lilacs are at their peak and soon will be in the midst of wild grape season. It is most enchanting here, but no one to enjoy it: so deserted everyone away at war. Down front all the fauna of this zone have taken it over for their own and resent like fury any human intrusion. I expect to find a moose on the lawn any morning. . . . As ever: Dad*

February 23, 1952, to his wife Lydia:

> . . . *At last I have my Income Tax list done and waiting for your signature to hand over to Fitzgerald [the Parrish solicitor and accountant]. A circular letter sent out by the Tax department implores people to read over carefully the instructions as out of 54 million tax returns, 14 million contained errors, thus making necessary the enormous force of tax deputies. It might help the 14 million if they'd implore the Tax Dept. to write the damn thing in English so's the average citizen could understand it. . . .*

March 1, 1956, to Edward Latham, Baker Library, Hanover, New Hampshire, after being sent an early letter (1898) that had appeared at an auction of famous signatures:

> *Dear Latham:*
> *Who'd ever thought any of my old letters would be quoted as for sale on the Exchange. Talk about unearned increment! Ought I not claim a royalty? I dare say they thought I was dead, and they may be right. I must look into that. The number of letters that pour in these days is a caution. One yesterday, just as an example, from Rutgers University, to supply information on "The Political Philosophy of Herbert Croly." I ask you!*
>
> *Why a body would ever use dangerous sleeping tablets with a copy of "Promise of American Life" in the house, I don't know. Or, "Please send a history of your life and list of work to be read before the Ladies Uplift Assoc. of East Smithfield Center next Wednesday at 3 p.m." As you know yourself, in New Hampshire murder is frowned upon. . . . I return the cutting [letter]: it may be of great value: I wouldn't know. My best to you: Maxfield Parrish*

August 5, 1960, to Robert Eldridge, Art Editor, Southern Publishing Association, Nashville, Tennessee:

> *Dear Mr. Eldridge:*
> *I wonder, did you know you have written me a most delightful*

letter: yours of June 21st. Marvelous things you said about my work, all of it sweet music, but dear Sir, I could not possibly be THAT good. You mentioned could you have something retrieved from the wastebasket? I wish you could have asked that two years ago. Then it was I met a dear old man, head of the Stockton Art Museum in California, Earl Royland by name and sent him contents of second drawer from the bottom: sketches, studies, all kinds of junk including two dead wasps. Also, the original of Jack Frost, an old cover for Collier's Magazine which happened to be a favorite of his.

You might have thought I'd sent him contents of the Louvre. I have discovered that in California they are Past Masters in the gentle practice of "taking-on." But it left nothing to send you. My 90th birthday was celebrated by cleaning the studio and behind a door I found some studies for paintings, very rough scruffy affairs thinking possibly you might find among them something to keep, the rest should go in a stove. I do value your grand letter, and thank you for it. With all sincerity: Maxfield Parrish

February 27, 1962, to Susan Lewin Colby, thanking her for a crate of oranges sent to him from Florida:

Susan! Susan! Susan! Those were the most wonderful oranges I ever saw or tasted! . . . Each orange was evidently registered in the Florida Board of Trade: each just like another, some even more so. Each one heavy with delicious juice.

. . . After lunch Beiling the hardware man phoned. The box of oranges had just arrived and was daughter [Jean Parrish] coming over by any chance, and she was, and he said he'd go out and try and get her. And he did. Then the fire department sirens began to blow, all the traffic lights turned red, and mothers got their children off the streets and indoors. Even with the roads glare ice, Jean got the Jeep here safely. Now that was a present, let me tell you. They acted like tonic for I've been hard at the yearly chores of Income Tax, checking a long list of investments with the year before, then re-checking to make sure. If there's anything more tiresome it hasn't come this way yet. . . . With thoughts unutterable. M. P.

September 10, 1963, to A. O. Jacobsen, New York, upon learning that Jacobsen was inquiring about purchasing a Parrish oil that he had seen at Baker Library in Dartmouth College:

. . . I fear there has been some misunderstanding about the painting over the sofa, the one which was in the exhibition at the Dartmouth library some years ago. This one is not for sale and goes in a more expensive class. The man at the library threw out rather strong hints that they would like to own it, but colleges I find like such things as gifts. Some years ago the Library asked if I would not like to give them a painting as the honor to me would be quite sufficient, so they have one in the office and I have basked in the honor ever since, and another thing, my son Max Jr., has let it be known this painting is his property. . . . Best wishes. Maxfield Parrish

September 26, 1963, to A. O. Jacobsen, New York, who purchased the painting *Winter Sunshine* and had just received delivery:

> *". . . Glad Winter Sunshine was to your liking! Over here, none of us remember such a long procession of beautiful days: not a cloud, and not a drop of rain and neighbors on all sides hauling water. The strangest thing is our spring began to provide a little stream and has kept it up to overflowing. If somebody will kindly explain that. Moses and Aaron got around it by tapping a rock, but there were a number of things in those days that bear looking into. . . . Our color pageant is beginning to fade though we have to admit some trees put on a pretty good show. It is a lovely time when all of outdoors is taking a rest, not a leaf stirring, nature sort of sitting back contemplating her summer's work and finding it good.*
>
> *Bears have been seen around: one party saw one with her two cubs, the mother cuffing them into the ways of properly brought up bears. My best to you: Maxfield Parrish*

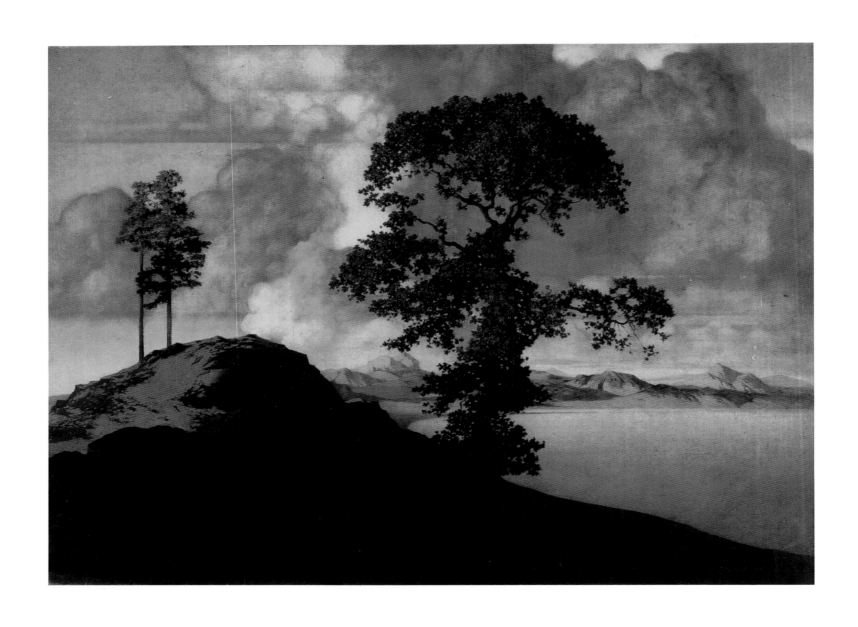

Fig. E.1

EPILOGUE

he Parrish phenomenon, the utter devotion to his prints and paintings by vast numbers of collectors, has created a following of almost cultlike proportions. I have seen people risk jail (and go to jail) for Parrishes. I have been told that "contracts" have been put out on people for losing a Parrish at auction, and have also been told that unscrupulous collectors have even resorted to stealing Parrishes, or paying someone else to steal one for them. I have known of people going to jail in contempt of court rather than reveal the whereabouts of a Parrish in a divorce or other property settlement case.

The *Study for River at Ascutney* (fig. E.2), a small (10″ by 10″) oil, was stolen twice from my gallery. When the police caught up with the fleeing suspect in San Francisco, the painting was recovered and returned to me, only to be stolen two weeks later by someone else. The FBI theorized that a "contract" had been put out on the painting by a collector who could not afford its price tag. The second time it was stolen, the painting was not recovered; it remains at large. Another small oil, from the 1950s, *Dingleton Farm* (13″ by 18″), was taken from

my gallery in San Mateo, California, by someone who had come to visit it almost on a daily basis as if on a pilgrimage. It was taken out of its frame, slipped under heavy winter clothing and spirited out of the gallery. The police and the gallery knew who had taken it, but the painting was not found on the individual and its theft could not be proven. It also remains at large.

Some comments of others of greater note than I, and their thoughts on Parrish:

Lawrence Alloway, curator of the Guggenheim Museum exhibition *The Return of Maxfield Parrish*, May 1964:

> *Maxfield Parrish is an artist who lives in the memories of Americans as well as in museums. Besides being a popular artist in his own time, he was regarded as a very fine artist. For instance, almost one hundred years ago, he received an honorable mention in the Paris Exposition of 1900, and the following year collected a silver medal at the Pan American Exposition. He was also a full member of the National Academy of Design. This testifies to the seriousness of his reputation as an artist.*

Time Magazine, June 12, 1964:

> *The pop art of fifty years ago had an attribute not shared with the pop art of today: it was popular!!! And the most popular artist of that time was Maxfield Parrish.*

John Canaday (*New York Times*), June 7, 1964:

> *As a painter, Parrish is established as a superb technician and a considerable wit, as well as a first rate story teller. His work is timeless.*

Robert Taylor (*Boston Herald*), May 24, 1966:

> *Today, of course, Parrish is "IN" but this only means that he is back in vogue with the current batch of intelligentsia and a group of taste makers who are busy creating tastes for each other. He has never been "OUT" with the public. If you grew up keeping cool with Coolidge, there was probably a Maxfield Parrish somewhere in your home. But if you're a mod teenager today there may be a Parrish around, too. He appeals to practically everybody. He was probably the last of his kind.*

Coy Ludwig (from his book *Maxfield Parrish,* now in its sixteenth printing):

> *Since the 1960s more and more Americans have been discovering Parrish's works not only in the print media of calendars, magazines and books, but also in museums and galleries. In this setting, his work can be seen in the original, as any artist's work should be seen to be evaluated properly. Audiences are able to study his composition, technique and use of color not only in its own right, but in juxtaposition with the original works of other artists. And so it is that with this new accessibility a new evaluation of Maxfield Parrish and his place in the history of American art is being discovered.*

Norman Rockwell (in a film entitled *Parrish Blue* by Syracuse University):

> *Maxfield Parrish was my absolute idol.*

Maurice Sendak, illustrator and writer, in *Notes on Books and Pictures* (New York: Abrams, 1988):

> *He was a popular artist in the best sense of the word. His work, like all popular artists, exists parallel to the world of fine arts. Maxfield Parrish was a modest man who once said of himself: "I am hopelessly commonplace!" Perhaps, but the commonplace transfigured.*

And finally, one of my favorite quotations (because I have seen it proven true over and over again throughout my dealings with the thousands of Parrish admirers who for the last twenty years have been attending my exhibitions of his work). Donald Reichert, curator of G. W. V. Smith Art Museum wrote these lines to Harold Knox, a good friend and one of the few donors to the Parrish Museum, inscribing them in the brochure for the exhibition "Maxfield Parrish: A Retrospect" (January 23–March 20, 1966), which Reichert had curated:

> *There is in this man, Maxfield Parrish, a singular spirit that ties strangers together as old friends.*

Parrish's art has challenged others, like

Fig. E.2

215

Fig. E.3

Louis Comfort Tiffany with *Dream Garden,* to achieve great heights and depths by exploring his paintings. Recently, I have seen Parrish's work blossom out and inspire a new media. The Peninsula Ballet in California performed its world premiere of a ballet choreographed and danced by Rosine Bena, another Parrish enthusiast. It was titled "Maxfield Parrish: A Love Story." The libretto was based on my book *The Make Believe World of Maxfield Parrish and Sue Lewin* (Pomegranate Books, 1990), the music composed by Susan Mazer and Dallas Smith. I was mesmerized by the performance, uplifted beyond words by the music and the dancers; tears streamed down my face, and the paintings came to life before my eyes.

Pomegranate Books had this to say about the ballet:

The ballet was conceived as a sensual, visual, and musical celebration of one of the greatest love stories ever told. The musical themes include depictions of individual paintings, especially those that featured Sue Lewin as model, as well as portrayals of the drama that surrounded these works. Here is the story of a man and his art, making visible both the love and pain of the secret romance between Maxfield Parrish and Sue Lewin.[46]

I have come to realize that the masterworks that Parrish created will live on, inspiring and challenging others to beauty, love, and perfection through their inspiration for centuries to come. Art, the great communicator for our civilization, has found a worthy exponent in the artist Maxfield Parrish.

List of Figures for Epilogue

NOTES

CHAPTER 2. The Book Illustrations

1. Maxfield Parrish, letter to Winston Churchill, April 1, 1903. Special Collections, Dartmouth College Library, Hanover, N.H.

2. Coy Ludwig, *Maxfield Parrish* (New York: Watson Guptill, 1973), 48.

CHAPTER 3. The Great Southwest Paintings

3. Ludwig, *Maxfield Parrish,* 19.

4. Editor's comments, "Southwest Series," *Century Magazine,* July 12, 1902.

5. "Open Letter from Maxfield Parrish," *Century Magazine,* August 12, 1902.

CHAPTER 4. The Magazine Work

6. The Correspondence of Augustus Saint-Gaudens, Special Collections, Dartmouth College Library, Hanover, N.H.

7. Maxfield Parrish, Jr., letter to Robert Korey, April 28, 1975. The letter authenticates the sets that had been found in the attic of The Oaks and that Korey had purchased from the Wells. Letter collection of the author.

8. For a more detailed review of the Parrish-Lewin relationship, see Alma M. Gilbert, *The Make Believe World of Maxfield Parrish and Sue Lewin* (San Francisco: Pomegranate Books, 1990).

9. M. Parrish, letter to Rushing Wood, February 5, 1923. Parrish Family Papers, Special Collections, Dartmouth College Library, Hanover, N.H.

CHAPTER 5. The Mazda Calendars

10. J. L. Conger, "Maxfield Parrish's Calendars Build Sales for Edison Mazda Lamps," *The Artist and Advertiser,* June 1931, 34.

11. M. Parrish, "An Open Letter," *Century Magazine,* August 12, 1902.

12. "Maxfield Parrish Will Discard 'Girl-on-the-Rock' Idea in Art," Associated Press, April 27, 1931.

CHAPTER 6. The Murals

13. M. Parrish, "An Open Letter," to Mr. Streeter, editor of *Table Topics,* May 4, 1946.

14. M. Parrish, letter to Helen Hess, February 8, 1949. Parrish Family Papers.

15. "Two Original 'Interludes'?" *New York–Pennsylvania Collector,* August 1991.

16. "The Most Beautiful Dining Room in America," *Ladies' Home Journal,* August 1912.

17. M. Parrish, letter to Edward Bok, January 18, 1912. Parrish Family Papers.

18. Edward Bok, letter to M. Parrish, April 19, 1915. Sharon Bloemendaal, "Maxfield Parrish: New Photos and Information Found," *New York–Pennsylvania Collector,* August 1991.

19. *Ladies' Home Journal,* May 1912.

20. M. Parrish, letter to Edward Bok, July 27, 1911. Parrish Family Papers.

21. See Gilbert, *Make Believe World,* 39–43.

22. Ludwig, *Maxfield Parrish,* 166–167.

23. "The Dream Garden." Prospectus (Philadelphia: The Curtis Center, September 1985).

24. M. Parrish, letter to Lydia Parrish, August 1915. Bloemendaal, "New Photos."

25. "The Dream Garden." Prospectus.

26. Louis Tiffany, *The Dream Garden* (Philadelphia: The Curtis Publishing Company, 1915).

CHAPTER 7. The House of Art Prints

27. M. Parrish, letter to Stephen Newman, January 24, 1922. Parrish Family Papers.

28. Jay Hambidge, *Dynamic Symmetry of the Greek Vase* (New Haven: Yale University Press, 1920). Hambidge (1867–1924) was a Canadian artist, pupil of the Art Students League in New York and of William

Chase. His theory was used by Parrish, Pyle, N.C. Wyeth, and other illustrators of the day.

29. Gordon Parrish, "Maxfield Parrish: A Grandson's View," *New York–Pennsylvania Collector,* August 1991.

CHAPTER 8. Landscapes: The Final Works

30. Kathleen Read, letter to author, June 1990.

31. M. Parrish, letter to Roy Hill, December 15, 1959. Parrish Family Papers.

32. Clair Fry, letter to M. Parrish, January 13, 1955. Parrish Family Papers.

33. M. Parrish, letter to F. W. Weber, January 7, 1950. Published in *New York–Pennsylvania Collector,* August 1991.

34. Steve Crimmins, "Oral History of Maxfield Parrish," August 1979. Brandywine Museum, Chadds Ford, Pa.

35. M. Parrish, letter to Jerome Conally, May 5, 1952. Parrish Family Papers.

36. Gilbert, *Make Believe World,* 74.

37. A special note of thanks to octogenerian poet and Parrish devotee John Barker of Montgomery, Alabama, who suggested that this poem be included.

CHAPTER 9. The Past Thirty Years

38. M. Parrish, Jr., letter to Robert Korey, April 28, 1975. Letter collection of the author.

39. M. Parrish, Jr., letter to author, October 9, 1974.

40. M. Parrish, Jr., letter to author, November 16, 1974.

CHAPTER 10. Technique

41. M. Parrish, Jr., letter to author, May 29, 1975.

42. M. Parrish, Jr., letter to author, September 3, 1976.

43. Ludwig, *Maxfield Parrish,* 193.

44. M. Parrish, letter to F. W. Weber, January 7, 1950. Published in "Maxfield Parrish's Techniques," *New York–Pennsylvania Collector,* August 1991.

CHAPTER 11. Letters

45. All letters quoted in chapter 11 are from the collection of the author.

EPILOGUE

46. "Maxfield Parrish: A Love Story." Prospectus (San Francisco: Pomegranate Books, 1991).

BIBLIOGRAPHY

Alloway, Lawrence. "The Return of Maxfield Parrish." *Show* IV (May 1964): 62–67.

Bloemendaal, Sharon. "Maxfield Parrish: New Photos and Information Found." *New York–Pennsylvania Collector* (August 1991).

Bok, Edward. *The Americanization of Edward Bok.* New York: Charles Scribner's and Sons, 1922.

Canaday, John. "Maxfield Parrish's Calendars Build Sales for Edison Mazda Lamps." *The Artist and Advertiser* (June 1931): 4–7, 33–35.

The Correspondence of Augustus Saint-Gaudens. Special Collections, Dartmouth College Library, Hanover, N.H.

Crimmins, Steve. "Oral Histories of Maxfield Parrish." The Maxfield Parrish Museum, Cornish, N.H. (Donated to Brandywine Museum, Chadds Ford, Pa.)

"The Dream Garden." Prospectus. Philadelphia: Curtis Publishing Center, 1985.

Gilbert, Alma. *The Make Believe World of Maxfield Parrish and Sue Lewin.* San Francisco: Pomegranate Books, 1990.

Gilbert, Alma. *The Maxfield Parrish Poster Book.* San Francisco: Pomegranate Books, 1989.

"Grand Pop." *Time Magazine* 83 (June 12, 1964): 76.

Hambidge, Jay. *Dynamic Symmetry of the Greek Vase.* New Haven: Yale University Press, 1920.

Jackson, Denis C. *The Price and Identification Guide to Maxfield Parrish.* 7th ed. Sequim, Wash., 1990.

Knox, Harold. *Collector's Guide to Maxfield Parrish.* Lebanon, N.H., 1972.

Ludwig, Coy. *Maxfield Parrish.* New York: Watson Guptill, 1973.

"Maxfield Parrish: A Love Story." Prospectus. San Francisco: Pomegranate Books, 1991.

"Maxfield Parrish Will Discard 'Girl-on-the-Rock' Idea in Art." The Associated Press (April 27, 1931).

"Maxfield Parrish's Techniques." *New York–Pennsylvania Collector* (August 1991).

"The Most Beautiful Dining Room in America." *Ladies' Home Journal* 29 (May 1912): 17–18.

Norell, Irene P. *Maxfield Parrish, New Hampshire Artist, 1870–1966.* San Jose, Calif., 1971

Parrish Family Papers. Special Collections, Dartmouth College Library, Hanover, N.H.

Parrish, Gordon. "Maxfield Parrish: A Grandson's View." *New York–Pennsylvania Collector* (August 1991).

Parrish, Maxfield. "The Southwest in Color: Open Letter to the Editors." *Century Magazine* 65 (November 1902): 160–161.

Skeeter, Paul. *Maxfield Parrish: The Early Years.* Los Angeles: Nash Publications, 1973.

Taylor, Robert. "Maxfield Parrish Is In." *The Boston Herald* (May 24, 1966).

Tiffany, Louis. *The Dream Garden.* Philadelphia: The Curtis Publishing Company, 1915.

"Two Original 'Interludes'?" *New York–Pennsylvania Collector* (August 1991).

INDEX